The Official Story of The Championships

WIMBLEDON
2012

20 12

THE CHAMPIONSHIPS
WIMBLEDON

MONDAY 25TH JUNE
TO SUNDAY 8TH JULY

12 FOR 2012
A SELECTION OF POSTER
IMAGES FROM LOCAL
COLLEGE STUDENTS.

WIMBLEDON.COM

The Official Story of The Championships
WIMBLEDON
2012

By Neil Harman

(**Left**) *Art and Graphic Design students from Kingston were invited to design this year's Championships poster, with the best 'Twelve for 2012' selected.*

VSP

Published in 2012 by Vision Sports Publishing Ltd

Vision Sports Publishing Ltd
19-23 High Street, Kingston upon Thames
Surrey, KT1 1LL
www.visionsp.co.uk

ISBN: 978-1907637-64-3

Written by: Neil Harman
Additional writing by: Alexandra Willis
Edited by: Jim Drewett and Alexandra Willis
Copy editing: Alex Morton
Designed by: Neal Cobourne
Photography: Tom Lovelock, John Buckle, Matthias Hangst, David Levenson,Tommy Hindley,
Bob Martin, Chris Raphael and Neil Tingle
Picture editor: Paul Weaver

All photographs © AELTC

Results and tables are reproduced courtesy of the AELTC

The All England Lawn Tennis Club (Championships) Limited
Church Road, Wimbledon, London, SW19 5AE, England
Tel: +44 (0)20 8944 1066
Fax: +44 (0)20 8947 8752
www.wimbledon.com

Printed in Slovakia by Neografia

This book is reproduced with the assistance of Rolex.

ROLEX

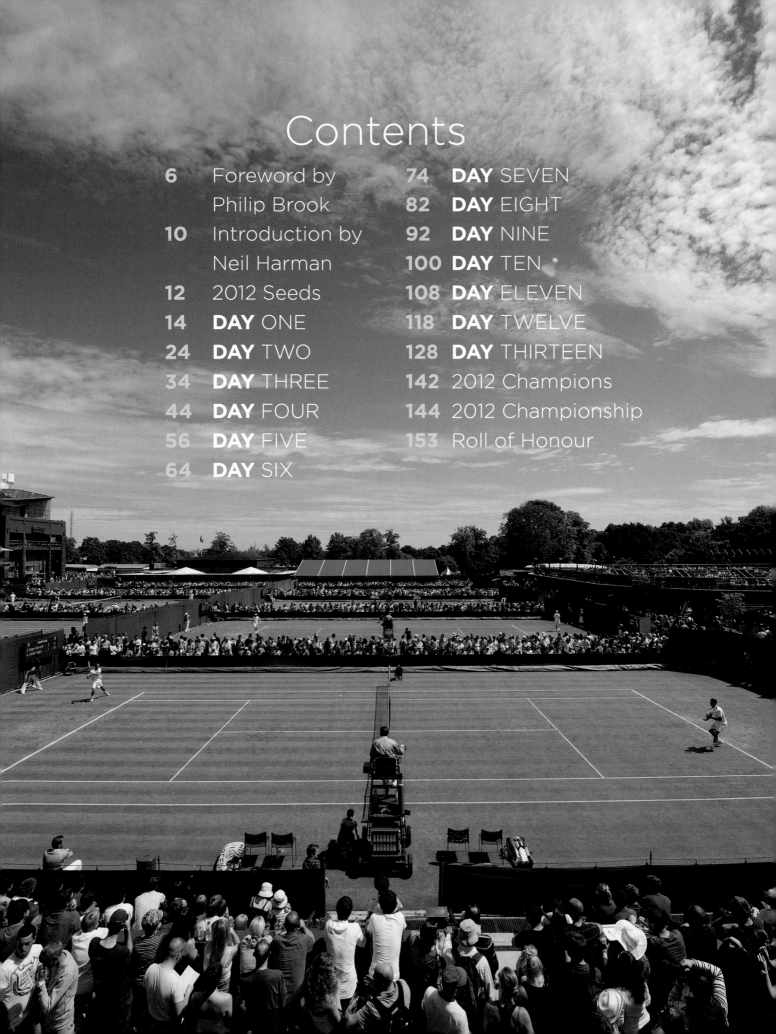

Contents

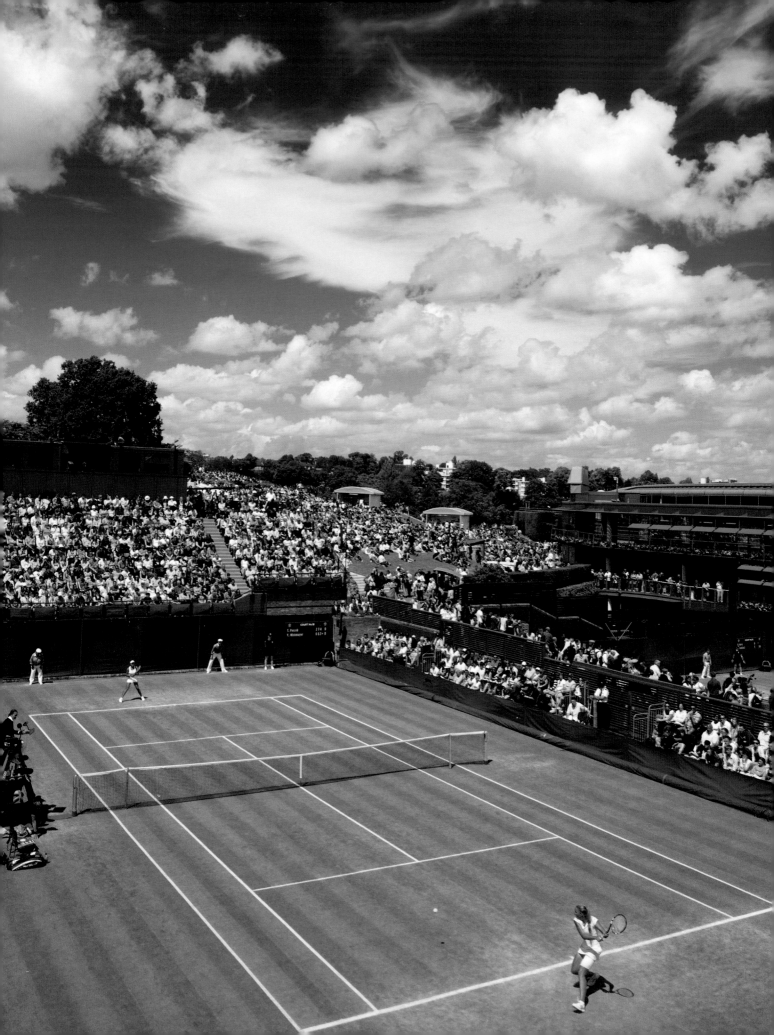

Foreword
By Philip Brook
Chairman of the All England Lawn Tennis & Croquet Club and
Committee of Management of The Championships

At this year's 126th Championships we were once again reminded of the gladiatorial nature of professional tennis – 'triumph and disaster' as Rudyard Kipling put it. We had arguably a 'dream' Gentlemen's Singles final, with six-time champion Roger Federer against Andy Murray, Britain's first Gentlemen's Singles finalist since Bunny Austin in 1938. After three and a half hours of incredibly high-quality tennis Roger triumphed, and in so doing equalled the record of seven wins held by William Renshaw from the 1880s and Pete Sampras from the 1990s.

In a year when experience seemed to count, Serena Williams prevailed in the Ladies' Singles for the fifth time, thereby bringing to 10 the number of Ladies' Singles titles won by the Williams' sisters at Wimbledon. For good measure, they teamed up and won their fifth Ladies' Doubles title. In the Gentlemen's Doubles, the wild card pairing of Britain's Jonny Marray and Denmark's Freddie Nielsen won against all the odds. Not bad for a pair ranked 76 and 111 in the world.

2012 was also a significant anniversary for Centre Court. Built in time for the 1922 Championships, the Court is 90 this year. The retractable roof, added in 2009, was used on nine days during a Championships of very unsettled weather. Unsurprisingly perhaps, Wimbledon titles were decided under the roof for the first time – in Gentlemen's Singles and Doubles, Ladies' Doubles and Mixed Doubles.

With only 20 days from the end of The Championships to the start of the Olympic tennis event, the main task was to restore the courts. One day later re-seeding of all 19 courts with a specially selected pre-germinated grass seed had been completed. It is the second time that Olympic tennis has been played at the All England Club, the last being in 1908, and we are delighted that Wimbledon is playing its part in London 2012.

Once the Olympic tennis was over, our Head Groundsman, Eddie Seaward, retired after 22 years in the role, and I congratulate him and all of his team for their outstanding commitment and for the exceptional quality of their work.

One significant postscript to this year's Championships is that, from 2015, Wimbledon will be held one week later, giving the players precious additional time to recover from the demands of playing Roland Garros and to prepare for Wimbledon.

I hope this annual will bring back many happy memories of Wimbledon 2012.

Philip Brook

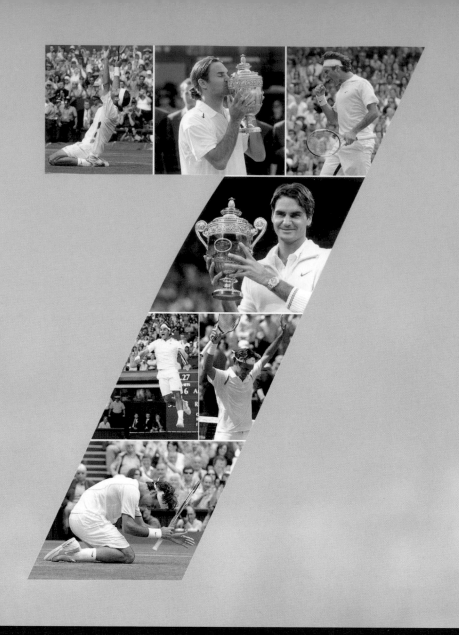

OYSTER PERPETUAL DATEJUST II

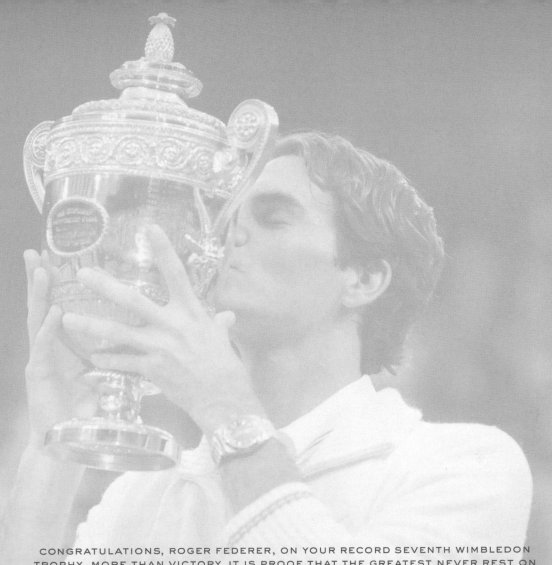

CONGRATULATIONS, ROGER FEDERER, ON YOUR RECORD SEVENTH WIMBLEDON
TROPHY. MORE THAN VICTORY, IT IS PROOF THAT THE GREATEST NEVER REST ON
THEIR LAURELS. YOU CONTINUE TO SET THE BAR HIGHER AND HIGHER.

ROLEX

ROLEX AND ROGER FEDERER.
UNITED BY SETTING A STANDARD
TO WHICH ALL OTHERS ASPIRE.

Introduction

By Neil Harman

It had barely stopped raining in Britain since a hosepipe ban had been introduced in April in several locations, and there appeared to be a greater lushness than ever across the grounds of the All England Club as the 126th Championships approached. The weekend before the event began, a month's precipitation had fallen in one night in parts of northern England. There was much covering and uncovering of courts as finding any practice court became an imperative.

On the way to the grounds on Sunday, small lakes that passed for puddles had formed on nearby motorways, the skyline was forked with grey outlines and relaxation was at a premium. For the first time since the Centre Court roof had been formally introduced in 2009, it looked as if it might be employed more often than not.

Once more, Andy Murray would carry the home hopes, something he had become accustomed to since his teenage years. He was 25 now, the maturing process had been a painstaking, often painful one and he had a new coach, who had been working with him since 1 January, in the shape of Ivan Lendl, someone who had strived to master the grass and never quite succeeded.

A week before The Championships, Murray received a message from Novak Djokovic who had travelled to Scotland for a few days relaxation with his girlfriend, Jelena Ristic. Djokovic was on the A9 when he passed Dunblane and, to Murray's great surprise, flashed a picture of the road sign to his mobile phone. "I had been asked a lot by people in Scotland whether Andy can win a Grand Slam, and I said of course he can," Djokovic said. "It is a matter of being in those moments and finding that something. These are small margins."

The margins at the top of the game were so tiny that, at the start of the Gentlemen's event, it was possible for either Djokovic, Rafael Nadal or Roger Federer to finish as the world No.1. Federer had not been to a Wimbledon final since 2009, he had seen the younger pair steal his Grand Slam thunder and divide it between themselves, and to say that it was nagging at him was an understatement.

There were five British men in the event – Murray, James Ward, Jamie Baker, Josh Goodall and Oliver Golding – and six women – Anne Keothavong, Elena Baltacha, Laura Robson, Heather Watson, Naomi Broady and, making her debut under the British flag, Johanna Konta. The top seed for the Ladies' Singles was Maria Sharapova of Russia, fresh from completing her Grand Slam set of trophies with victory over Sara Errani of Italy in the final of the French Open two weeks earlier.

The Chairman's Special Guests had been announced. Frank Sedgman had won the Gentlemen's Singles, the Doubles and the Mixed Doubles 60 years earlier; it was half a century since Rod Laver had won all four of the Grand Slam tournaments, and the sport's most famous married couple, Andre Agassi and Stefanie Graf, had both won singles titles in 1992. I surely wasn't the only one to wonder where those 20 years had gone.

It being the All England Club, innovations were rife. The Championships would start on the outside courts at 11.30am, half an hour earlier than before (to ensure matches have a greater chance of being finished on the original day of schedule), there was the new digital service, Live @ Wimbledon, "a content-rich and engaging audio-visual experience", and, the south east still being largely in drought, there would be ways of reducing the Club's non-essential water consumption – such as revised planting schemes with drought-tolerant plants, and a reduction in hanging baskets outside the grounds.

From the minute the AELTC made that announcement, of course, it had not stopped raining.

Wimbledon 2012

Gentlemen's Seeds

Novak Djokovic
(Serbia)
Seeded 1st
Age: 25
Wimbledon titles: 1
Grand Slam titles: 5

Rafael Nadal
(Spain)
Seeded 2nd
Age: 26
Wimbledon titles: 2
Grand Slam titles: 11

Roger Federer
(Switzerland)
Seeded 3rd
Age: 30
Wimbledon titles: 6.
Grand Slam titles: 16

Andy Murray
(Great Britain)
Seeded 4th
Age: 25

Jo-Wilfried
Tsonga (France)
Seeded 5th
Age: 27

Tomas Berdych
(Czech Republic)
Seeded 6th
Age: 26

David Ferrer
(Spain)
Seeded 7th
Age: 30

Janko
Tipsarevic
(Serbia)
Seeded 8th
Age: 28

9th Juan Martin del Potro (Argentina)
10th Mardy Fish (USA)
11th John Isner (USA)
12th Nicolas Almagro (Spain)

13th Gilles Simon (France)
14th Feliciano Lopez (Spain)
15th Juan Monaco (Argentina)
16th Marin Cilic (Croatia)

Seedings

Ladies' Seeds

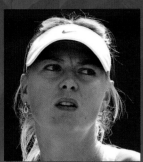

Maria Sharapova
(Russia)
Seeded 1st
Age: 25
Wimbledon titles: 1
Grand Slam titles: 4

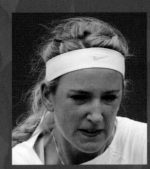

Victoria Azarenka
(Belarus)
Seeded 2nd
Age: 22
Grand Slam titles: 1

Agnieszka Radwanska
(Poland)
Seeded 3rd
Age: 23

Petra Kvitova
(Czech Republic)
Seeded 4th
Age: 22
Wimbledon titles: 1
Grand Slam titles: 1

Samantha Stosur
(Australia)
Seeded 5th
Age: 28
Grand Slam titles: 1

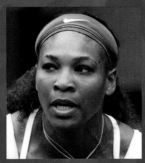

Serena Williams
(USA)
Seeded 6th
Age: 30
Wimbledon titles: 4
Grand Slam titles: 13

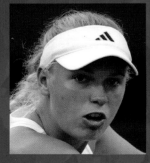

Caroline Wozniacki
(Denmark)
Seeded 7th
Age: 21

Angelique Kerber
(Germany)
Seeded 8th
Age: 24

9th Marion Bartoli (France)
10th Sara Errani (Italy)
11th Li Na (China)
12th Vera Zvonareva (Russia)

13th Dominika Cibulkova (Slovakia)
14th Ana Ivanovic (Serbia)
15th Sabine Lisicki (Germany)
16th Flavia Pennetta (Italy)

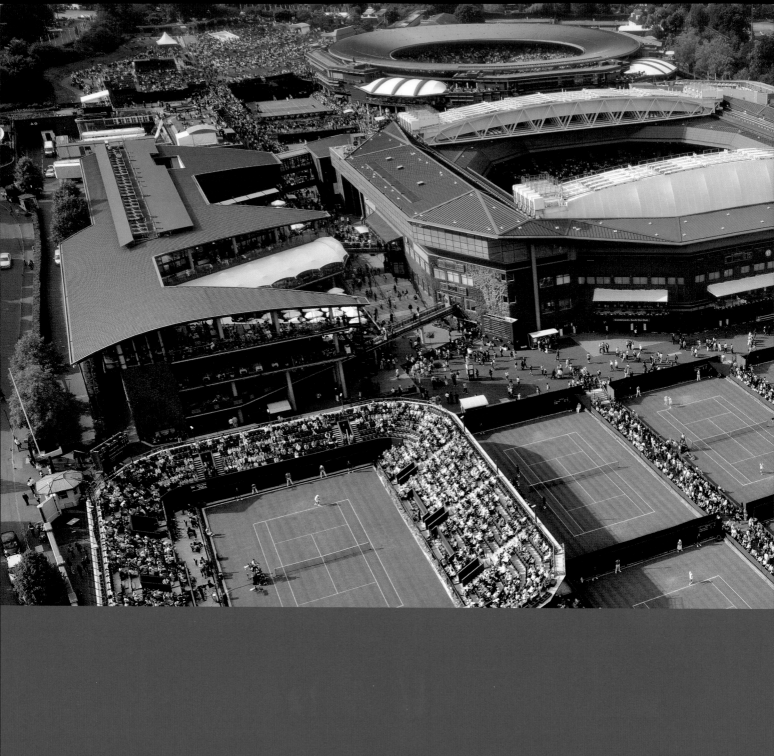

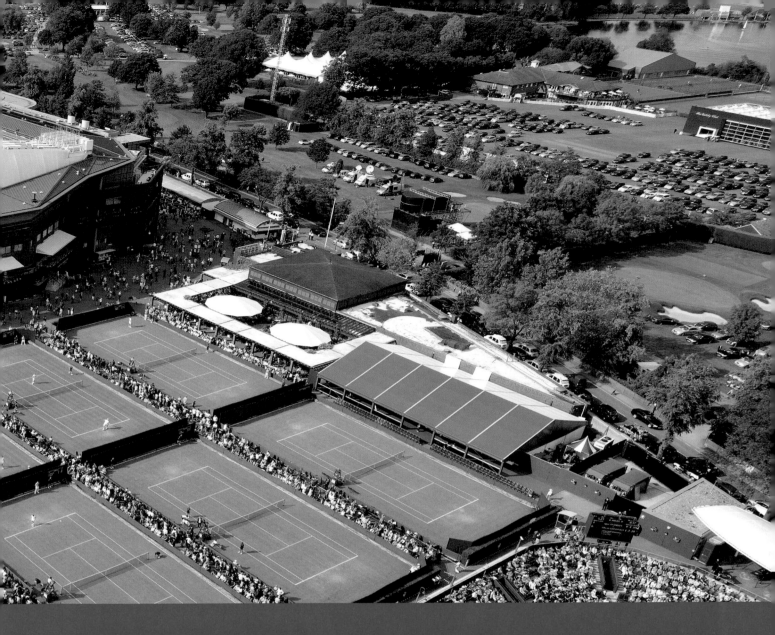

DAY ONE
MONDAY 25 JUNE

The year 2012 definitely signalled changing times, and those of us of a certain vintage felt content that they were. In the Gentlemen's Singles draw, there were 33 players aged 30 or over and 56 who were 28-plus. In the Ladies', 16 players were 30 or older, including two qualifiers, while Kimiko Date-Krumm of Japan, at 41, was the oldest by five years.

But, at the end of the opening day of the 126th Championships, if you had plugged into her system, it was a 20-year-old who could have illuminated the entire spread of SW19. When the Order of Play had originally been sent out, Heather Watson against Iveta Benesova of the Czech Republic was listed as one of those additional matches that could be staged on any court at any time, so long as it was past 5pm.

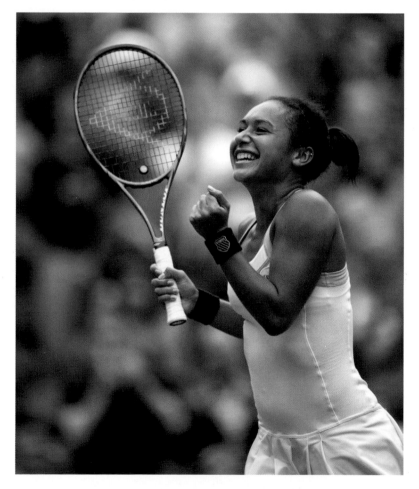

Heather Watson became the first British woman to win on Centre Court since 1985

Just occasionally, something happens that offers an opportunity that you could not have prepared yourself for and to which you respond in compelling fashion. As Watson's luck would have it, the first three matches on Centre Court were all straight-set affairs, the champion Novak Djokovic dispensing of Juan Carlos Ferrero, the former world No.1 from Spain; Maria Sharapova swinging through five games in 14 minutes before taking a little pity on Australia's Anastasia Rodionova; and the gifted Ernests Gulbis of Latvia provoking the day's massive shock, a 7-6(5), 7-6(4), 7-6(4) success over the No.6 seed Tomas Berdych of the Czech Republic. My tournament dark horse had already been put out to graze.

And so, at 7.25pm, the girl from Guernsey was sent through the curtains with her opponent, who was ranked 48 places higher on the WTA, and proceeded to play as if this was her 50th match there, rather than her first. Extraordinarily, such was Watson's dominance in a match that took just an hour and 24 minutes that she managed to claim 20 break points against the Czech's serve and, even if she only took four of them, a 6-2, 6-1 victory was an illustration of her qualities.

"I kept getting the tingles, and after I won I got a bit lost and couldn't find my way off the court," she said. Well, if British players want to hang around out there for longer than is always necessary, you will not find the sport minding too much.

The first couple of days of The Championships, in domestic terms, tend to be used as a barometer of the general state of the game. Perhaps this is a touch unfair because what players do in the other 50 weeks of the year is as important, if not more so, but judgments and critiques of them do not carry the same weight as they do at Wimbledon.

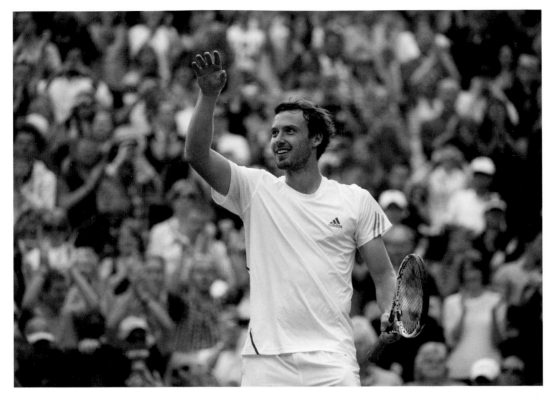

(Left) *Ernests Gulbis of Latvia achieved the first upset of the tournament with his defeat of Tomas Berdych*

(Below) *Kim Clijsters began her final appearance at The Championships with an impressive straight sets victory over fellow former world No. 1 and No. 18 seed Jelena Jankovic*

Oliver Golding's 1-6, 7-6(4), 7-6(7), 7-5 defeat to Igor Andreev of Russia would be seen, in the cold light of the next morning's headlines, as a bit of a blow and to him it clearly was. The difference between his post-match interview and that of Watson could hardly have been more marked. And yet the 18-year-old from Richmond gave a compelling account of himself, given that he was ranked No.481 in the world and was playing someone who, in November 2008, had been inside the top 20.

Taking such elements into account, Golding's promise is undoubted, the crowd on No.2 Court was lifted and dropped in equal measure and, if only he had been able to find that spark of something in either tie-break, it could have been different. In time, he will learn how to make the most of these moments.

Josh Goodall, the British No.4, was equally despondent not to have made more of his draw, a first-round match against Grega Zemlja of Slovenia, who had been granted a wild card into the singles as a result of his victory in the ATP Challenger event in Nottingham in late May. Goodall, an unashamed Chelsea supporter, named his tennis rackets after several of their players; he had a Drogba, a Terry, a Torres and a David Luiz, which he used when he was feeling "a little crazy on the court". The one he used against Zemlja was the Torres, and it misfired in front of a few open goals as often as the Spanish striker can do, Goodall going down 6-4, 3-6, 7-6(3), 6-4.

In the wider world, there were a couple of seismic shocks for the United States. Venus Williams had not been beaten in the opening round since her happy-go-lucky, beaded hair days of

Opening The Championships

It is one of those traditions that is quintessentially Wimbledon. All the four majors invite the defending champion to open play on the main Show Court on the first day, but there is something that little bit different about opening Centre Court. Perhaps because the grass has been untouched and unplayed on before that moment. So it was that Novak Djokovic, the defending Gentlemen's Singles champion, strode out head to toe in white to perform the honour at 1pm on Monday 25 June 2012.

"It's a very unique feeling. I think that's the first time I experienced that in my career," Djokovic said. "So it was great. You know, the grass was untouched. It was so soft, so smooth. It was great to play on."

But Djokovic, being Djokovic, added a little something extra to the mix. As he set down his Head bag on the turf, he pulled out a mini golf club. "I don't know if you noticed, but all the Head players, they have the bags which look like golf bags because you can place them the way the golf bag is standing," Djokovic explained. "So it was a little funny thing. Being creative, that's all."

Five-time champion Venus Williams suffered her earliest loss at Wimbledon since 1997

the late Nineties, but here she was, getting thumped by the Russian Elena Vesnina 6-1, 6-3, and though she said she felt like a great player — emphasising that sentiment with, "I am a great player" — the decline that was expected when she was diagnosed with an auto-immune illness in 2011 was all too vivid.

The five-times champion had lost that verve, the bounce, the conviction, that made her, yes, such a great player. "I've lost before so I know how to deal with it," she said. She seemed now, though, to be sapped of energy, and it was to the world No.79 Vesnina's credit that she did not celebrate one of her finer victories too wildly, keeping her emotions, as high as they were, in composed check.

John Isner had endured one of those strange years, with vivid successes on clay in the Davis Cup, reaching the final of the BNP Paribas Open in Indian Wells, California, in March and yet, having chosen to go home to North Carolina after Paris, he had no genuinely competitive grass court form coming in to Wimbledon.

As such, he was vulnerable early on and Alejandro Falla of Colombia — the man who had served for the match in the first round against Roger Federer in 2010 — did not have to face the same knee-knocking prospect against the 6'10" Isner, breaking him for the second time in the match (the first had been in the very first game) to win 6-4, 6-7(7), 3-6, 7-6(7), 7-5.

"It is all on me, it was just not great on my part," Isner said. "I just got so clouded and frustrated. I just can't get out of my own way, to do the right things in the match that I need to do. I'm just getting too down on myself. There have certainly been better times than right now."

Djokovic was not certain how he would feel — who is? — when he walked back onto Centre Court 50 weeks after taking a bite out of it after his 2011 victory. For any player in his situation, it is all about getting the matches out of the way with as little trouble as possible, and about getting your emotional game and accuracy aligned. A champion doesn't want emotional peaks until deep into the second week, when they become unavoidable, so the fact that his performance was in the five-out-of-10 category and he didn't lose his cool once was just about right.

Flying home was David Nalbandian, the Argentine finalist from 10 years ago who had become the naughty boy of tennis with his advertising-board-kicking exploits at The Queen's Club a week before The Championships. There was no bloodshed, no cowering officials, in fact hardly anything worth raising an eyebrow over as Nalbandian was defeated in straight sets by Janko Tipsarevic, the No.8 seed from Serbia.

WIMBLEDON IN NUMBERS

25 Women in the Ladies' Singles draw with an 'ova' at the end of their name.

Green Wimbledon

While the staging of the Olympic tennis at Wimbledon negated any significant building works in 2012, there were two pieces in the puzzle of a longer-term plan in evidence – the ambition to make Wimbledon "greener".

Firstly, to fit in line with the nationwide drought measures, the number of hanging baskets adorning courts and nearby streets was slashed from 260 to 115 inside the grounds and 362 to zero in surrounding streets.

A more long-term change was the trialling of a new "no petrol, no oil, no emissions" battery-powered Toro Mower on No.2 Court as part of the AELTC's environmental business practice policy.

"It is the AELTC's policy to seriously consider our carbon footprint and take into account the environmental impact of everything we do," said Neil Stubley, the Head Groundsman designate.

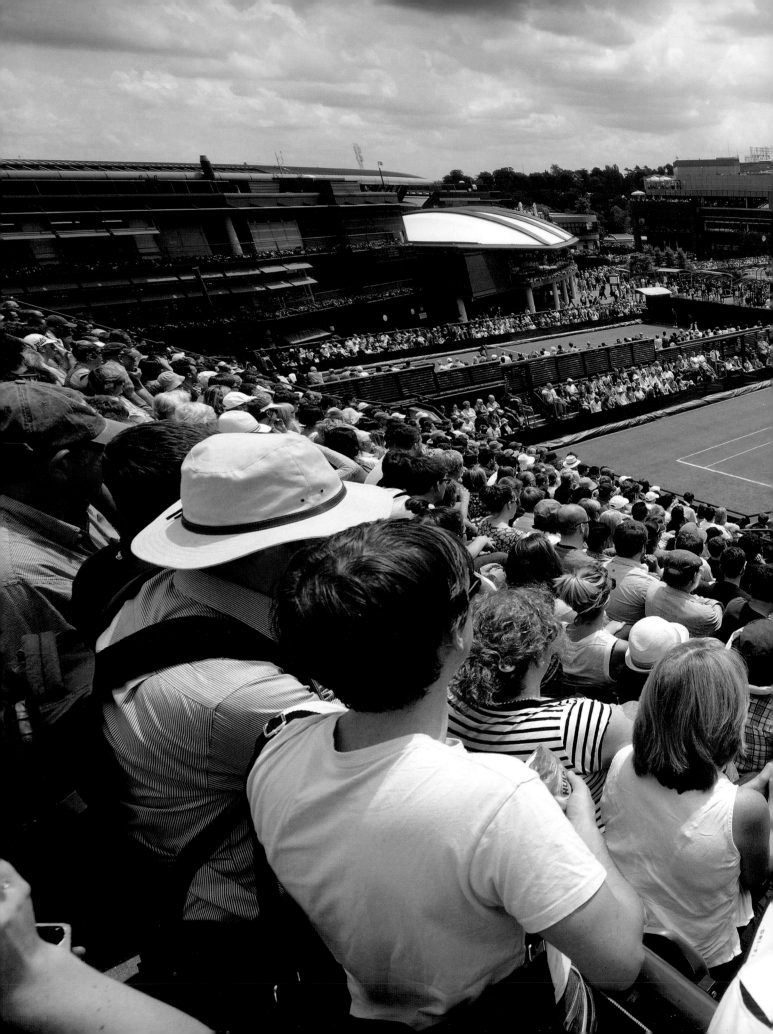

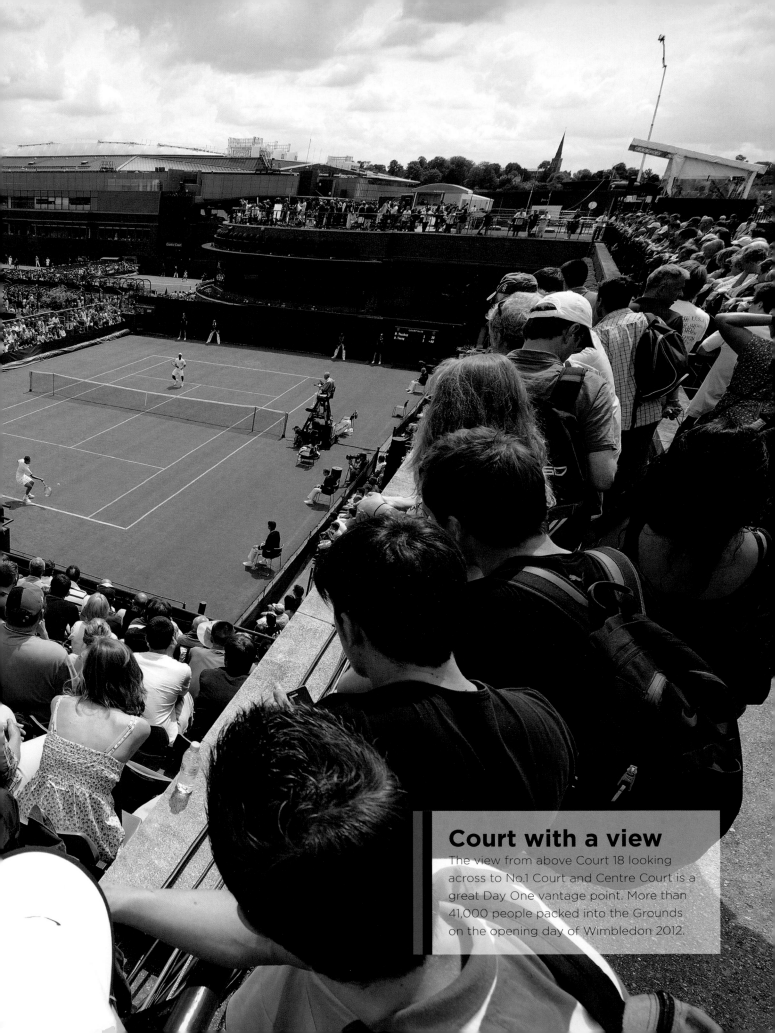

Court with a view

The view from above Court 18 looking across to No.1 Court and Centre Court is a great Day One vantage point. More than 41,000 people packed into the Grounds on the opening day of Wimbledon 2012.

DAY TWO
TUESDAY 26 JUNE

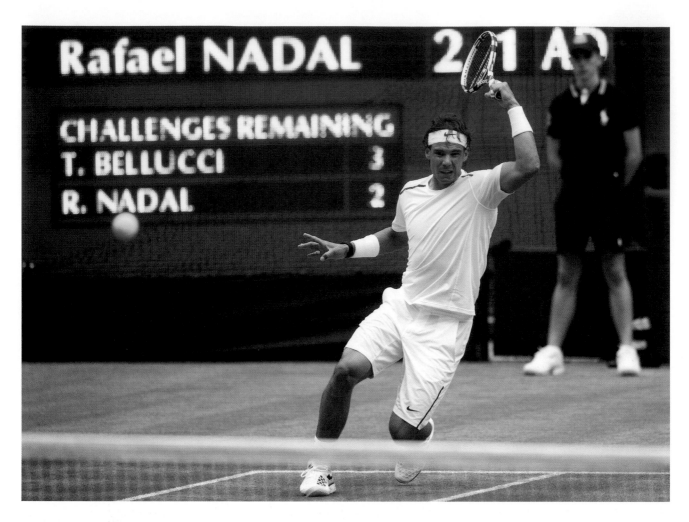

With J.K. Rowling, the author of the *Harry Potter* books, in the Royal Box, it was expected that there may be some Expelliarmus on Centre Court, and for 20 minutes or so Thomaz Bellucci of Brazil had done his best to make the wand with which Rafael Nadal weaves his own particular brand of tennis magic appear lifeless.

(Above) *Two-time champion Rafael Nadal was slightly slow out of the blocks before seeing off Thomaz Bellucci*

(Far right) *The outer courts saw plenty of action in the first days of Wimbledon*

Bellucci, a tall, explosive left-hander from Brazil, won the first four games against the not-quite-so-tall but equally explosive left-hander from Spain. There were "ooohs" and "aaahs" and generally all manner of reactions of astonishment from the crowd, as if they were attending a magic show. But Bellucci's period of ascendancy against the man who had just won his 11th Grand Slam singles title, on the clay in Paris, proved to be something of an illusion.

A stung Nadal is a very dangerous customer, as the world No.80 subsequently discovered. It was not that Bellucci — who reached the fourth round in 2010, his best Grand Slam performance to date, before Nadal stopped him in his tracks — declined, so much that the former champion stepped up, appearing to exert more whip and spin on his forehand than ever before.

Nadal eventually triumphed 7-6(0), 6-2, 6-3, and the boy from Brazil concluded that his conqueror's game did not possess a weakness. "Well, I think I have, but thank you for the words of Thomaz, no?" Nadal responded. "I think today I didn't play my best match, especially during the first set I was a little bit too nervous, little bit not knowing exactly what to do. My movements were a little bit in defensive

way, not in aggressive way." That soon changed in the way the No.2 would have wanted.

Whatever magic dust Nadal had left on the court then transferred itself to the fortunes of Andy Murray, the brightest British hope. Murray's 6-1, 6-1, 6-4 victory over Nikolay Davydenko of Russia, once the third-best player in the world and still mightily efficient at No.47, was one of his coldest and most clinical first-round performances at any Championships, least of all this one.

Simon Barnes, in *The Times*, wrote: "The first two sets in particular were staggeringly good. We are watching a proper contender, one who needs no apologies, one who doesn't have to rely on anything except talent for the game in front of him. On this performance I would tip him for the title right now – were it not for the other three."

Murray was not the only British player spending some time in the limelight. James Ward, the British No.2, ranked No.176 in the world, was involved in a fascinating tussle on Court 14 with Spaniard Pablo Andujar. Andujar had risen to No.36 in the world on the back of an ATP World Tour victory in Casablanca, a semi-final in Belgrade on clay and for being a tenacious scrapper. As a demonstration of the vagaries of the match, Ward took the second set without dropping a game and then won the last six games of the match, to triumph 4-6, 6-0, 3-6, 6-3, 6-3. He could now afford to buy back the Arsenal season ticket he had decided to sell to a friend that very morning.

Play was finally postponed for the night with two matches on the precipice. Jurgen Melzer of Austria had had three match points, one of them a gift of a forehand that he nudged long, against Switzerland's Stanislas Wawrinka, the No.25 seed, at 5-4 in the fifth set but could not take advantage and play was suspended at deuce. Over on Court 16, the situation was even tenser and faintly ridiculous. Sara Errani, the Italian who had reached the final of Roland Garros, led Coco Vandeweghe, a qualifier, 6-1, 5-3 and had reached match point on the American's serve when it became too wet to continue. Imagine having to come all the way back to the grounds,

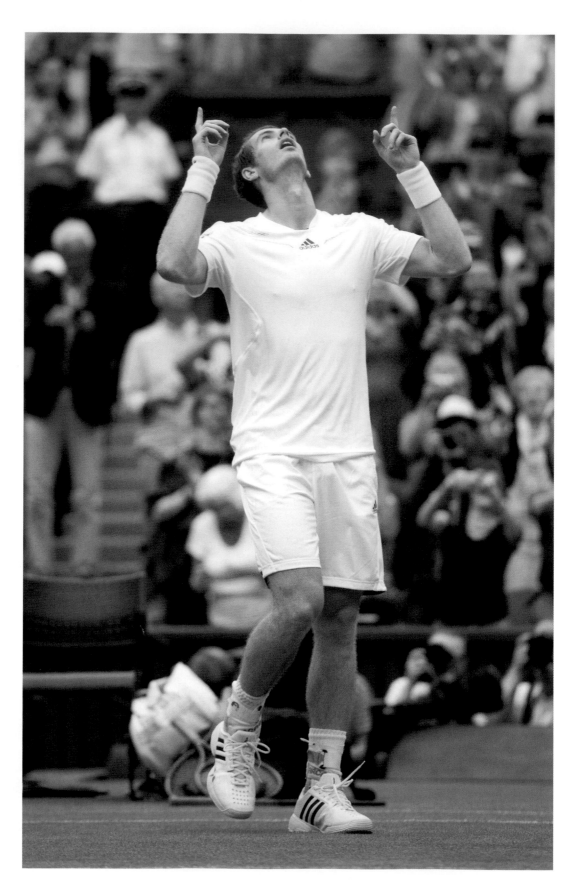

Andy Murray
reacted to a superb
win over Nikolay
Davydenko with a
new celebratory
gesture

get yourself all prepared, go through all the motions and possibly have only to play a single point. That was the state of abeyance in which they had to leave it.

As for British opportunities on the women's side, there were mixed emotions. Laura Robson, the former Junior champion, started so magnificently against Francesca Schiavone, the former French Open champion from Italy, that word-of-mouth brought flocks of folk from elsewhere to crowd the corridors around No.3 Court. Schiavone had taken a 10-minute break at the end of the first set for some manipulation of her back, but Robson was undeterred and led by a set, 3-2 and had 0-40 on her opponent's serve. It was at this moment that the teenager's racket arm appeared to tense.

The cunning Schiavone sensed that her opponent might be wavering and burst through to take the second set and lead 5-1 in the third, only for Robson to remember to start going for her shots, reducing the arrears to 5-4. But she could not quite complete the recovery. Elena Baltacha, who has never done things easily, lost the first set against another Italian, Karin Knapp, but responded with bravado, taking the match 4-6, 6-4, 6-0 and racing tearfully into the arms of Judy Murray, the British Fed Cup captain, who informed her that she had been granted a wild card into the team for the Olympic Games.

For Australia, the overriding emotion was consternation. The losses for Lleyton Hewitt, the 2002 champion, Bernard Tomic, the 2011 quarter-finalist, and Matthew Ebden, a promising exponent of the grass court game, all coming on the same day guaranteed that no male from the country which gave us Laver, Emerson, Hoad and Rafter would be into the second round for the first time since 1938.

Hewitt has been troubled for a long time with injuries; indeed, a metal plate has been inserted into his left foot so that he can actually run around the court. A draw that placed him alongside Jo-Wilfried

(Above) There were Day Two wins for Brits James Ward, Anne Keothavong and Elena Baltacha, as well as a promising performance from Laura Robson

(Below) Lleyton Hewitt lost in the first round to Jo-Wilfried Tsonga

The Bionic Man

After five operations (three on his hip, one on his elbow and one sports hernia) and almost six years in the off-court wilderness, you could forgive a man for wanting to give up on a sport that had caused him so much grief. But not Brian Baker.

Having blistered through the qualifying event for Wimbledon 2012, the former Junior French Open finalist beat Rui Machado, the world No.96, in straight sets on Day Two and his fabulous unexpected run to the last 16 became one of the great stories of The Championships.

"The worst moment was probably sitting in the operating room before my elbow surgery because I'd already had all the hip surgeries and I knew that this one was going to be the longest recovery," Baker reflected. "I told myself that I'm not going to keep having surgeries to prolong my career.

"I'd be lying if I sat here and said I expected all this success to happen right now when I was going through all those surgeries," he continued. "But I never gave up hope that I would be able to come back, and I was always confident in my abilities that if I was able to stay healthy that I would have success."

WIMBLEDON IN NUMBERS

1 Australian through to the second round, the least at Wimbledon since 1938. Sam Stosur was the lone survivor.

Tsonga in the first round was hardly beneficial. The Frenchman won in straight sets, and it was suggested that it wasn't impossible to imagine Hewitt still scampering along the baseline 20 years further down the line, even if by then he was officially half man, half truck.

Tomic's loss to David Goffin, the elfin-faced Belgian, was marked by a loss of discipline which brought a code violation for unsportsmanlike conduct and almost certainly a dressing down later from John, his disciplinarian father and coach. This was not the Wimbledon he would have been expecting from his talented offspring. "I'll wake up and get back to the way I was playing," Bernard said.

Alongside J.K. Rowling in the best seats in the house were Mr and Mrs Jiri Kvitova, the parents of the defending champion who was tasting that particular sensation for the first time, as Djokovic had done the previous afternoon. Initially the nerves got to her against the world No.96, Akgul Amanmuradova of Uzbekistan, who offered a particularly intimidating figure across the net. Twice in his commentary for BBC Radio 5 Live, Nick Bollettieri gave up trying to pronounce her name and simply said, "the other female". Well, the other female played spectacularly well for 20 minutes until Kvitova found her range and was able to secure a 6-4, 6-4 victory. "I stayed calm inside and did not panic on the important points," she said.

(**Left**) *Defending champion Petra Kvitova battled to a tricky opening-round win*

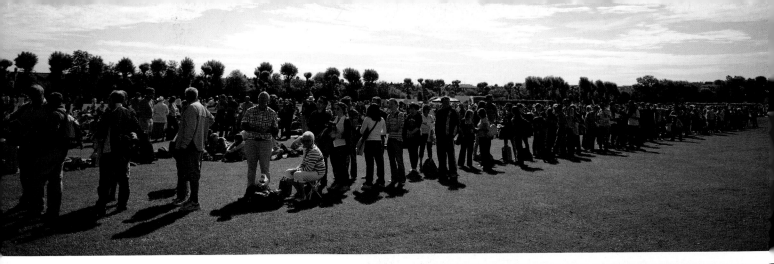

The Queue

Wimbledon remains one of the very few sporting events where you can buy tickets on the day, and the infamous Wimbledon Queue is almost as well known as the tournament itself. But The Queue has come a long way since the days when members of the public laid down their sleeping bags on the pavement. Visitors to The Queue in 2012 were greeted by a set of arches as they entered the Wimbledon Park golf course, before meandering alongside a row of tennis netting, adorned with quotes from various Wimbledon greats.

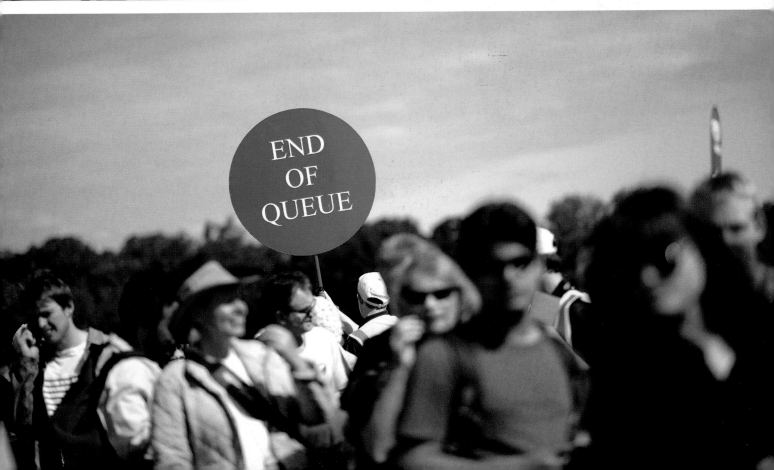

END
OF
QUEUE

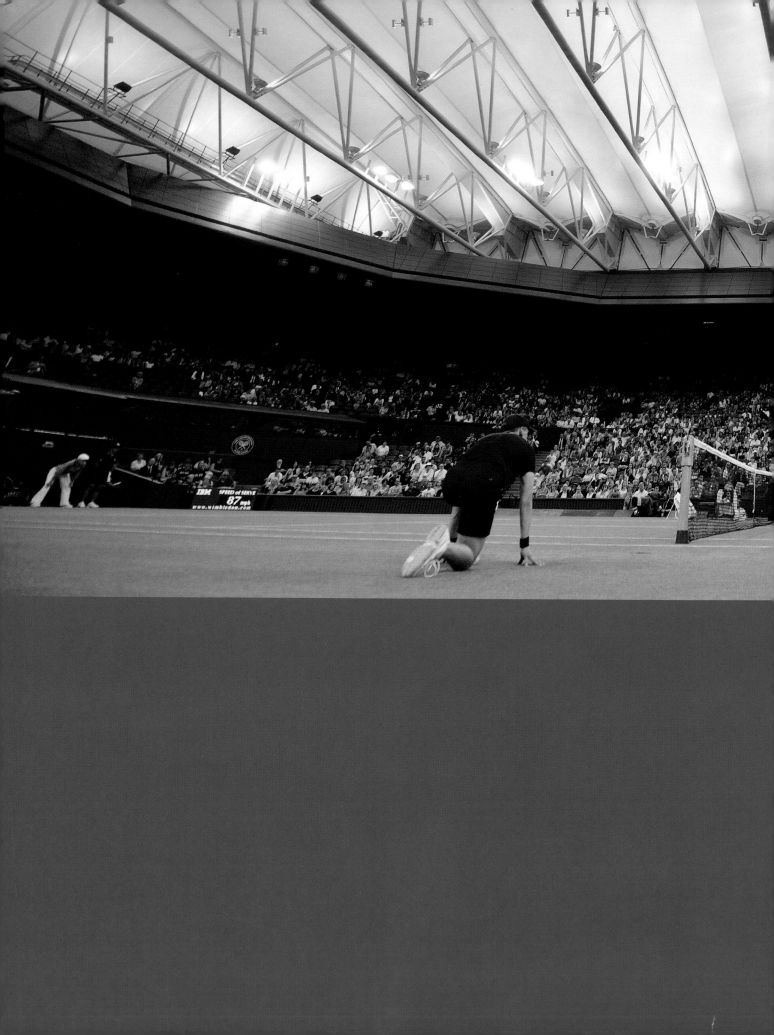

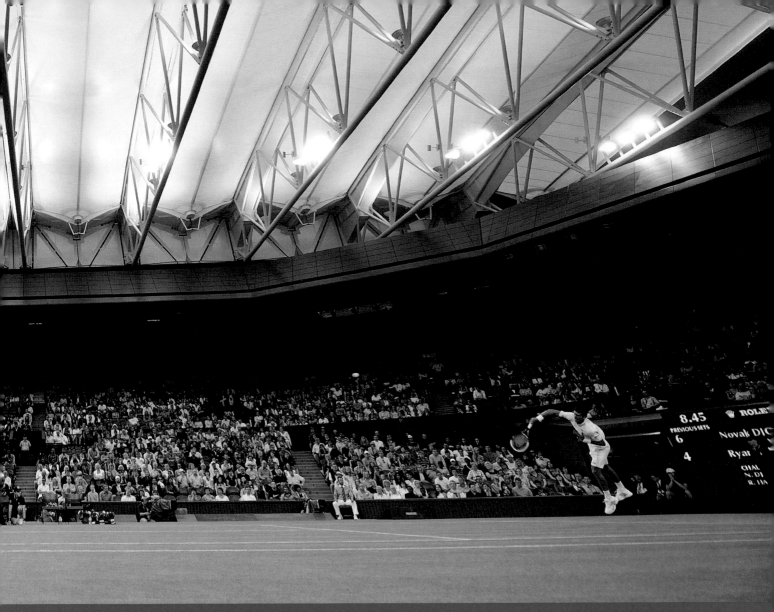

DAY THREE
WEDNESDAY 27 JUNE

F or the first time in 42 years, HRH The Prince of Wales graced the AELTC with his presence in the company of his wife, the Duchess of Cornwall, which offered Roger Federer an opportunity to show that he remains the personification of elegance, whether it be in demonstrating the perfect bow or the perfect single-handed backhand.

It looked as though Prince Charles revelled in the occasion, engaged in jaunty conversation, thrilled with the quality of the combatants and fortified by the finest that the All England Club's catering provides – especially, one presumes, the Herb Crusted Welsh Lamb Cutlet or, if cold was the preference, some Poached Shetland Isles Salmon (I am going to make a request that these are served in the media restaurant when and if supplies last).

Six-time champion Roger Federer produced an impeccable display in front of HRH The Prince of Wales

Federer was playing Fabio Fognini of Italy, who cuts quite a dash, sporting a bandana, moustache and small beard that puts one in mind of Errol Flynn; indeed, one quite expects to see him walk onto court with a cutlass clenched between his teeth. Federer also had his dark hair controlled by a bandana, and he certainly had his game under greater control; every 10 points or so Fognini was absolutely brilliant, every 10 shots Federer was relatively ordinary. His ordinary moments were quite enough to put paid to the world No.68, the Swiss losing only six games en route to the third round.

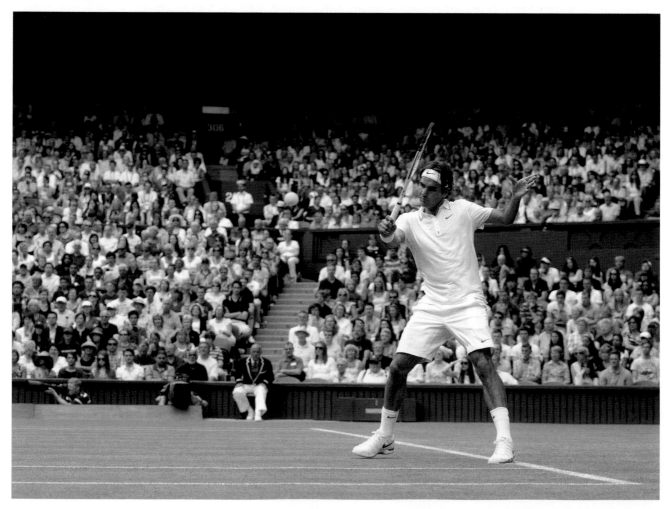

Both prince of the realm and prince of the courts had departed before the tennis got really meaty and the weather took a bit of a turn for the worse. The clouds rolled in, the mist and mizzle intensified and there was enough moisture in the air to bring out the covers on the outside courts and the roof over Centre.

There, Caroline Wozniacki of Denmark and the Austrian Tamira Paszek were locked in what would be the Ladies' match of the event to date. Paszek had lifted the AEGON International trophy at Eastbourne four days earlier, and so this was going to be a particularly tricky match for the former world No.1 whose slip down the rankings and concurrent loss of confidence had become a real concern.

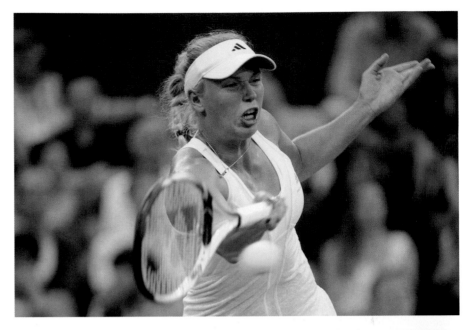

The rallies between them were invariably intense, often 18 or 20 strokes long, but the moment that turned it in the Austrian's favour came at 6-5 to Wozniacki in the second set, two match points indeed. On the first, Wozniacki almost stopped a rally in mid flow, as she should have done, seeming to think a backhand had landed beyond the baseline, a momentary delay that cost her dear. The point went to Paszek, as did the game and, even when Wozniacki broke at the start of the third set, her inability to extend a lead became her undoing. Wozniacki did hit four successive winners when Paszek served for the match and was 40-30 ahead serving to stay in it, but she missed a regulation backhand, struck a forehand long and then watched in disbelief when a clinical forehand service return on match point brought the world No.37 a thrilling victory.

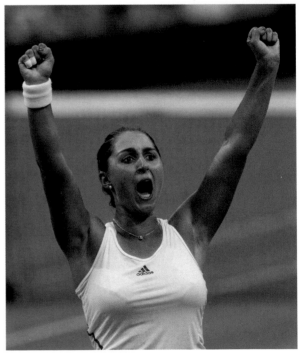

Kevin Mitchell, reporting for *The Guardian*, wrote that "if Shakespeare could have invented a sport, he surely would have chosen tennis with its twists and turns, and the demise of the Dane was a suitably grim closing scene in the day's rain-swept narrative."

Wozniacki was once more asked if her burgeoning relationship with Rory McIlroy, the champion golfer from Northern Ireland, was having a detrimental effect on her tennis, to which her response, brief and to the point, was, "No."

It was not only those striving for a first Grand Slam (in Wozniacki's case this was her 22nd failed attempt) who were losing their way. Others who wanted to build on success in the majors fared just as poorly. Samantha Stosur, the reigning US Open champion, had been beaten in the semi-finals of the French Open by Sara Errani of Italy, but there was a case to be made for her game transitioning well to grass, even if her record at Wimbledon was yet to prove it.

Austrian Tamira Paszek (above) pulled off the first upset of the Ladies' Singles with her win over Caroline Wozniacki (top)

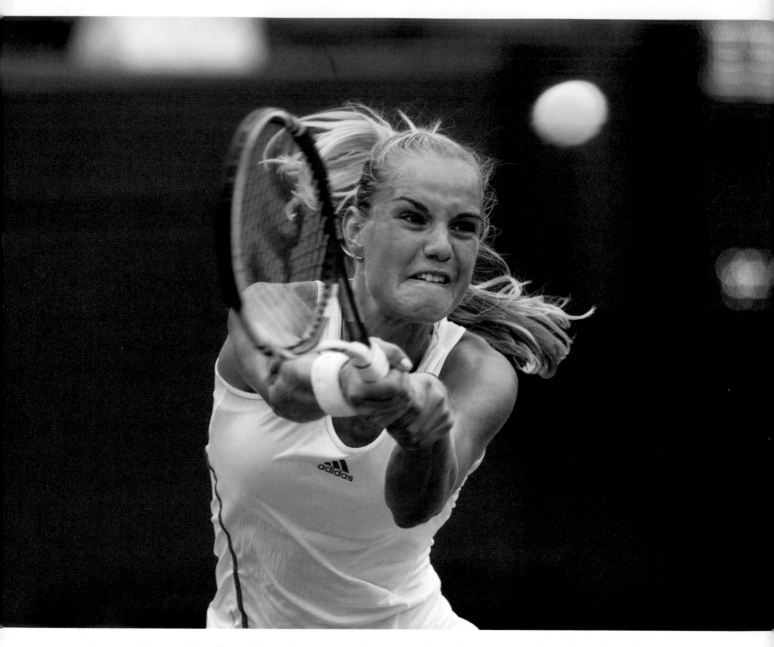

The powerful Dutch player Arantxa Rus has long been touted as a one to watch

Stosur's match against Arantxa Rus of the Netherlands was the like of which we had come to expect from her on grass, a fitful, fretful occasion on No.1 Court that had no rhyme nor reason. Stosur won the first two games, lost six in a row and with them the first set; won the next six to assume what we thought was complete control; lost three at the start of the final set and finally, having saved two match points, succumbed on the third, 6-2, 0-6, 6-4.

"It was a pretty woeful performance, not just from me but by all of us [Australians]," she said. "It is just one of those things. I don't think you can look at something from one tournament and think, 'Oh my God, we've got to change everything.'"

Channel Island eyes were smiling, by way of refreshing comparison. Heather Watson, who had been fast-tracked onto Centre Court on the opening day, was on No.2 Court for her second-round match against Jamie Lee Hampton of the United States. Watson won 6-1, 6-4, another profound example of using all that she had, both a wonderful appetite for the game and a love of competition.

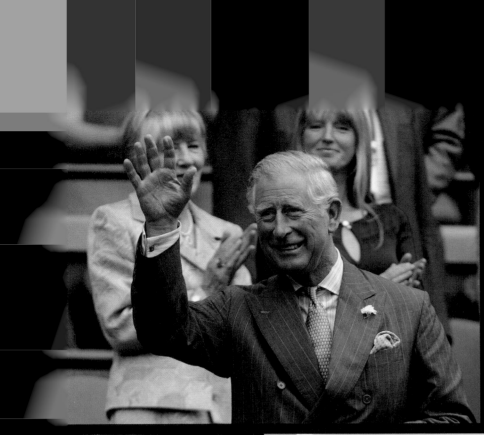

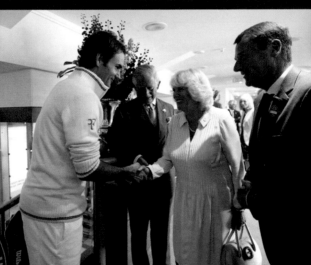

(Top left) Prince Charles waves to the Centre Court crowd

(Top right) Roger Federer and Fabio Fognini execute their bows

(Far left) The Prince of Wales is accompanied by Chairman Philip Brook

(Left) The Duchess of Cornwall greets Roger Federer after his win

A Royal Visit

HRH The Prince of Wales has long been known to enjoy watching the sport of tennis, so it was with some delight that the All England Club welcomed Prince Charles to The Championships for his first visit since 1970.

The Duchess of Cornwall, who had visited The Championships in 2012, arrived at 11.40am and was met by Philip Brook, Chairman of the All England Club, and committee member John Dunningham.

be around and was invited to be part of the presentation, describing it as 'a lot of fun.'

Prince Charles was not due until after lunch but arrived 45 minutes ahead of schedule, so a place was made for him at the table. He met four retired Australian players, Frank Sedgman, Ashley Cooper, Neale Fraser and Judy Dalton, as well as Tim Henman.

The Royal couple then settled into the Royal Box

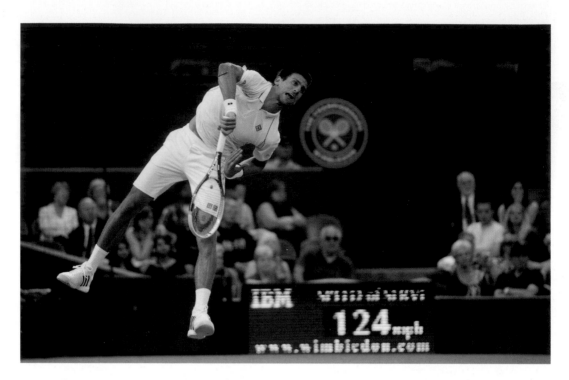

(Right) Defending champion Novak Djokovic did what was needed under the Centre Court roof

(Far right) For the second night running, the Centre Court roof lit up the sky at Wimbledon

For all of those youngsters and their parents who may think that a lack of size is an impediment to the prospect of success, Watson is hardly built in the mould of a Kvitova or a Sharapova, but it doesn't always matter. There is not a negative ion in her body, and when she led 4-3 in the second set but was 0-40 down on her serve you could sense her resolve stiffen and her concentration re-double. She held.

"I'm still quite new to the tour," Watson, who became the first British woman to reach the third round since Elena Baltacha in 2002, said. "I'm glad I'm finally bringing to the match court what I have been endeavouring to do in practice. I love to volley. I probably volleyed once today and I missed it, but I have worked on being more aggressive on the court."

John Isner had been beaten on the first day. On the third, he may have had to play Nicolas Mahut, his old pal from 2010, for a second consecutive reunion. Mahut did survive the opening round, but not the second. Alejandro Falla of Colombia, having defeated Isner 7-5 in the fifth set on Monday, repeated the dose on Wednesday, taking the fifth set 7-5 against Mahut. Surely, this had to be as quirky a coincidence as Isner and Mahut being drawn again so near to each other (a situation that would be replicated in the Newport tournament a week after Wimbledon).

The young American Ryan Harrison, known to viewers of one US television channel as 'Mr Crankypants' for his occasionally volatile behaviour on the court, was bouncing around on Centre for all his worth under the roof against Novak Djokovic. With the courtside clock showing 9.52pm, which seemed late at the time, Djokovic emerged from a considerably tricky match with a 6-4, 6-4, 6-4 victory. As the score suggested, Harrison played one poor game per set, and was punished in the way world No.1s tend to punish such lapses. "I thought he played really well, but I thought I played really well, too," the Serb said.

WIMBLEDON IN NUMBERS

7 Seconds it took Sara Errani to complete her delayed match against Coco Vandeweghe when they resumed on match point.

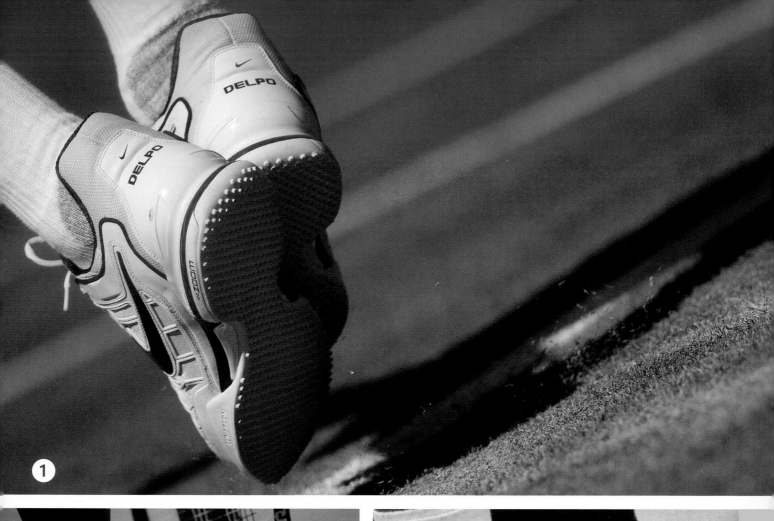

1

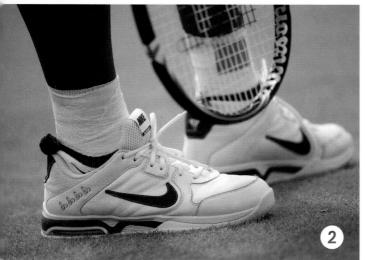

2

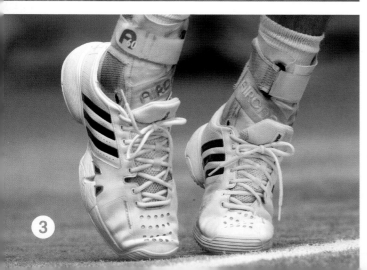

3

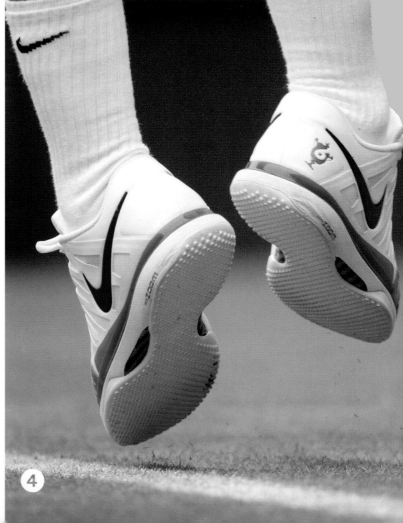

4

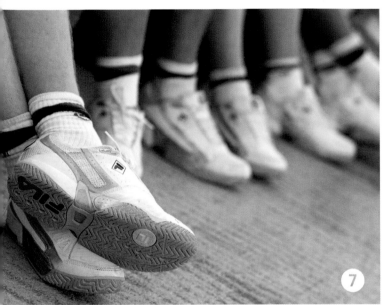

5

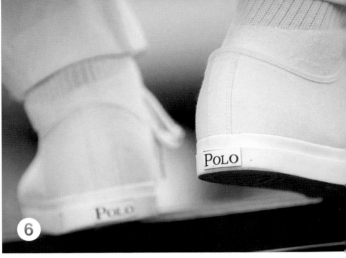

6

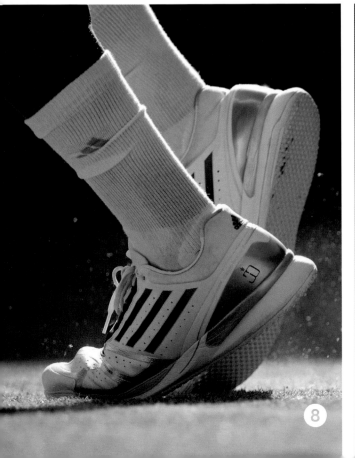

7

Foot Fashions

Tennis shoes have come a long way since the days of the Dunlop Green Flash, and a huge array of personalised trainers were on show at Wimbledon 2012. Including those of Juan Martin del Potro ❶, Serena Williams ❷ (marking her four previous Wimbledon triumphs), Andy Murray ❸ (note the ankle protectors) and Roger Federer ❹. Defending champion Petra Kvitova ❺ (the '11 signifying her 2011 triumph), umpire and line judge shoes ❻ by Ralph Lauren, ball boy and girl trainers by Fila ❼, Jo-Wilfried Tsonga ❽ and Rafael Nadal ❾.

8

9

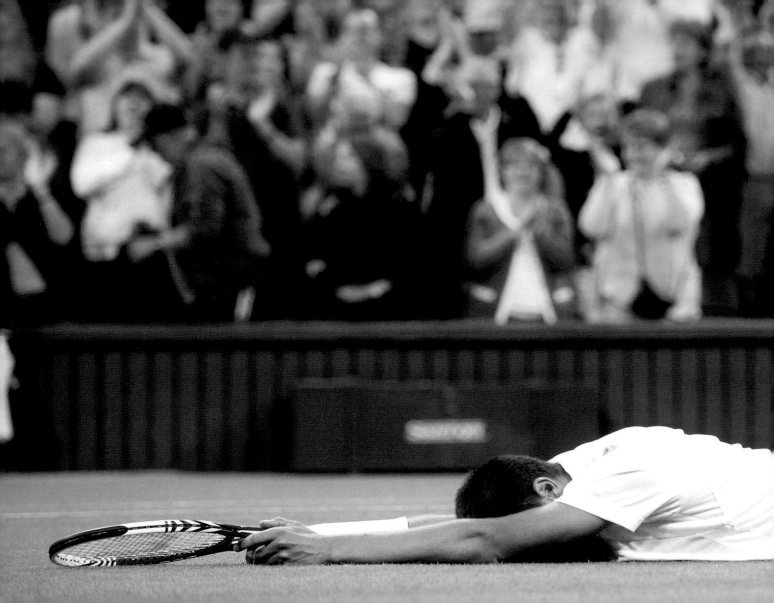

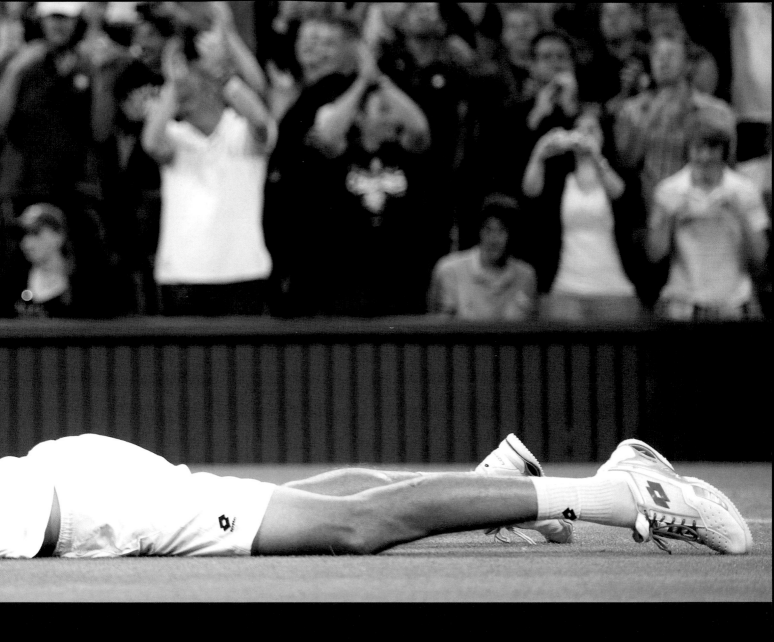

DAY FOUR
THURSDAY 28 JUNE

H e had lost in the first round of qualifying five years in a row, so the fact that he had been able to raise his ranking to No.100 spared Lukas Rosol the indignity of having to endure the possibility of a sixth consecutive humiliation. There were few people, it emerged, who worked harder on their game than the 26-year-old from Brno, the birthplace of former Ladies' Singles champion Jana Novotna, so he merited his place in the main draw, proper.

(Far right) Lukas Rosol celebrates the biggest win of his career, arguably one of the most significant upsets in Wimbledon history

(Below) In his earliest loss at a Grand Slam since 2005, Rafael Nadal was left covering a lot of ground

Rosol appeared on domestic radars on Wednesday when he took part in a five-set victory in the Gentlemen's Doubles with Mikhail Kukushkin of Kazahkstan, over the British pair, Colin Fleming and Ross Hutchins. Watching the match, Ross's father, Paul, the former Davis Cup captain, remarked that he had rarely seen anyone strike the ball harder.

The next day, he was scheduled third on Centre Court against Rafael Nadal, twice the champion, in one of those once-in-a-lifetime experiences you either embrace or not. Rosol, it is safe to say, embraced it totally. The essence of the match came after the first four sets had been completed in the open air, with Nadal winning the fourth in his best form of the match, breaking Rosol's serve twice, and eager for the fifth. The decision was then taken to close the roof, which sparked a delay of half an hour.

Upon the resumption, Rosol played a set of tennis the like of which few of us had ever seen. It was take-your-breath away tennis. He broke Nadal in the opening game, drawing a mishit on the Spaniard's forehand, made 21 of 23 first serves, thumped winner after winner and sank to his knees at the conclusion of an upset unparalleled (or so it was argued) in the annals of The Championships' history, winning 6-7(9), 6-4, 6-4, 2-6, 6-4.

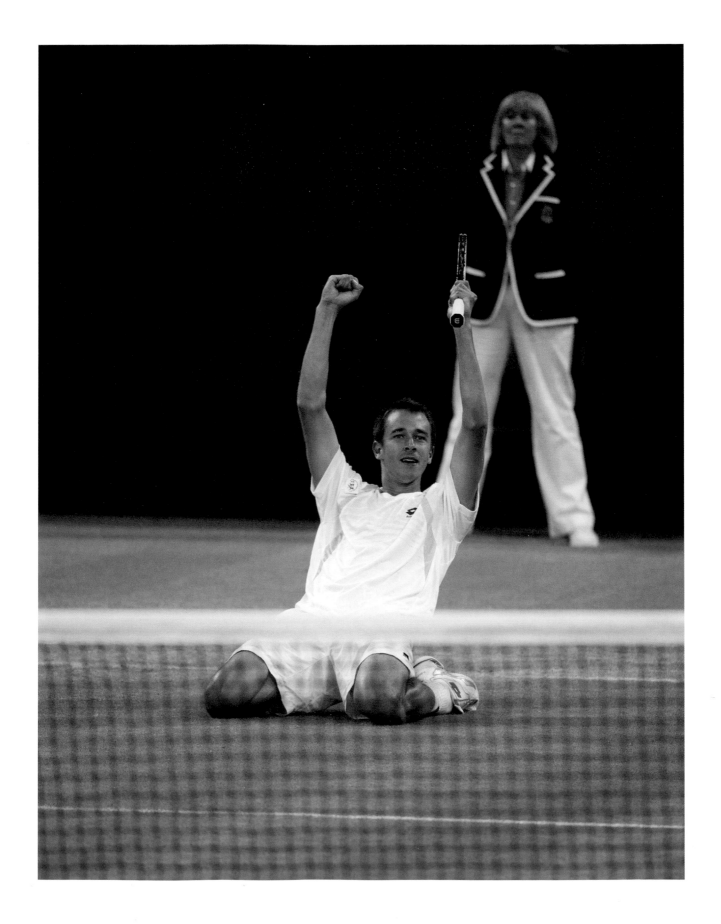

Rafael Nadal was reflective in his post-match press conference, crediting Rosol for his performance

"It was not a tragedy, it was a tennis match," Nadal said, echoing the sentiments of Boris Becker when he was beaten in the second round as defending champion by the Australian Peter Doohan 25 years earlier. "The decision to close the roof was not the best for me, but I have to accept that he played unbelievable. It is not the right moment for me to say what happened out there because it is going to sound like an excuse and I never want to use an excuse after a match like today."

The loss of Nadal was greeted with dismay and delight in equal measures. For the thousands who supported the French Open champion, who had enjoyed another staggering season on clay, this was a discouraging moment; for those who liked their upsets, this was one for the ages. Rosol talked about being in a trance. He would quickly have to snap out of it.

There had been quite a bit of contention in the first Gentlemen's match on Centre Court, not least as Ivo Karlovic was called for a number of foot faults during his match against Andy Murray. How many of them became the subject for debate, and the timing of them — especially one at 4-4 in the fourth set tie-break — provoked a sense in the 6'10" Croatian that there was some kind of conspiracy against him, which was an absurd suggestion.

For Murray to come through against him required every ounce of the Scot's fortitude, for the shorter and more explosive the points, the greater the levels of concentration and focus demanded of him. He knew aces would likely fly past him regularly, but he could not have been as prepared for the excellence of Karlovic's net play, his soft hands on the volley. In *The Times*, Simon Barnes likened Karlovic to Mongo, the heavy in *Blazing Saddles*, "forever accidentally knocking down walls, sending grown men to the floor with a pat of affection, breaking chains by complete accident and felling a horse with a single punch."

In these circumstances, there was a huge sense of relief when Murray came through 7-5, 6-7(5), 6-2, 7-6(4) in three hours and eight minutes he would not want to have to go through again. Asked about Karlovic's foot faults assertions, Murray was rightly circumspect. "There have been hundreds of thousands of matches played here and I've never heard of this before. I would need to see the videos."

By the fourth day, Murray was the lone British singles player left in the draw. There was much to commend the British No.2 James Ward for, however. In a four-and-a-half-hour sweat-bath of a

"Unbelievable"

How would you describe what you did tonight?

So many emotions. I didn't expect that. I'm sorry for Rafa, but today I was somewhere else and I'm really happy for this, you know. Still I cannot find the words. I still can't believe it. It's like a dream for me.

What were you feeling in the fifth set when it seemed you couldn't miss?

After fourth set I had pain a little bit. I just came to the locker room and I took a shower. I had some physio. So when I came on the court I didn't feel anything. I was just like somewhere else and I believed in myself and I knew that I could make it.

You have lost five times here in the first round of Qualifying. Suddenly we see you play so well.

It's because before I only played the Wimbledon Qualifiers. I came just a day before and I wasn't really prepared, good prepared, for the tournament. But this year I change and I play already Queen's and Eastbourne, a couple more weeks. If I play on grass more I think I can get better.

Q. Where does this moment rank in your career?

Where is this match in my career? It's the highest. Never, never happened to me. Also, Wimbledon Centre Court, you know, I didn't expect it. I was going on the court before just to see how it looks like, everything, how many people is there.

Q. What were your expectations before this match?

Just to play three good sets. Just to not lose 6-0, 6-1, 6-1. I mean, I didn't expect it, but I played relaxed, you know. Sometimes I can wake up and I can beat anyone, you know. Some days I know I can lose to player at 500. I need to keep going same level.

Lukas Rosol speaking after his amazing win

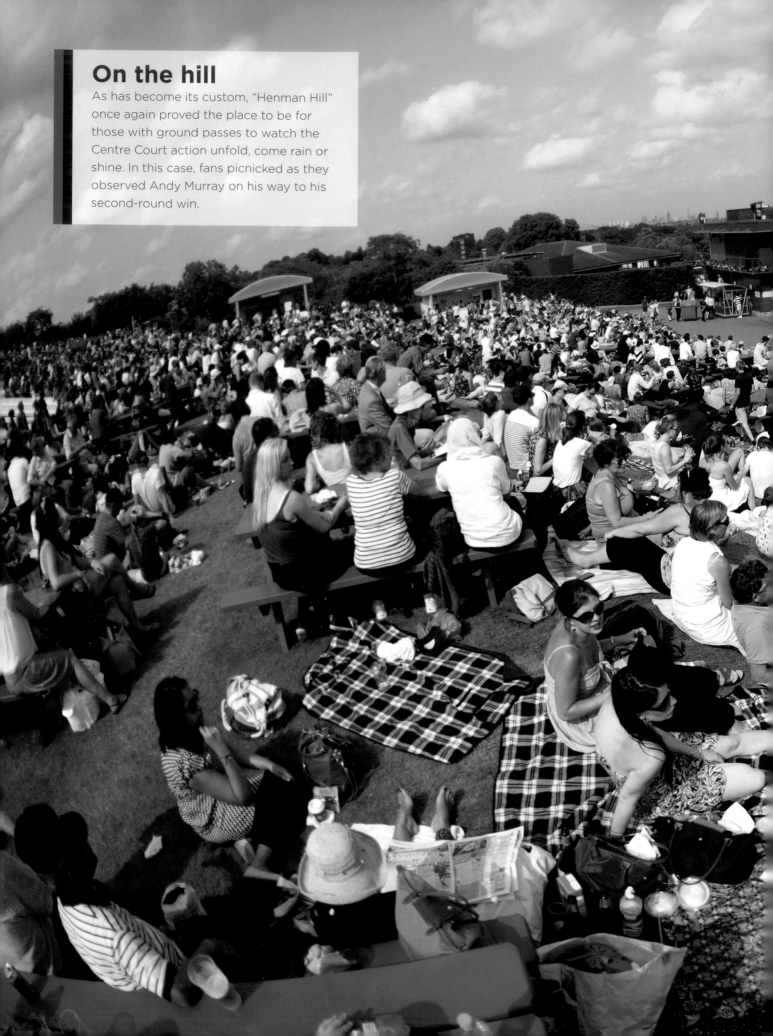

On the hill

As has become its custom, "Henman Hill" once again proved the place to be for those with ground passes to watch the Centre Court action unfold, come rain or shine. In this case, fans picnicked as they observed Andy Murray on his way to his second-round win.

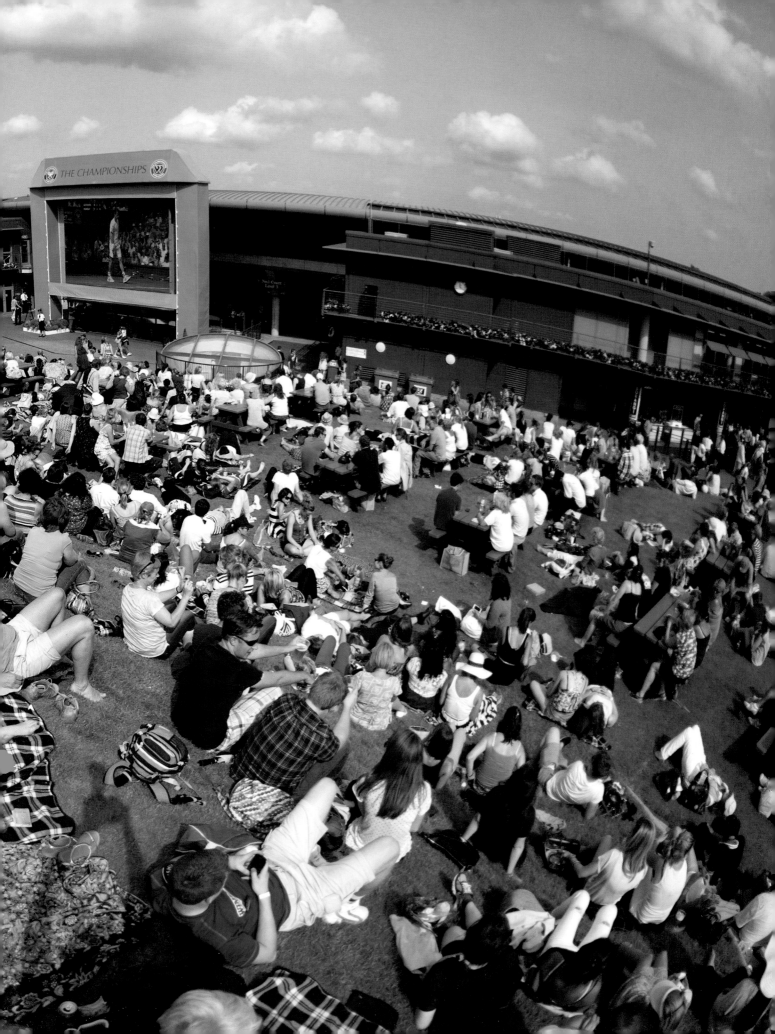

Around the Grounds

The first week of Wimbledon is a wonderful time to get yourself a ground pass and meander round the outside courts. Not only is there a fantastic atmosphere, there's a chance to see some of the world's top players, as not everyone can fit on the Show Courts. And if the sun is shining too...

(Above) *James Ward (top) pushed a beleaguered Mardy Fish to the limit, but the American proved too strong*

(Far right) *Maria Sharapova was not at her best against 2011 quarter-finalist Tsvetana Pironkova*

match against the No.10 seed, Mardy Fish of the United States, Ward was beaten 6-3, 5-7, 6-4, 6-7(3), 6-3. "Me, I'm disappointed," the London cabbie's son said later. "Everyone else seems to be happy."

Not many of the crowd who took their seats at 2.30pm and watched Ward stiffly dump his first service game dared to imagine they would still be there as 7pm approached, with the shadows gathering, the players drenched and slowing and the umpire at least 10lbs lighter in jacket, shirt and trousers.

Ward refused to wilt at any stage, winning the fourth set with a stirring tie-break having saved a match point on his own serve at 3-5. The fifth would be decided, it seemed, by the player who would be able to master their increasingly rubbery limbs. The eighth game was to prove critical, Ward mishitting three times in succession and offering another on a break point to give Fish his lifeline. Three unplayable serves in the next game won him the match. This was a remarkable performance from someone who had required an operation in May to correct an irregular heartbeat and was playing in his first tournament since April. "Ward played good enough to win, for sure," Fish said. "He served as well as anyone has served against me all year. I guarantee his percentage on the big points was very high."

Neither Elena Baltacha nor Anne Keothavong was able to prise a set from their second-round matches but, given the quality of the opposition, perhaps it was not a surprise. Baltacha was playing the reigning champion, Petra Kvitova, and took four games, having lost the first set to love. And there was only 61 minutes of tennis in Keothavong's 6-1, 6-1 defeat to Sara Errani, the French Open runner-up. Few people win matches when they take only 12 per cent of the points on their second serve and win less than a third of the points from the baseline, which were the British player's aggregates.

Maria Sharapova looked anything but the top seed in her squeaky victory over the Bulgarian Tsvetana Pironkova. Having left the grounds the previous day leading 2-1 in the second set after taking the first, Sharapova was rocked by Pironkova's riposte, and it was only when, from her concoction of the brilliant and the fragile, she managed to find more of the former that she prevailed 7-6(3), 6-7(3), 6-0. "If she played on grass 365 days a year, she would probably be a top-five player," Sharapova said, which was probably right.

WIMBLEDON IN NUMBERS

0 Points lost on serve by Lukas Rosol in his last three service games.

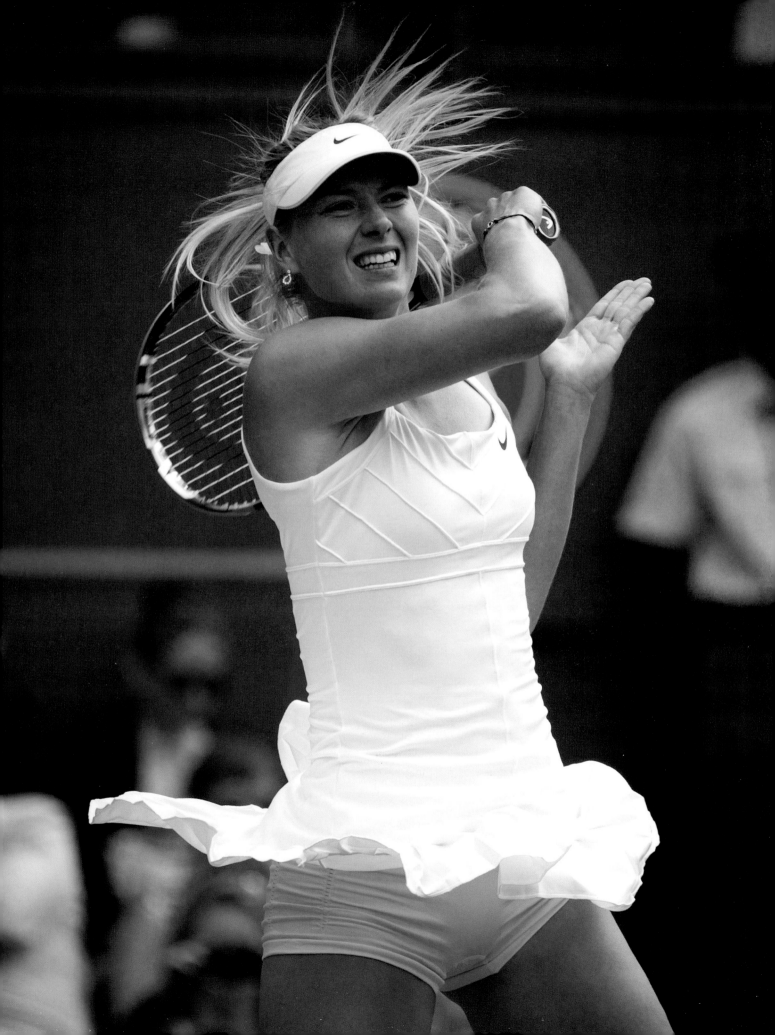

DAY FIVE
FRIDAY 29 JUNE

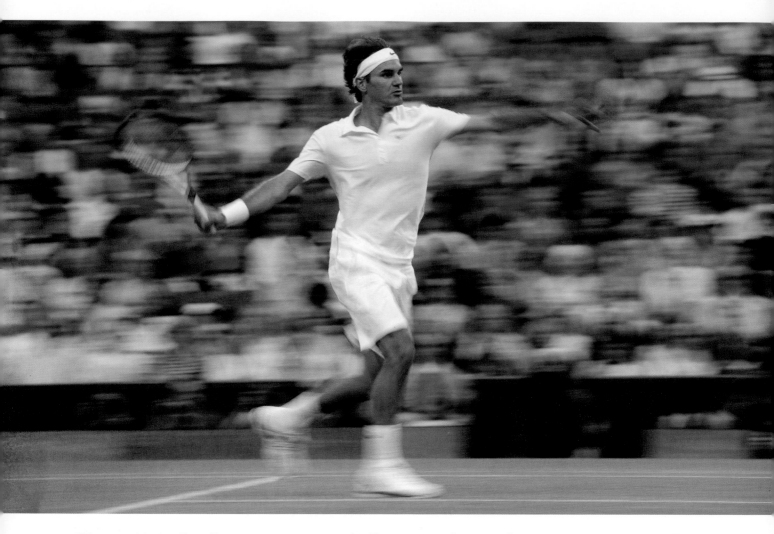

On 19 April, Julien Benneteau was rolling around on a clay court in Monte Carlo – probably disturbing the diners on the balconies above – after trapping his ankle in an earthen rut and landing painfully on his right wrist. Initial indications were that he would probably not play tennis for another couple of months at least.

(Above) Roger Federer managed to stop time to defeat Julian Benneteau in five sets in another late-night thriller

On 29 June, Benneteau led Roger Federer by two sets to love on the Centre Court at Wimbledon, running about like a frisky colt and delivering remarkable jabs to the six-time champion's midriff using that same right arm to juddering effect. Were we about to witness a truly remarkable event in The Championships, the first time that the Swiss had been beaten before the first weekend since his first-round, straight-set defeat to Mario Ancic of Croatia in 2002?

Benneteau, the No.29 seed, was certainly playing well enough. He did not seem to be perturbed by the magnitude of the task, and the fact that the match was being played under the Centre Court roof – even though it was a nice day – did not deter him; he had won the pair's previous indoor match at Paris Bercy in 2009.

Ah yes, the roof. Just before play was due to start, the Referee's office had checked with its meteorological expert (it seemed he had taken up permanent residence) and there was a 70 per cent chance of showers in the afternoon. The safety-first decision was taken. As it transpired, just as

the button was pushed, the sun came out and there was not to be a single raindrop in the vicinity all afternoon – though showers passed by left and right.

The ball had been doing the same to Federer in sets one and two. By the third, it all looked very different, though, and he won it at a canter. The fourth was exceedingly tight, there were five occasions when Federer was within two points of defeat, including at 5-5 and 6-6 in the tie-break, but once he had settled that situation in his favour Benneteau visibly faded.

It was desperately close until all but the closing moments, and for that we had Benneteau to thank for bringing the fight out in Federer, whose thirst for these long battles had waned over the past couple of years. For a player regarded by many as the greatest of all time, his record in completed five-setters is ordinary: now 20 wins, 16 losses.

Ultimately, but unsurprisingly, it was Benneteau whose body and resolve collapsed, as he twice received a massage to heavy legs in the fifth set, a stretching of the regulations allowing for strictly medical attention on court. It was Federer's ability to pull him around the court that put the lactic acid and debilitating weight in those legs, and he should not have been allowed the luxury of his trainer's help. "I was cramping on my quad," Benneteau said, "so it was tough for me to serve. He's like a rock. If your level is a little bit lower, he takes the opportunity. If you do not put the ball in the right place, you lose the point nearly every time." Federer had a single word for it: "Brutal."

There were two other five-set matches in the Gentlemen's Singles on this freaky Friday. Belgium's Xavier Malisse was playing his 12th Championships, having been a semi-finalist in 2002. He is one of the game's most naturally gifted performers, and it was often said that if he had possessed nerves of steel surely one of the majors could have been within his compass.

The same could be said for Fernando Verdasco, the No.17 seed from Spain and his opponent, who had reached the semi-finals of the Australian Open in 2009. This was a sparkling match, full of brightly coloured rallies, great touches and changes of pace, a match very much in the players' vogue. "Sometimes a year can turn around at the right moments and this has happened for me," Malisse said of his 1-6, 7-6(5), 6-1, 4-6, 6-3 success. "I am finding my best form at my favourite tournament."

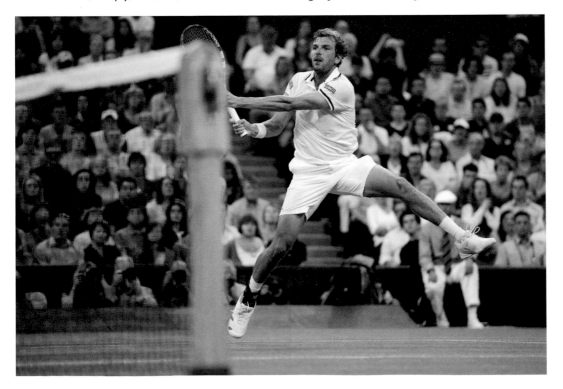

Julien Benneteau came tantalisingly close to the win of his career against Roger Federer

Also playing rather well was the German, Florian Mayer, a real throwback player, who could find plenty of awkward angles and shifts of gear, taking the pace off and suddenly finding it again with terrifically astute shots. He had to keep his nerve against the qualifier Jerzy Janowicz of Poland, who had defeated Ernests Gulbis in the previous round and was red hot. That Mayer did, winning 7-5 in the fifth set.

For Serbia's Viktor Troicki, this felt like a bit of a rest day, though he was definitely out there playing. In each of his previous seven Grand Slam tournament matches, he had been taken to the full five-set limit. And his first two wins over Marcel Granollers of Spain and Slovakia's Martin Klizan were equally

exhausting, and he had tied the longest streak of five-setters in the Open Era. Not only did his 7-5, 7-5, 6-3 victory over Juan Monaco of Argentina seem like a stroll in the park by comparison, but it was also an exceptional win over a very fine performer.

Among the dark horse nominations for the event, Canada's Milos Raonic was very much to the fore. Everyone knew that the lad could serve, that his game was making profound strides and that one day he could well be a contender. His chances this time were stopped dead in their tracks by American Sam Querrey who, like Raonic, had had his share of injuries at the tail end of 2011.

Querrey, a genial, phlegmatic man from California, had required elbow surgery that curtailed his progress, and he said that it may have taken a year for him to feel right about his game again. So, this 6-7(3), 7-6(7), 7-6(8), 6-4 victory was an enormous fillip for him. He was asked if he was a better competitor than he had been before his injuries. "No, but I hope I can keep playing and become a better one," he said. "I haven't really noticed that I'm a better one now. It feels like I'm almost starting over again, like I'm 19 years old and trying to climb my way up the rankings."

For Heather Watson, the third round was also the day to say goodbye. For the second time, she was back on Centre Court, but heroics were hard to come by. Her opponent was Agnieszka Radwanska, the No.3 seed from Poland and one of the most able of players. Really, Watson did not get a look in, and there was that horrible numb time in the opening set

(Above) Former semi-finalist Xavier Malisse completed a five-set upset of No.17 seed Fernando Verdasco

(Far right) Much was expected of Canadian Milos Raonic, who was upset by Sam Querrey

when you dearly hoped she wasn't going to end up without a game at all.

My colleague Simon Barnes wanted to write a nice piece but ended up needing to tell it like it was. "Heather is young and jolly and carries no side and can play tennis like anything," he said. "I want to try to get through this piece without saying anything hurtful, without mentioning she got beaten, without mentioning the score (6-0, 6-2). It was altitude sickness, I suppose. Radwanska is three and Heather is 100 places below her. Seriously, Heather is terrific. I stuck with the match right to the end, but on the whole I'd sooner have been drinking Pimm's."

WIMBLEDON IN NUMBERS

7 Straight five-set matches that Viktor Troicki had played at a Grand Slam up until Wimbledon 2012. That streak finally ended when he secured a straight set win over No.15 seed Juan Monaco.

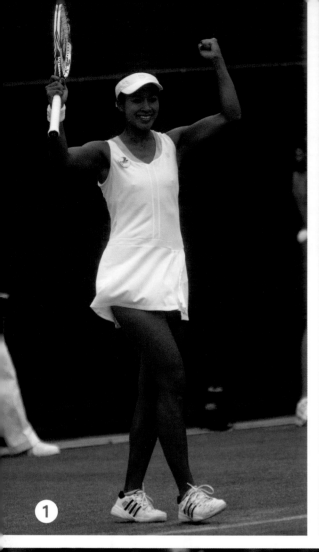

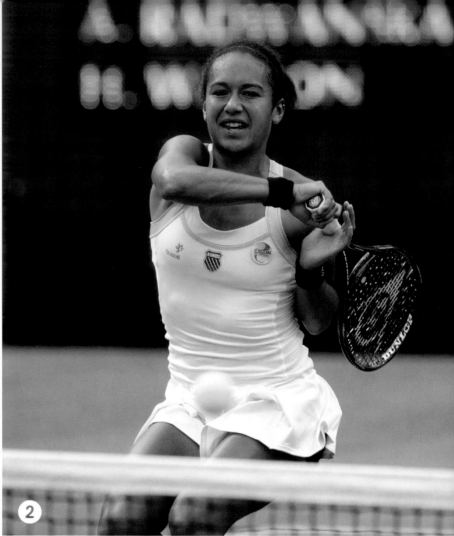

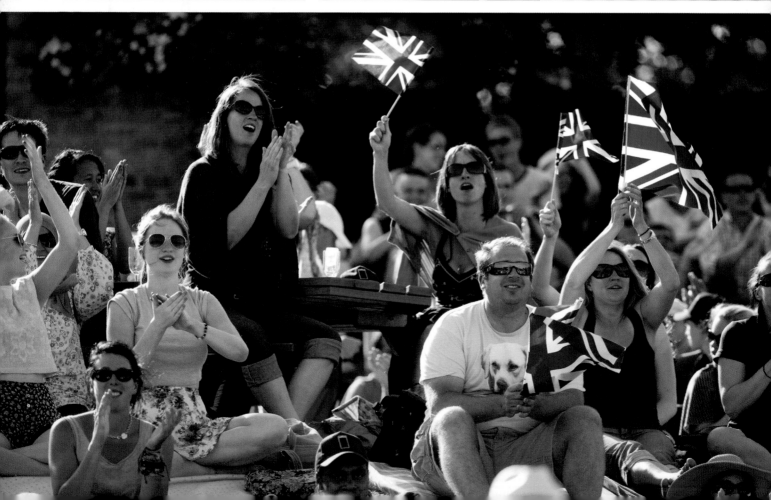

Flying the Flag

The newspapers are so used to writing about British tennis in bad terms that it took everyone a little bit by surprise when five British players advanced to the second round of Wimbledon 2012, doing their bit for the Queen's Diamond Jubilee celebrations in quite some style.

Elena Baltacha ❹ pulled off a tremendously emotional topsy-turvy three-set win over Karin Knapp out on Court 18, while James Ward ❸ won the type of five-setter he has lost in the past, seeing off Pablo Andujar on Court 14. Anne Keothavong ❶ blitzed through in two sets against Laura Pous-Tio, Andy Murray had no difficulty at all in seeing off Nikolay Davydenko, and Heather Watson ❷ made it five with her win over Iveta Benesova. Not to mention very close-run performances from Laura Robson, Johanna Konta, Jamie Baker, Oliver Golding and Josh Goodall in the first round also.

While Ward, Keothavong and Baltacha bowed out at the second-round hurdle, the smiling Watson went on to become the first British woman into the third round at Wimbledon for a decade, following in the footsteps of Elena Baltacha when she defeated Jamie Lee Hampton in straight sets. The Guernsey girl didn't have enough to hurt Agniezska Radwanska, leaving Andy Murray as the last Briton standing once again. But at least he had company for significantly longer this Wimbledon.

DAY SIX
SATURDAY 30 JUNE

On Armed Forces Day, the Royal Box was filled with those heroes that we should never take for granted, even if too many of us may consider them only fleetingly. For an awful lot longer than I have been covering Wimbledon, members of Her Majesty's services have been the eyes and ears around the courts, guiding people to their seats and offering that sense of decorum and authority required of the best of their ilk.

It was only right and proper that The Championships should recognise such dedication and service on the middle Saturday, and so it was that a section of the prime seats were reserved for the military crème de la crème. It was true of the sporting world as well, with Sir Bobby Charlton and Jack Nicklaus – a man with four grass tennis courts in the back garden of his home in Florida – taking pride of place on this honours day.

Nicklaus stayed for a decent while, Sir Bobby and Lady Norma until the roof was drawn back over the court after three sets of the third-round match between Andy Murray and Marcos Baghdatis, which was to become heralded as yet another in the long list of the fortnight's milestones.

The day had been pretty arduous already, with Serena Williams (whose special guest in her player's box was Dustin Hoffman) taken to three sets by former semi-finalist Zheng Jie of China who, it had to be said, had enough opportunities, not least when leading 2-1, 0-40 in the final set, to have made the occasion even more awkward for Serena than it became.

Leading members of the Army, Navy and Royal Air Force stand to attention on Armed Forces Day

Zheng, like many players from Asia, stood on the baseline and used her compact, controlled swing to take the ball early, even on those serves from Williams that have brutalised many of her opponents. The Chinese lady was having a rare old time, as Serena found it really difficult to discover a way through her defences. That Williams did not join the trail of big names falling by the wayside had much to do with her unflagging will to win.

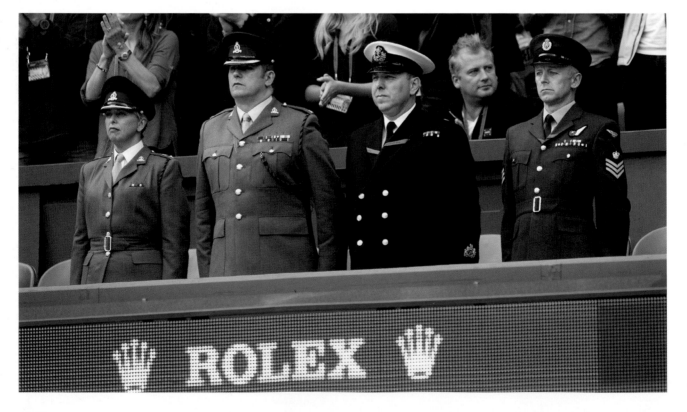

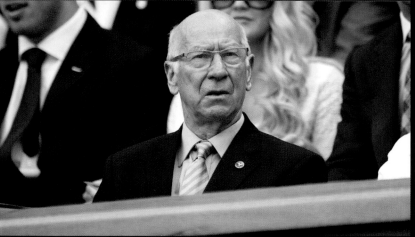

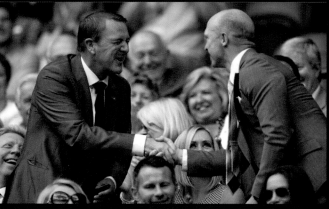

Sports Saturday

The tradition of inviting great names from the sporting world to the first Saturday of The Championships meant the Royal Box was bursting with greats from the worlds of tennis, football, rugby, cricket and, it being 2012, the Olympics. These included, top row from left to right: Sir Bobby Charlton (football), Alastair Cook and Andrew Strauss (cricket); second row: Phil Tufnell (cricket) and Matt Dawson (rugby), Ilie Nastase and Boris Becker; third row: Judy Murray, Jack Nicklaus (golf), Dame Kelly Holmes (athletics); bottom row: Martina Navratilova.

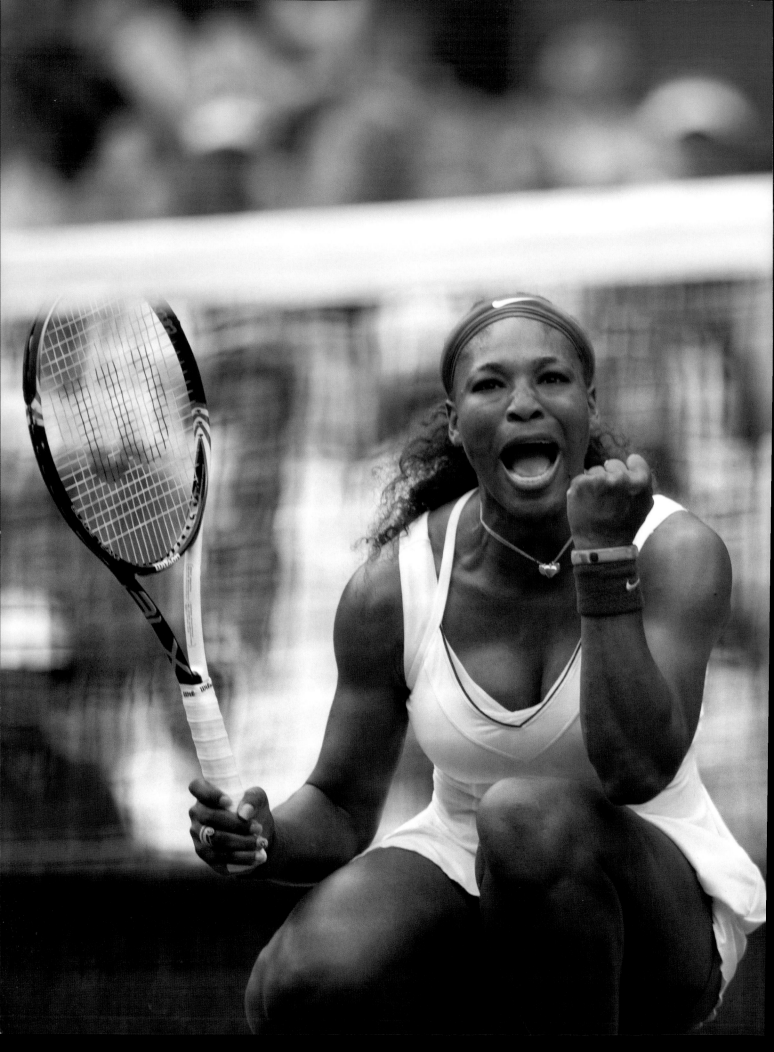

(Left) *Philipp Kohlschreiber stopped Nadal-beater Lukas Rosol in his tracks in straight sets*

(Far left) *Serena Williams produces one of the images of the tournament as she celebrates her win over Zheng Jie*

"I'm just doing the best I can," the American said when asked about the list of casualties in the first week. "I am trying not to make too many excuses. You cannot underestimate anyone, everyone plays tough nowadays. I definitely felt like this was a gut check. I've always been very strong mentally – that's not going to go anywhere."

Those guts would need to be spot on in the fourth round, for Serena's subsequent opponent would be Yaroslava Shvedova of Kazakhstan, who became only the second player in the Open Era to record a "golden set" (winning all 24 points) in the first set of her 6-0, 6-4 third-round victory over Sara Errani of Italy. Not only was this quite some feat, but it was achieved against a player who had been in a Grand Slam final three weeks earlier.

The only previous player not to lose a point in a set was American Bill Scanlon, who defeated Marcos Hocevar of Brazil at Delray Beach in 1983. Remarkably, Shvedova also held the previous women's record for the most consecutive points won, winning the first 23 points of her match against American Amy Frazier in the second round at Memphis in 2006, but she went on to lose the match 1-6, 6-0, 6-0 (who said women's tennis was predictable?).

Though it is considered a Show Court, Court 12 at Wimbledon is one of those far-flung outposts where the hardy and athletic muster. On a day when the canopies were rattling against their moorings, saplings waved and a crowd of 300 in its temporary pavilion was considered a full house, it was here where Lukas Rosol, the hero of Thursday evening, had been despatched. Rather a come-down really.

Instead of Rafael Nadal (who was back in Majorca), the man across the net was the No.27 seed Philipp Kohlschreiber, who can walk through Wimbledon Village and a lot of other villages undisturbed. Instead of calm under a roof, there was a distinct breeze: shifting the big white clouds overhead and tugging at Rosol's shorts and his huge flat shots.

And instead of a follow-up victory after a huge upset, there was – as is often the case in the head game that is tennis – a quick tumble back to planet earth. "Of course I was hoping he's not having that day again against me," Kohlschreiber said after his 6-2, 6-3, 7-6(8) victory. "I mixed up the pace a lot – every time he hit a strong ball I tried to slice it back, keep it short. He doesn't like to move too much around the court." What, hadn't Rafa thought of this?

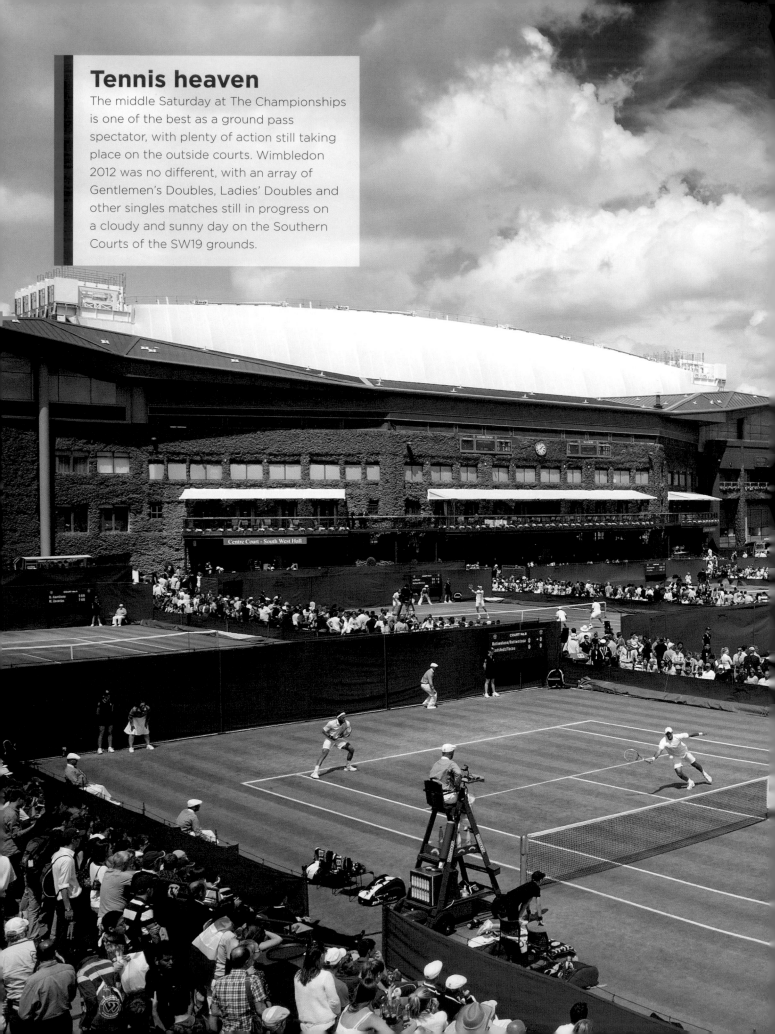

Tennis heaven

The middle Saturday at The Championships is one of the best as a ground pass spectator, with plenty of action still taking place on the outside courts. Wimbledon 2012 was no different, with an array of Gentlemen's Doubles, Ladies' Doubles and other singles matches still in progress on a cloudy and sunny day on the Southern Courts of the SW19 grounds.

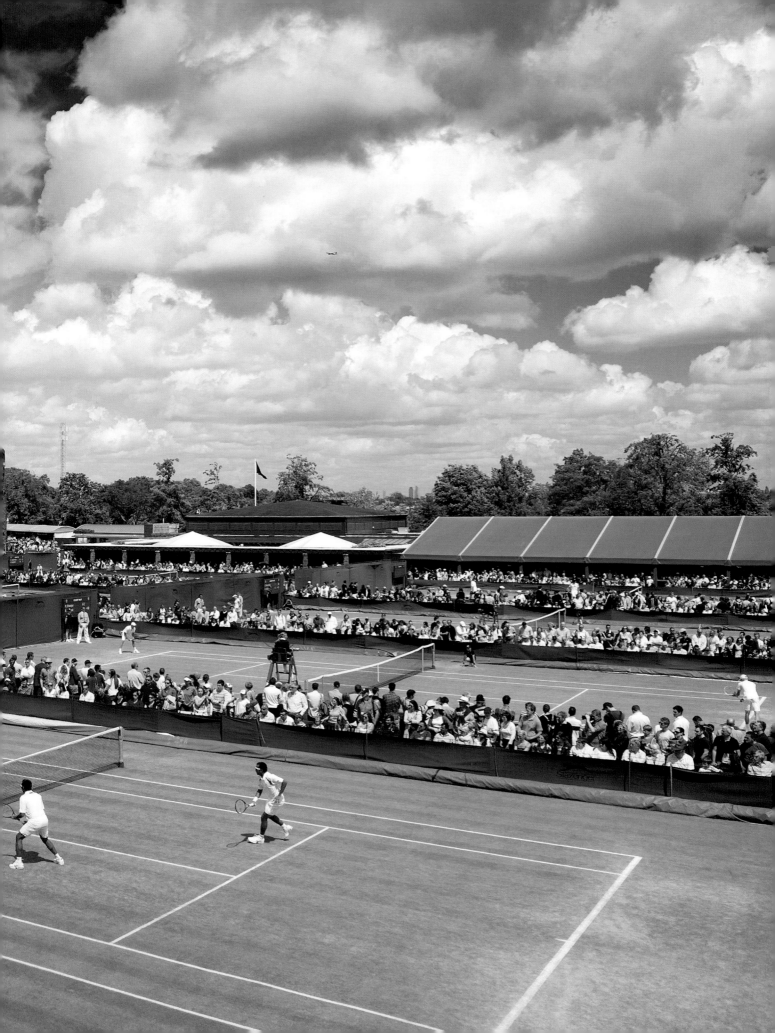

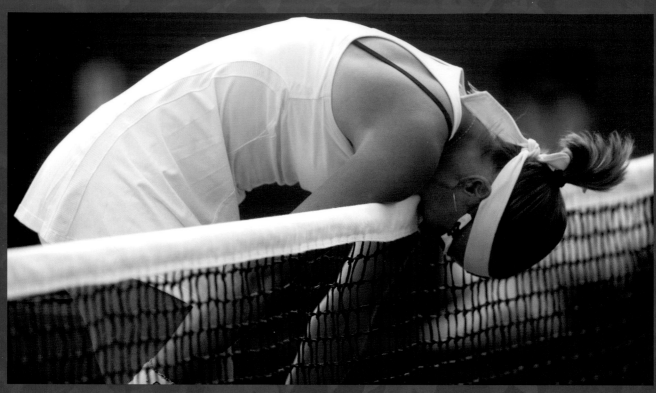

The Golden Set

By winning 24 straight points in the first set in her match against the 2012 French Open finalist, Sara Errani, Kazakhstan's Yaroslava Shvedova achieved the first "golden set" (one achieved without dropping a single point) since Bill Scanlon against Marcos Hocevar in the first round of the Gold Coast Classic in 1983.

Shvedova's feat – which included four aces and 14 winners – was the first at the All England Club and the first in women's tennis since the professional Open Era began in 1968. In 2006, Shvedova had almost achieved the feat by rattling off 23 straight points against Amy Fraser in the last 16 at Memphis. But having lost the 24th point Shvedova, then ranked No.228, went on to lose the match to her No.7-seeded opponent in three sets, 1-6, 6-0, 6-0.

On Day Six at SW19, however, the wild card and Roland Garros quarter-finalist proved too strong for her No.10-ranked opponent, earning those 24 straight points in just 15 minutes.

"I had no idea. I was just playing every point and every game. It didn't feel like every game was 40-love, it was only when I started to lose some points in the second set," Shvedova said. "So it was incredible."

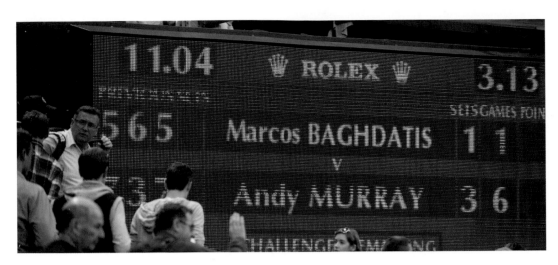

A shot of the Centre Court scoreboard taken two minutes after Andy Murray's 11.02pm finish against Marcos Baghdatis, which was the latest in Wimbledon history

Back across to Centre Court and the afternoon dragged on to the evening and further towards the night. Andy Murray and Marcos Baghdatis of Cyprus, who had beaten him in the fourth round six years earlier, were involved in a surreal match, dripping with oddities, heroics and not a little controversy – in short, a classic Murray performance. It passed the tennis version of *The Old Grey Whistle Test* as everyone on site, from the cleaners waiting to move away the detritus of Day Six to those busying themselves in the offices and food booths, craned to catch the action on any visible TV screen.

Inside the stadium, there was a building tumult, with everyone from umpire to ball kids snatching a look at the clock as the players went blow for blow in the final set. The 11pm finish time was set in stone to honour Merton council regulations about residual noise from the tennis, lest the locals be inconvenienced, but pragmatism, thankfully, drowned out bureaucracy. Murray won 7-5, 3-6, 7-5, 6-1 in three hours, 13 minutes and, for once, the numbers mattered a lot because, if he had not pressed the action over a final frenetic set of just 28 minutes, he would have gone home robbed of the momentum that took him to one of his most memorable victories.

Murray fell over three times, hurting his already troubled body from ankle to shoulder to brain, and three times his reserve service ball spilled from his pocket – costing him in the first two instances the replay of the point and, on the third occasion, the point itself. As it happened, those incidents did not accumulate to do lasting damage, but they certainly added to the extraordinary sense of theatre on Centre Court, which, for the fourth night running, entertained an audience under the roof.

As the match went into a fourth hour, now under the roof, word came through that they might go "a minute or two" past 11pm if a finish was in sight. At 5-1 up at 10.58pm, would Murray be allowed to do it? He was. And so it went: 15-0; 30-0; 40-0 as Murray secured three match points with his 10th ace, then the spoils with another 130mph howitzer, exactly two minutes past the deadline.

"When I got up at 4-1 [in the fourth set] I did not sit down," Murray said. "I said to the umpire, 'Are we going to finish?' He said, 'Yes.' I had no idea what the rules were."

WIMBLEDON IN NUMBERS

4 Fourth rounds at Wimbledon achieved by David Ferrer. The last Spaniard standing made it into his fourth round of 16 with an impressive defeat of Andy Roddick on Day Six.

DAY SEVEN
MONDAY 2 JULY

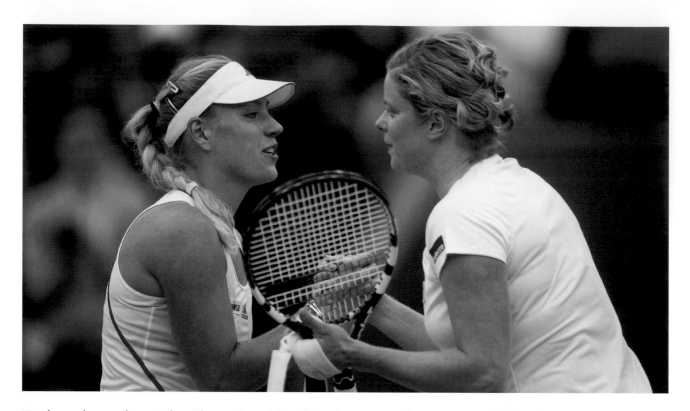

It has always been The Championships' 'Don't Know Where To Turn' day. The second Monday is the round-of-16 day in both Gentlemen's and Ladies' Singles, a potpourri of personalities and pleasure, where excellence can be found on every court, stretching the length and breadth of the grounds.

(Above) *Kim Clijsters bid farewell to The Championships at the hands of German Angelique Kerber*

That Wimbledon remains lone among its Grand Slam cousins in eschewing play on the middle Sunday gives that defining sense of a break, a drawing in of breath, a lull before the storm is regenerated and, wouldn't you know it, it was a rather nice day – nice enough for the two-year-old twin daughters of Roger Federer, Myla and Charlene, to be out on their pink-trimmed scooters on the concourse. Apparently they were developing quite a rapport with the young daughters of Tim Henman, now a Wimbledon Committee of Management man. It was all very sociable.

There was practice to be had, of course. The courts of Aorangi Park were filled, a constant shuttling of to-and-fro of those still in the event, trying for a little court time before hostilities were renewed. One of those was Kim Clijsters, the Belgian whose appetite for the sport had been rekindled three years earlier when she was invited to christen the Wimbledon roof in a gala affair.

Thankfully for Kim, her final year playing in the event after a long struggle with injury would involve one trip to Centre Court for her second-round match against Andrea Hlavackova of the Czech Republic, but by the fourth she could only be found a spot on No.3 against Angelique Kerber of Germany and that is where her participation came to an end in quite a resounding fashion, a 6-1, 6-1 defeat. She so much wanted to do more to make the match a contest, but could find nothing by means of the inspiration required.

"I am not sorry about anything," Clijsters, who played the event first in 1999 and reached two semi-finals, in 2003 and 2006, said. "I've given my best and that is the only thing I can try. When I first saw this event, I thought it was like Disneyland would be to another child. It was magic on television.

There are so many memories with my family and especially with my dad [who had passed away three years earlier]. I was able to go to the Champions' Dinner once, because I won the doubles."

Neither Victoria Azarenka, the No.2 seed, nor Ana Ivanovic, the No.14, have been to a final here, either, though their chance may come. They were on Centre, though not for an extortionately long time as Azarenka thrashed her opponent for the loss of a single game. One had seen many sights and heard many noises on this court down the years, but I must confess to never having encountered a match being halted for feathers. At one stage in the second set, probably as a pigeon had been trapped under the roof (yes, it was closed again), and was trying to find a way out, some of its feathers became dislodged and floated gently to the grass. Azarenka went about collecting the debris and gently handing them to a ball girl.

Serena Williams was spitting a few feathers herself. Out on No.2 Court for the second time, she was perturbed almost as much by being closed in on all sides by fans as she made her way back to the main locker rooms as she was by the tennis of Yaroslava Shvedova, which was pretty powerful in itself.

In 24 minutes, Williams led 5-0, but Shvedova was not here for a mauling and promptly took a 4-2 lead in the second set thanks to a smoking forehand return and then began to throw herself across the grass and drew level. By now the ball tosses were flying all over the place, the wind blew, the clouds gathered and, whether it was mental tiredness or not, two double faults at 5-5 from the Kazakh were meat and drink to Serena who served out for the match.

Many of us had pencilled in a potential meeting between Serena and Maria Sharapova in the final, but here was another prognostication that counted for nothing as the No.1 seed from Russia was defeated in straight sets by Sabine Lisicki of Germany. Just to rub her first victory over Sharapova into the face of the French Open champion, she concluded affairs with an ace on a second serve. "She did many things better than I did today." Sharapova said. Including aces on second serves.

Victoria Azarenka, about to serve, had to pause while feathers from a pigeon caught in the Centre Court roof floated down

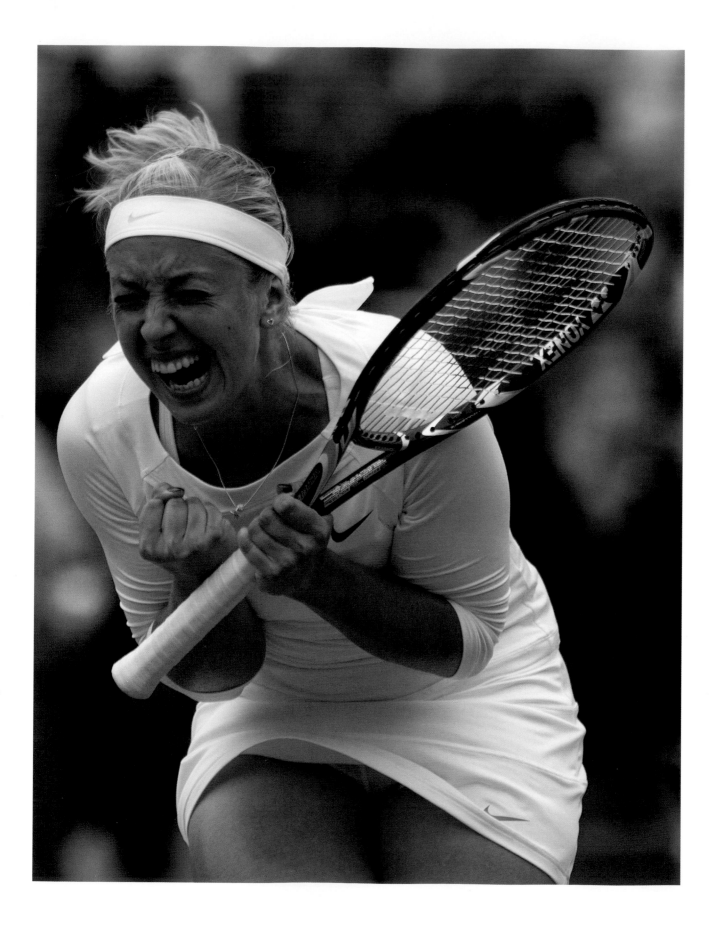

Roger Federer got his task completed, though not without a worry or two against the Belgian Xavier Malisse. The greatest concern for him was that, after he had played just seven games, Federer retreated from the sight of the crowd for some work on his back. Never had we long-time Federer watchers seen him retire from a match, but he was clearly hurting, and the weather could not have helped. Rather than take the match on boldly, Malisse began to play in a subdued manner as if punishing the greatest when he was a little hurt would in some way be another infraction of the spirit of the game. Roger bounded back to win 7-6(1), 6-1, 4-6, 6-3. "I've had bad backs over the years," he said later. "I've been around. They go as quick as they come. Give me two good nights' sleep and I'll be 100 per cent on Wednesday. I did apologise to Xavier for the first set, not that I had anything to do with it. I know how hard it is to play somebody who is injured."

The second men's match on Centre Court would offer Novak Djokovic, the champion, the opportunity to do what he normally did to his Serbian compatriot Viktor Troicki and win with considerable ease, 6-3, 6-1, 6-3. He was bounding along very nicely indeed.

To much debate, Andy Murray had been transported to No.1 Court and this in the face of a forecast that indicated we would be exceedingly lucky to get through the day. There was, we were told, an unwritten rule by which each of the top players should have to play at least once on No.1 Court, though I recalled Murray once having gone throughout an event without such a detour and no one had mentioned it. Having endured quite a number of finishes at around 11pm, it was refreshing that play ended at 7.55pm. Murray was leading Marin Cilic, the Croatian, 7-5, 3-1 (40-0) having recovered from a relatively sluggish start in conditions which made such lethargy hardly surprising.

As the rain pitter-pattered down, there were looks of consternation on several faces. Juan Martin del Potro and David Ferrer, due on after the Murray match, did not even get started. Richard Gasquet, trying to complete his match against Germany's Florian Mayer on No.3 Court and thus that section of the draw, was mooching around the players' area and I wondered if he might ask the Referee if he could perhaps be allowed to move to Centre. Off went he and his coach Riccardo Piatti towards the offices, but as they were on the schedule for resumption at 12 the next morning it was clear that any pleas on their behalf had not received quite the answer they were looking for.

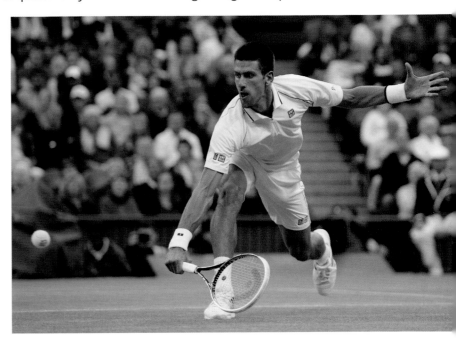

(**Above**) *Novak Djokovic on his way to an easy fourth-round win.*

(**Far left**) *Sabine Lisicki celebrates her upset of world No.1 Maria Sharapova*

WIMBLEDON IN NUMBERS

3 Number of reigning French Open champions Sabine Lisicki has defeated at Wimbledon in her last three appearances. She defeated Svetlana Kuznetsova in 2009, Li Na in 2010 and Maria Sharapova in 2012.

'The People's

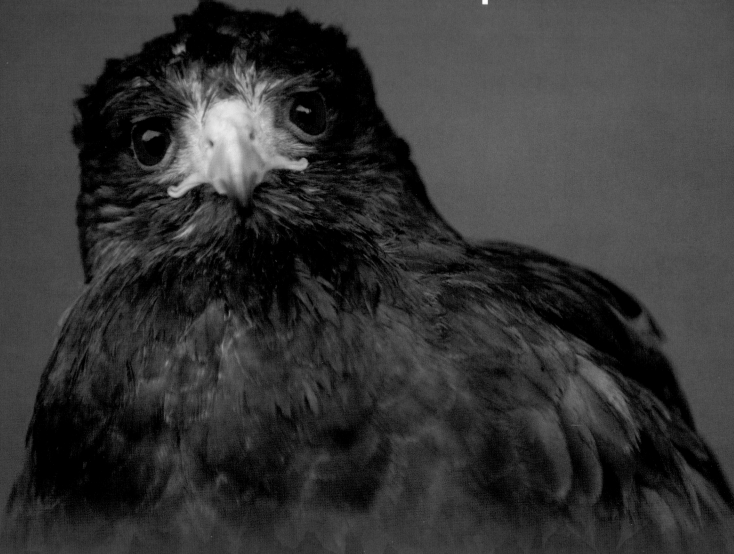

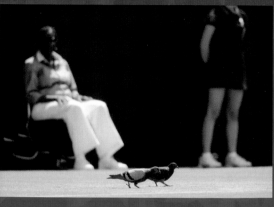

The All England Club and its many fans were sent into a tailspin over the middle weekend of The Championships, when it emerged that Rufus the Hawk, faithfully employed to keep the pigeons away, had been stolen, cage and all, from the boot of a car in one of the car parks. After 24 hours of agony for his owners, Rufus was retrieved on Wimbledon Common, the only casualty a rather sore leg that prevented him from flying. In his absence, the pigeons caused havoc, one even getting stuck in the Centre Court roof during the match between Victoria Azarenka and Ana Ivanovic.

Hawk'

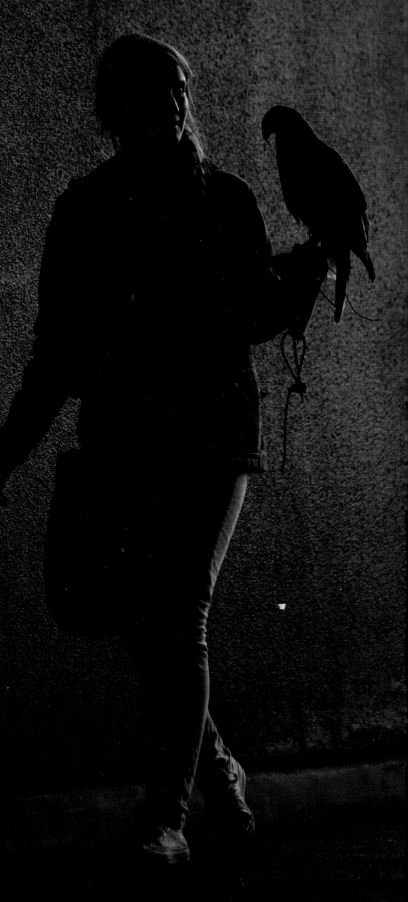

"Rufus gets so much lovely attention," says his handler, Imogen Davies. "He's very responsive, very trusting, and a great 'people bird'. I've heard some say, when they're asked what Wimbledon means to them, 'Pimm's, strawberries and cream, and Rufus!'"

Imogen, 25, has recently joined the family firm – Avian Control System – founded by her father Wayne. Rufus and his fellow high-flying raptors have been working with Wayne at the All England Club since 2000, and also ensure Westminster Abbey and the 600ft Barclays Bank tower in Canary Wharf remain untroubled by pigeons.

And for Rufus Wimbledon is not just about two weeks in June and July, it's a year-round responsibility. Except during The Championships when he is lodged in Wimbledon Village, Rufus travels from Northamptonshire to start his airborne patrols by 6am.

As hawks are motivated by food he is sent off to fly hungry, often going on from one site to another on the same day. Then once his pigeon-scaring patrols are completed he's fed up for the day and allowed to rest.

"Rufus is particularly suited to Wimbledon. As a woodland hawk, he is good at weaving in and out of the courts. He's very agile and particularly good at clearing the spaces up in Centre Court's retractable roof," explains Imogen.

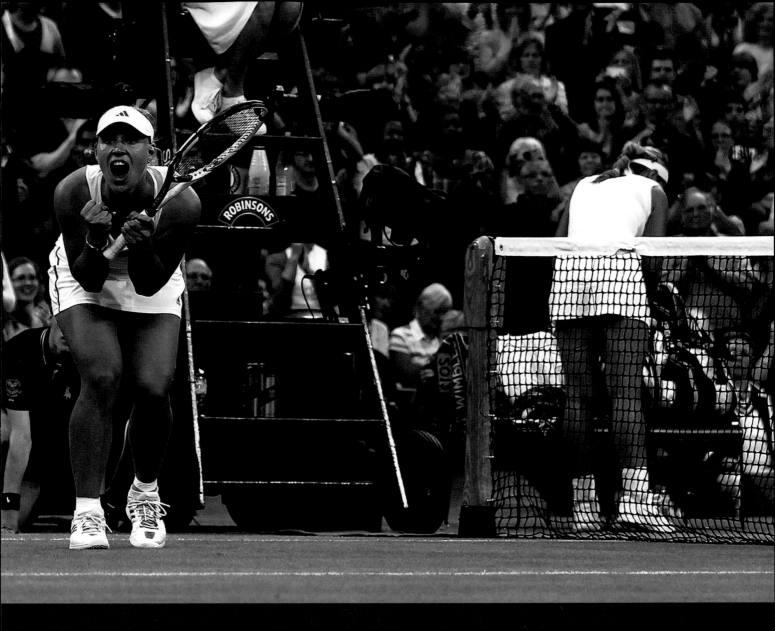

DAY EIGHT
TUESDAY 3 JULY

Those who purchased tickets for the outside courts on the second Tuesday expecting to see a phalanx of old-timers strut their (little more than they used to carry) stuff had something more up-to-date to keep them entertained. The inclement nature of Monday's weather and the backlog of matches meant that, on Ladies' quarter-finals day, there were outstanding Gentlemen's matches to be completed.

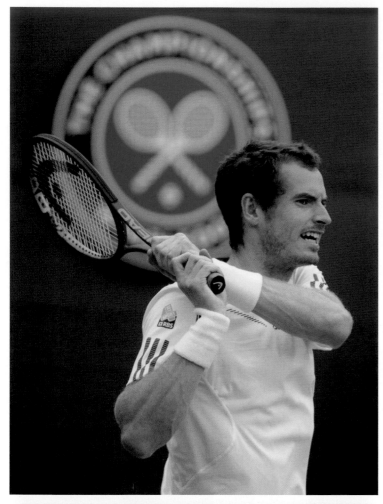

Thus, on No.1 Court, Andy Murray and Marin Cilic had to get things over and done with, as did the pairings of Richard Gasquet and Florian Mayer and Mardy Fish and Jo-Wilfried Tsonga; whereas Philipp Kohlschreiber and Brian Baker, as well as Juan Martin del Potro and David Ferrer, were starting their matches from scratch.

More than a few anxious looks were being shot to the skies. We really needed to get everything back on track if possible and, despite the odd spit and spot of rain which interrupted proceedings now and again, that is what happened. Everyone was duly thankful.

Murray, it has to be said, was positively brutal in getting rid of Cilic 7-5, 6-2, 6-3, a performance of touch, power and precision, his judgment invariably on the money, giving his opponent minimal opportunities to get a foothold in the match. Resuming after the postponement on rainy Monday, he hit 35 clean winners behind some high-class serving. It was a mildly surprising fact that Murray was winning more points on his second serve, 94 from 140, than anyone in the tournament. David Ferrer, who defeated Del Potro in three clinical sets, stood second with 88 from 130.

Murray polished off the second set and rushed through the third with all the urgency he brought to the finish of his curfew-buster on Centre Court on Saturday. He served out the match with two aces, to add to the 14 he had already posted, and looked in a mean fist-pumping mood as he walked to the locker room. All but Ivan Lendl in his box stood to acclaim him, old Stone Face preferring to acknowledge the performance with a quiet, seated clap, his judgment hidden by dark glasses – he was suffering from grass allergies – on a sunless day. They remained a curious but compatible pair.

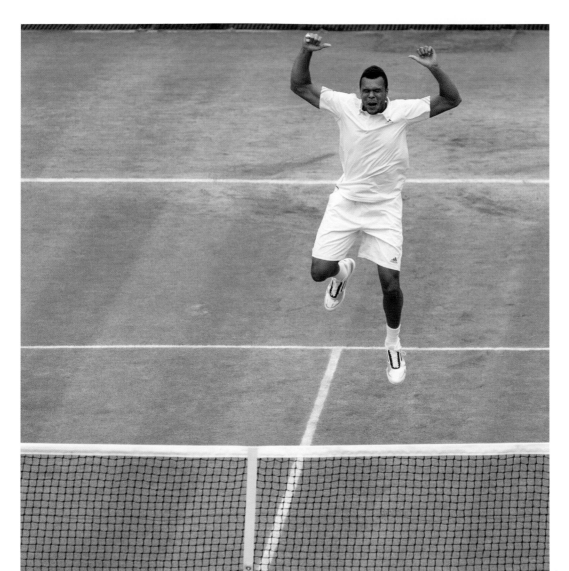

(Left) *Jo-Wilfried Tsonga produced his traditional celebratory jig after beating Mardy Fish to reach the last eight*

(Far left) *Andy Murray was ruthless in his resumed disposal of Marin Cilic, to the delight of those in his players' box*

Nothing was disturbing Murray's mood, which had to be a good sign. He said he was not bothered about having to play outdoors while others had the benefit of the roof, but it sounded very much as if diplomacy was drowning out frustration. He has learned to his cost that complaining tended to bring down the wrath of the gods (in the shape of past champions with TV obligations), but he did say: "You can build momentum and leads, then when you stop and come back out again you feel like you're starting from square one. He started the third set well. He had a few chances. I came up with some big serves."

Talking of big serves, they were a prominent feature of the four-set victory enjoyed by Tsonga over Fish, a veritable delight for those with No.2 Court access. Fish had been on top on the first day, but as with so many matches like this, which were forced to re-start, the balance altered. "Who knows what happens if there is not a rain delay?" Fish said. Who indeed?

A nagging back and hip did not help Fish, but that he was here at all, biffing balls in a major championship, was not to be sniffed at. Though he felt he played better on the second day, he accepted that Tsonga had stepped up even more. "He is an unbelievably athletic player," the American said. "I'm a big fan of his."

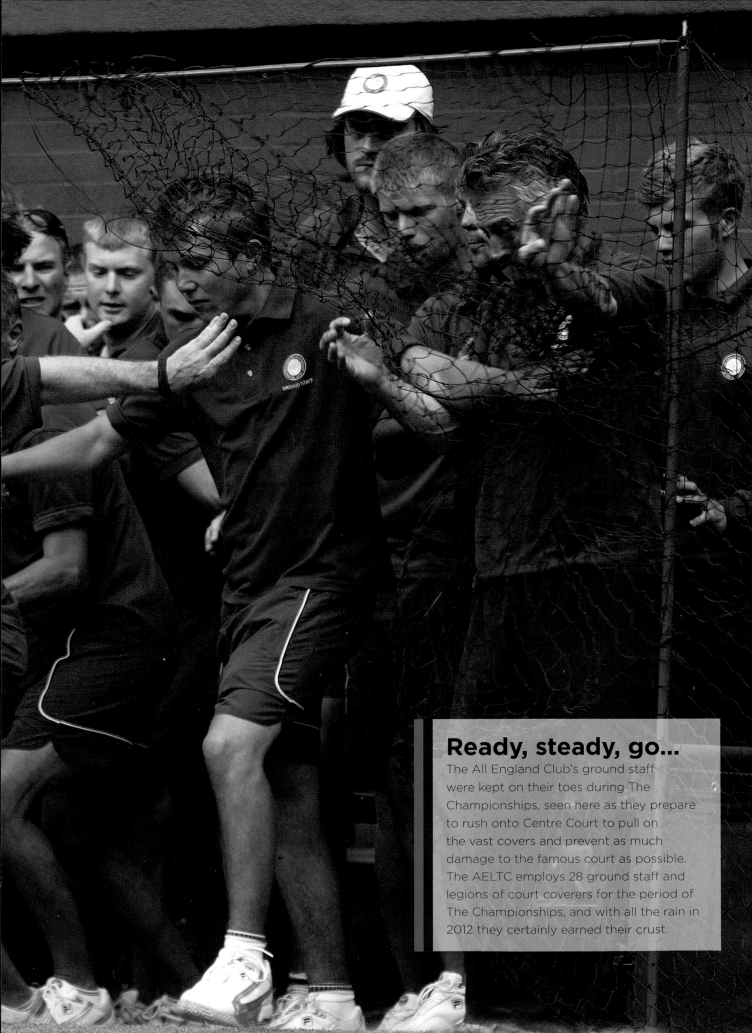

Ready, steady, go...

The All England Club's ground staff
were kept on their toes during The
Championships, seen here as they prepare
to rush onto Centre Court to pull on
the vast covers and prevent as much
damage to the famous court as possible.
The AELTC employs 28 ground staff and
legions of court coverers for the period of
The Championships, and with all the rain in
2012 they certainly earned their crust.

Most neutrals were. There was also a growing sense of a following building for Brian Baker, the American who had undergone five serious operations, three on his hips, one elbow and one sports hernia, that caused him to miss almost six years of tennis – a lifetime in anyone's book. That he was in the event at all was to be cherished and even though he would lose 6-1, 7-6(4), 6-3 to the effervescent Kohlschreiber, he had every right to be satisfied.

"I didn't feel like I returned quite as well, but some of that had to do with [his] serving," the 27-year-old ranked No.127 said. "He hit his spots when he had to, so I didn't really put a lot of returns in play when I had chances. He took advantage of that. It's been an unbelievable run. I don't know if I put an expectation like I needed to get to this round or not. But I don't know if starting first-round qualies I would have thought I would have got to the fourth round." Patrick Kidd in *The Times* noted that Baker's kit had seemed to become greyer each round he played "as if he had to wash it every night." A fourth-round loser's cheque would allow him a few spare ones for the future.

(Below, from left to right) Petra Kvitova bade farewell at the hands of Serena Williams, while Victoria Azarenka, Angelique Kerber and Agnieszka Radwanksa recorded crucial victories

For Kohlschreiber, this was a profound moment, his first Grand Slam singles quarter-final. Not only that, he was to be joined by Florian Mayer, his compatriot, who had maintained the upper hand he had on Gasquet when they were chased from the court by Monday's rain.

But, remember, this was the Ladies' quarter-final day. They were the ones who were supposed to have top billing, and yet they all had to wait their turn to play. In the case of Petra Kvitova, the defending champion, it was the end of this year's road, Serena Williams once more proving that consummate ball-striking and self-confidence counted for an awful lot. Some of her shots were delivered with such strength, one wondered if she had not come out on court armed with a mortar rather than a racket.

Williams won in straight sets, as did Victoria Azarenka over Tamira Paszek. The other two matches were the best of the Ladies' Championship to date. In the first, Angelique Kerber defeated Sabine Lisicki

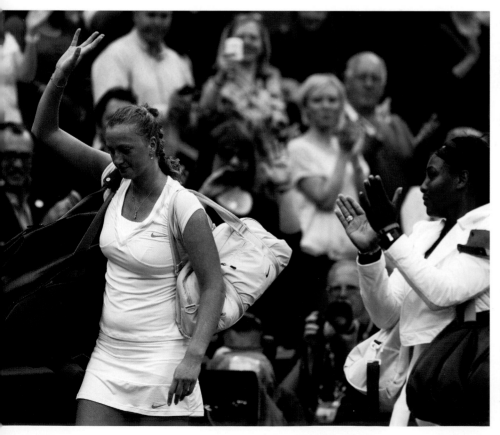

her fellow German (though both had Polish ancestry) 6-3, 6-7(7), 7-5, confirming her remarkable rise from the wrong side of No.100 in the WTA rankings to No.8 inside a year. This was jet-propelled improvement, and Lisicki tested it all the way in a marvellous match of impromptu winners – the Kerber backhand was especially sound – slices, volleys and yelps of delight.

Perhaps the most incredible was saved for last, a match of four rain delays. Agnieszka Radwanska of Poland and Russia's Maria Kirilenko had started their match on No.1 Court but were halted again and told to wait for a curtain call on Centre as Azarenka had rather speedily despatched Paszek. "It was 9.30 and they told us we had until 11," Radwanska said. "I said 'My God, you want us to play 'til 11?'" Yes, Aga, they did.

She said there was no time for mistakes because there was no time to come back, and so both she and Kirilenko, neither of whom had been to a Grand Slam singles semi, set about scorching the turf with a succession of groundstrokes that drew raucous applause from the 500 or so souls who remained. Restarting at 4-4, world No.19 Kirilenko held serve and was twice two points from victory on the Radwanska serve. But the Pole stayed firm to level at 5-5 and then broke in the next game before serving out under pressure to reach the last four. It was over by 9.48pm, way before their bed time.

WIMBLEDON IN NUMBERS

7 hours, 20 minutes

The time it took to complete the quarter-final match between Agnieszka Radwanska and Maria Kirilenko.

Go away rain…

PLEASE!!

Brolly Good Show!

The summer of 2012 was one of the wettest since records began. And whilst the rain and unseasonably low temperatures did not detract from one of the most exciting Championships ever, thanks in no small part to the relatively new Centre Court roof, they did provide some unusual sights around the grounds. During the course of Wimbledon 2012 numerous matches were disrupted by the rain and the damp conditions made conditions underfoot significantly more slippery than usual. But, as Francesca Schiavone proved on Day 8, sometimes when the heavens open all you can do is smile.

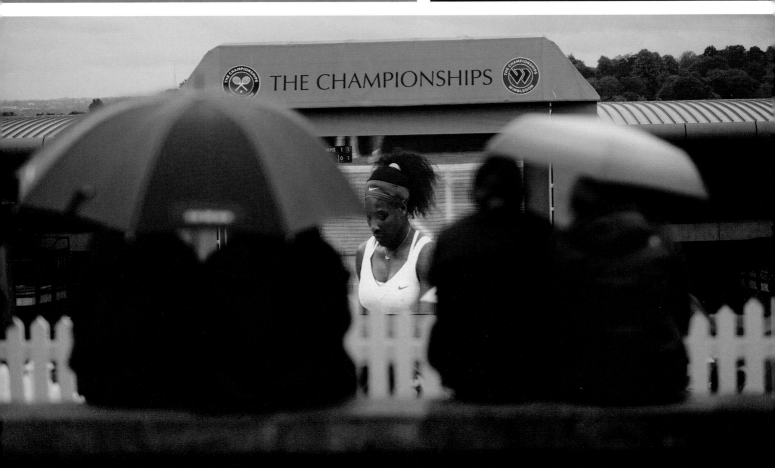

THE CHAMPIONSHIPS

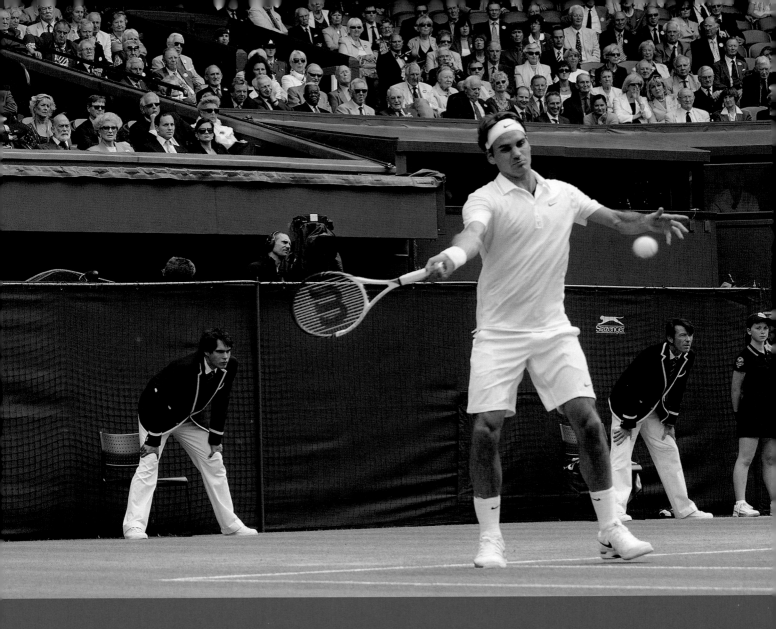

DAY NINE
WEDNESDAY 4 JULY

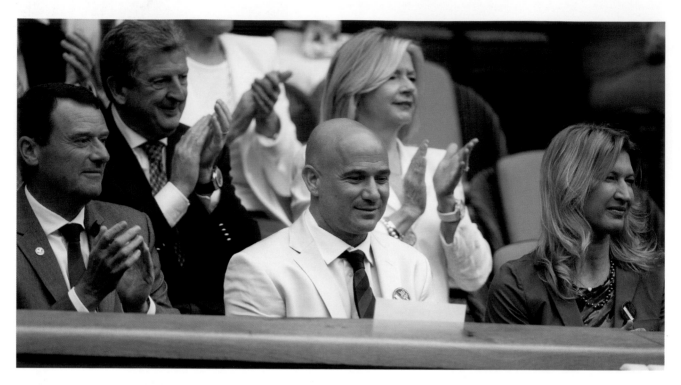

A diversion from SW19 for an hour or so took me to The Queen's Club and a meeting with one of the Chairman's special invitees for the year. Andre Agassi, the champion 20 years ago, was holding court next to a court, thanks to Jacob's Creek, the official wine of The Championships. We had so much to discuss in so little time. Andy Murray's name was to the fore.

(Above) Andre Agassi and Stefanie Graf were welcomed to the Royal Box as the Chairman's Special Guests

"He is so good defensively, he's comfortable not pulling the triggers that he should and can pull, and he finds himself reacting more than being proactive. That's what I want to see in some of the big moments," Agassi said. There were going to be plenty of such moments in the next few hours. I wondered how Agassi might feel when he stepped into the Royal Box for the first time and he might be accorded something of a hero's welcome. It gave him a moment's pause, and the realisation that he didn't have an idea as to how it would make him feel rather unnerved him.

With those thoughts uppermost in my head, it was back to the courts where, as the usual scheduling pronounced, Murray against David Ferrer of Spain would be the second match on the Centre Court agenda, after Roger Federer had played Mikhail Youzhny, the Russian competing in his 12th consecutive Wimbledon but who had never been to a quarter-final before and not beaten Federer in 13 previous matches.

Agassi and Stefanie Graf, his wife, took their seats in the front row, as did HRH the Duke and Duchess of Cambridge. If anyone had said two decades earlier that we might see the American – who had pronounced badly on elite tennis officialdom in the past – seated two away from the future king, they would have been given a wide berth.

Time was a great healer though. Youzhny's right eyebrow was also properly meshed together after he had once attacked it with his racket over a couple of bad shots in a tournament in Miami. There must have been occasions, when he struggled to keep the ball within the lines against Federer, that he felt like taking it out on himself again but, fortunately, he resisted the temptation.

Federer won 6-1, 6-2, 6-2 and Jonas Bjorkman, the Swede who had warmed him up for the day's play, sent his friend a message after, thanking him for the resounding nature of the victory which helped put into perspective the thrashing he had been given in the 2006 semi-finals by Federer, when he won only four games.

"Obviously I think it helps, particularly when you've never lost against someone or have such a one-sided head-to-head," Federer explained. "You feel that maybe it's up to him to change things up a bit. You just do what usually works against him, and if it doesn't you just adjust to it. I don't take these matches easily, I prepare for them like I do every big match." And, although it didn't look it, Federer was still receiving daily manipulative sessions on his back. "Regardless of how my body is, everyone gets treatment multiple times a day," he said, smiling.

Mikhail Youzhny (above) could do little to halt the passage of Roger Federer (below) into the semi-finals

The main course on Centre Court was to be a repeat of the French Open quarter-final a month earlier in which Ferrer had gradually worn the British No.1 down. There are few players in the game who retrieve as well as Ferrer, who has often been likened to one of those pesky dogs who refuse to let go of your trouser leg, no matter how many times you might try to prise their teeth free.

In winning 6-7(5), 7-6(6), 6-4, 7-6(5) to reach a fourth consecutive SW19 semi-final, Murray had to play both well within and outside of himself. Great points abounded, Murray was broken first in the match, responded in the ninth game, led the tie-break 2-0, was pegged back as Ferrer nabbed four points in a row, got himself back to 5-5 and was then undone by a couple of loose groundstrokes.

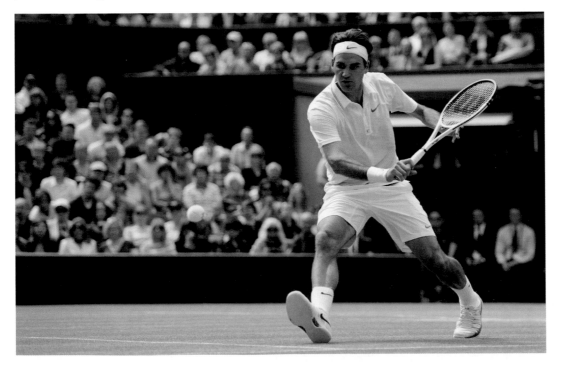

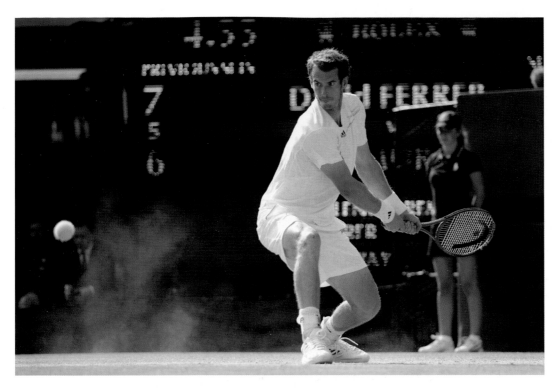

Andy Murray holds court on Centre against David Ferrer **(below)**, *successfully negotiating his way past the tireless Spaniard*

In the second set, once again, Murray lost serve first; Ferrer was serving for it but was broken to 15. Ferrer led 3-0 in the tie-break, extending that to 5-2, but Murray would not lie down and a forehand on the run was netted to take it to 5-5. Murray missed a backhand service return, set (possibly match) point, but the Scot smacked a glorious forehand inside-out winner, forcing Ferrer to net a backhand on set point and bring the match level.

"Between them," said Simon Barnes in *The Times*, "they constructed a succession of intricate rallies not always of all-out action; rather there was a thoughtful, almost intellectual, feel to them. There was a touch of chess in the way they went about it, and so Murray began to manoeuvre Ferrer around a little more than he was being manoeuvred around himself. The problem is you wait for a Ferrer mistake as long as you wait for Godot."

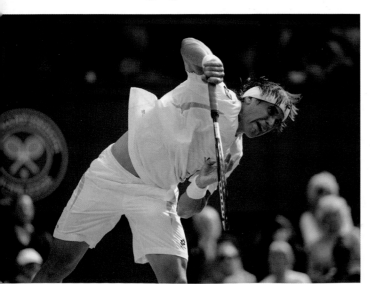

Agassi stayed in his place during the rain delay at 5-5 in the fourth set, one of the few who did, and was rewarded with a very special tie-break to end matters, a succession of thudding Murray strokes, much in the manner of being proactive that the old champion had wanted to see.

"I've had a good run in the last few years, but I'm not satisfied with that," Murray said. "I am shielding myself from the pressures as much as I can. I am in my own bubble, just listening to those around me and then I can deal with it all. I just know how hard this is. I've beaten some very good players, it's been a good tournament. So far."

Live @ Wimbledon

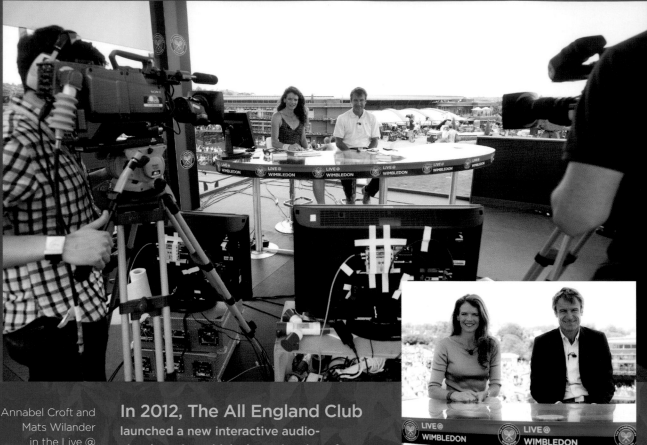

Annabel Croft and Mats Wilander in the Live @ Wimbledon studio on the Broadcast Centre roof, in the first year of the Club's new online television digital service

In 2012, The All England Club launched a new interactive audio-visual service which shows just how far Wimbledon is determined to push the boundaries of the viewing and listening experience.

Joining forces with its broadcasters, the AELTC created "Live @ Wimbledon", a special interactive service on the official website and mobile applications, which offered five hours per day of live TV coverage, and all-day radio coverage, also on local FM frequency, throughout The Championships.

Aiming to replicate for fans the experience they would have if they were at the All England Club themselves,

Live @ Wimbledon TV, presented by Mats Wilander and Annabel Croft, provided all the colour of the Grounds, whilst bringing live coverage of crucial moments plus interviews with the likes of Roger Federer, Jack Nicklaus and Martina Navratilova.

Live @ Wimbledon Radio, available worldwide, presented by Marcus Buckland and Mary Rhodes, provided listeners from every country with point-by-point coverage of all the action on Centre Court and No.1 Court, while reporters stationed around the Grounds brought the rest of the tournament to life.

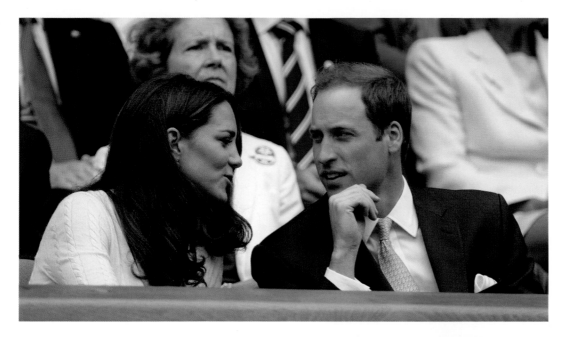

The Duke and Duchess of Cambridge made their second visit to The Championships together in 2012, seen here in conversation as they watched Andy Murray

Across on No.1 Court, it was to be a case of "Auf Wiedersehen" to the German challenge. Florian Mayer was beaten in straight sets by Novak Djokovic, who said that he had trouble adjusting to natural light after a succession of matches played under the Centre Court roof, and the first set, especially, was a real mixed bag from the Serb. Mayer's crafty play was to the fore in the initial stages, and Djokovic gave the air of man who was struggling both with an opponent and himself. "I was a little bit more nervous than usual at the start," he said. "I managed to get into the right rhythm at the right moments."

In a 7-6(5), 4-6, 7-6(3), 6-2 loss to Jo-Wilfried Tsonga there was enough high quality from Philipp Kohlschreiber to confirm that his place in the last eight was no trick of the light. The Frenchman made more mistakes than he would have preferred, though 28 unforced errors in a match of this importance was hardly worth losing sleep over. The steamrollering that took place in the fourth set ought to have reassured him that he was running into form just at the time he would have to run into Murray.

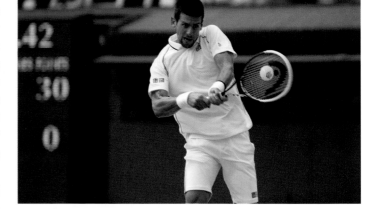

Novak Djokovic set up a semi-final meeting with Roger Federer but initially struggled to get used to playing in the light

Kohlschreiber lacked the ruthlessness to take his 27-year-old foe apart when it mattered. An illustration came in the first-set tie-break when, after going toe-to-toe with Tsonga in normal play, Kohlschreiber crumbled to allow him to race into a 6-1 lead before the German made what should have been a heartening comeback, to 6-5. But as throughout – the second set apart – the lesser-ranked man could not quite step it up when it mattered.

WIMBLEDON IN NUMBERS

32 Grand Slam semi-finals for Roger Federer, giving him the all-time record for most Grand Slam semi-finals reached.

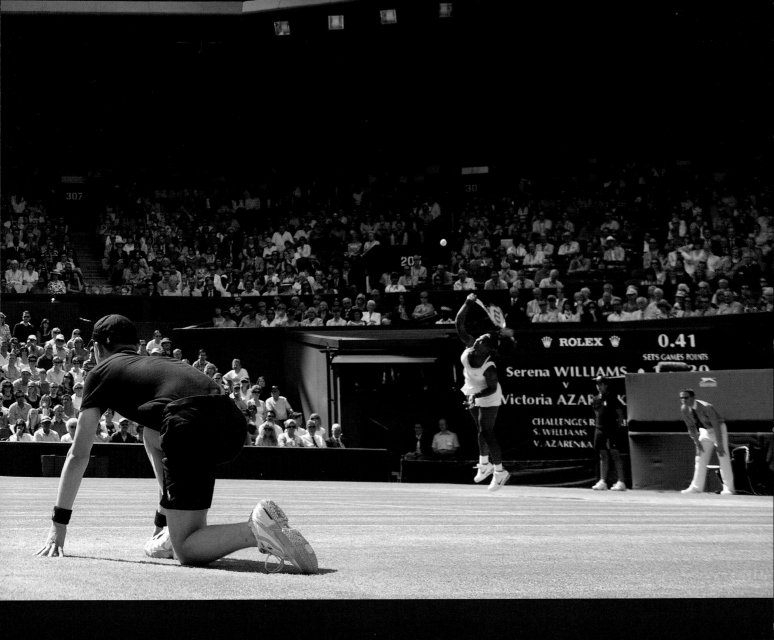

DAY TEN
THURSDAY 5 JULY

Sam Sumyk, Victoria Azarenka's coach, sidled up to my desk in the press room late into the evening armed with the statistics from the semi-final in which his girl had been beaten 6-3, 7-6(6) by Serena Williams. In all honesty, he looked a little shell-shocked. What would you advise Agnieszka Radwanska to do in the final, one wondered? "Pray," he answered softly.

If the first paragraph of this day's report gives the scores away, I am sorry. The two Ladies' Singles semi-finals were both straight-set affairs, which gave the crowd an opportunity to see three British players take to Centre Court in the late afternoon as Dominic Inglot and Laura Robson were defeated in two tie-breaks by Colin Fleming and Taipei's Su-Wei Hsieh (coached by former Wimbledon Gentlemen's Doubles champion and ex-Australian Open tournament director Paul McNamee) in the third round of the Mixed Doubles. And there was still time for Serena to make a second appearance as she and her sister Venus whipped through a Ladies' Doubles match.

Such were the reservoirs of energy that Serena had in her tank that she was able to still be burning bright at twilight even though she had been the second of the Ladies' Singles semi-finals on the schedule. This was to be very much her day. But Radwanska, too, merited a decent billing. Her match against Germany's Angelique Kerber had the prospect of being a test of real resolve, for they had played each other four times previously and had a history that told of lengthy three-set matches.

The view of Centre Court from the commentary boxes

More often than not, Kerber, the No.8 seed, came off second best in the protracted rallies as Radwanska opened up the court with sharp angles generated either from the back of the court or on regular forays to the net. When Radwanska served in the second, at 5-4, for the most important victory of her career, we were in that perennial state of wondering whether her nerve (rather than her serve) would hold.

The Pole hit what she believed to be an ace on match point, and Kerber challenged. Radwanska was already walking towards the other side of the court, but Hawk-Eye deemed the ball out and she was forced to walk back and play a second serve. She promptly lost the point to a blistering return, but she was steadiness personified thereafter.

The 23-year-old, who won the Girl's title in 2005, thus became the first Polish player to reach a Grand Slam main draw singles final since 1939 when Jadwiga Jedrzejowska (the writers used to have to dictate that to copy in those days, which might have taken some time in her case) reached the last of her three Grand Slam finals at Roland Garros. And should she manage to win, Radwanska would become world No.1 for the first time and, as the first Pole to do so, she would have deserved it beyond measure.

Kerber, beaten 6-3, 6-4, had every faith that her friend could lift the trophy two days hence. "I think she has, for sure, some chances in the final," she said. "She needs to play her game. She moved well on this court today, making not many mistakes. So if she will play like today, I think she has a good chance." Only time would tell.

Agnieszka Radwanska was imperious in her agile defeat of Angelique Kerber

Caught in the eye of Hurricane Serena, Azarenka, the Australian Open champion, did rather well actually. The first set was a little like one-way traffic, but the Belarusian hung tough, and if this had been a test of character she would have passed with distinction; but this was a tennis test and Serena was rampaging. It had to be a discouraging sight.

Halfway through the second set there was a distinct momentum shift. Williams was rampaging a little less and, though she was broken, Azarenka broke back and had the chances to break again. She had the edge as the set went into a tie-break, but perhaps she didn't believe that Williams looked a little vulnerable, though it is easy to write those words from the safety of the press seats.

Remarkably, Serena won that tie-break and reached another Wimbledon final more or less standing still. She finished the match off with an ace. In fact she had finished off most things with an ace. Break point? Ace. Love-15? Ace. Ace. She hit 24 of them altogether, a record for a Ladies' Singles match at Wimbledon. Twenty-four aces, just think of it. An entire set of tennis completed with a single shot. And she did not serve

WIMBLEDON IN NUMBERS

5 Games or tie-breaks ended on a Serena Williams ace.

one double fault. This was merciless tennis. "I have the feeling that Vika played very well," Sumyk, Azarenka's coach, said. "Serena? Pfff, incredible."

Disconcertingly for Radwanska (as it would have been when Azarenka heard the quote), Williams was adamant her serve was below par. "Actually, during the match I thought I wasn't serving well," she said. "I thought, 'Gosh, I've got to get more first serves in.' I didn't think my percentage was up there," – she claimed of her 67 per cent success rate as opposed to Azarenka's 65 per cent.

Williams said she had no idea she had broken her own ace record. "It really didn't feel like I hit 24 aces at all," she said. "I honestly felt like I hit maybe 10. I wasn't going for that much. I've just got to watch the film [of the match]. I thought my serve was off and clearly it wasn't – maybe I should be off a little more."

She did offer an apt description of the serve, branding it "mean". Many of the sport's luminaries had lined up to praise the Williams rocket, with the stroke also a threat on the second delivery: speed and power were replaced with precision and slice that also had Azarenka floundering.

John McEnroe is not a man to gush, but he said of the lesson Williams gave her 22-year-old opponent: "Serena's might be the best set of serving I've seen in a women's match. It's scary how good it is. It's not only the quality, it's the power and she mixes up her spins, so because she wins so many free points it allows her to take more risks on her returns and that puts more pressure on Azarenka. I would compare it with playing Pete Sampras."

Tim Henman knew what that was like. Earlier in the day, I had caught up with him on the roof of the broadcast centre and asked him about the prospects for Andy Murray in his fourth Wimbledon semi-final, exactly the number Henman had reached. "I was flicking through the papers this morning, and it would be terrifying for Andy to sit down and read it all," he said. "I can say hand on heart that when I was in the middle of it, the only expectation was from within. I couldn't wait to be out there and playing. His attitude has been great and he has been serving well at the right time and his percentages were going up against [David] Ferrer towards the end of the match, which is pretty rare."

Clambering down from the top floor, I walked straight into Jo-Wilfried Tsonga, who was wearing a denim shirt and cut-off shorts, not exactly Wimbledon attire. "I believe in myself. I am sure I will give my best tomorrow and if he is better than me, this is sport," Jo said. And so it was.

No it's Not All White!

The All England Club is well known for its 'predominantly white clothing' rule which governs the members of the Club all year round.

A few players do their bit to get round the rules – Serena Williams's purple shorts this year, for example, or Tatiana Golovin's infamous red underwear a few years ago – and at Aorangi Park, where the players practice, the rules are more relaxed. But Victoria Azarenka was one not able to get away with it when she attempted to practice on a Championship court in a yellow t-shirt ahead of her semi-final against Serena Williams. Presented with one of the Wimbledon white polos to cover up the offending yellow, the Belarusian quickly made the change, before resuming her practice.

History Beckons

As evening drew in on Day Ten there was a tangible buzz of excitement in the air in anticipation of the semi-finals the following day. And the only thing that could overshadow a mouthwatering Wimbledon semi-final between reigning champion Novak Djokovic and six times winner and tennis legend Roger Federer was the possibility of the first British man to reach the Gentlemen's Singles final for 74 years.

Andy Murray prepared for his match with Jo-Wilfried Tsonga with a practice session and round of television interviews on Court 5, all under the watchful eye of coach Ivan Lendl, a Wimbledon legend in his own right.

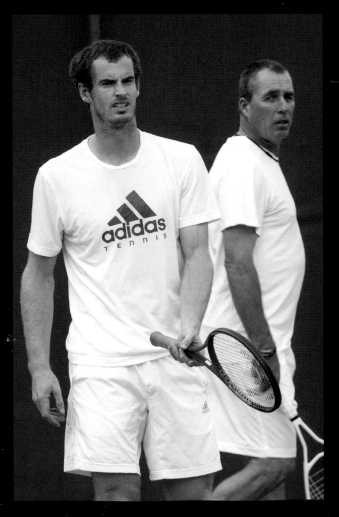

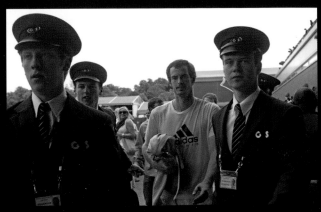

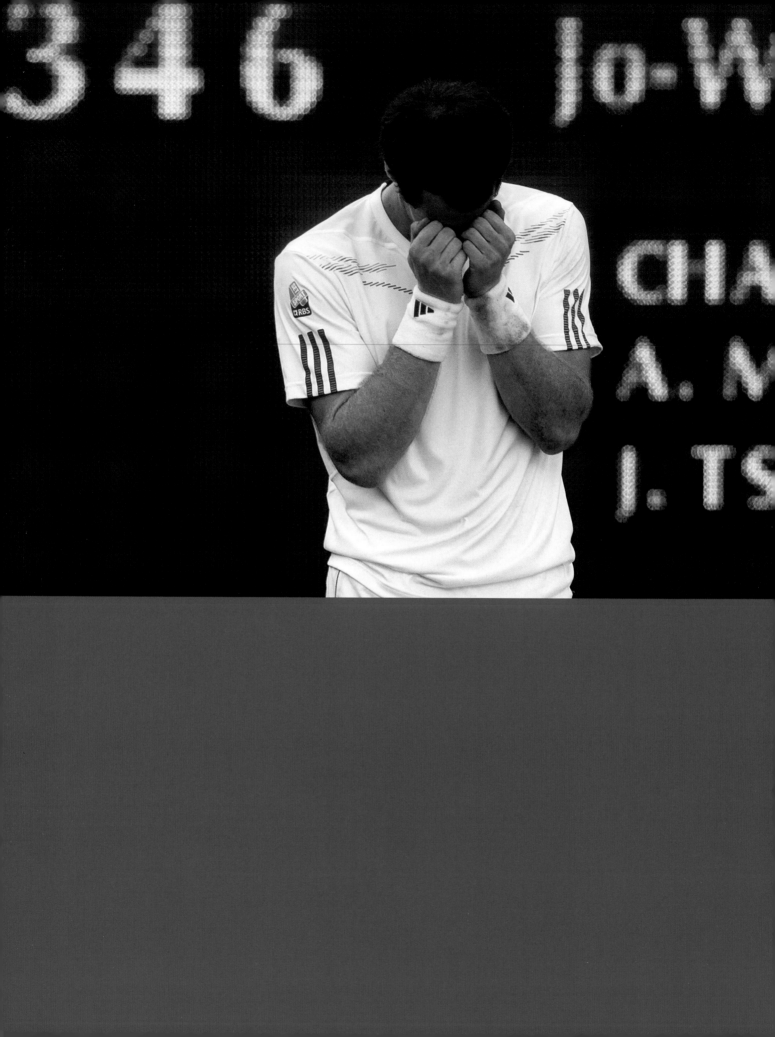

DAY ELEVEN
FRIDAY 6 JULY

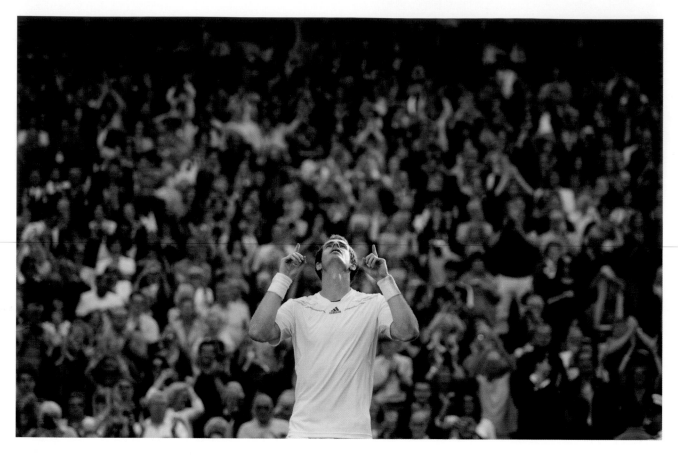

There it was, on the newsstands of the nation, "And Finally…" Front page news, the works, the splash, Euro crises overshadowed, the dreadful queues at Heathrow airport downsized, the dodgy bankers were tucked away inside (the paper that is).

Andy Murray **(above)** *looks to the skies after becoming the first British man into the Wimbledon singles final since Bunny Austin in 1938*

Novak Djokovic **(right)** *was not at his best against Roger Federer*

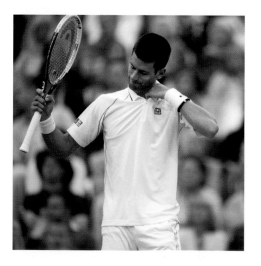

To see tennis accorded the newsworthiness it received on Saturday 7 July was quite something, a vintage moment; indeed, a moment that very few people the right side of 80 had seen, a British male reaching the Wimbledon Gentlemen's Singles final. Bunny Austin, the first man to wear shorts at The Championships, had lived long enough to be a part of the 2000 Centre Court parade and had really wanted to witness someone come along to take his pride of place. That, sadly, was not to be.

Think of 1938 for a moment. Errol Flynn played Robin Hood (I always preferred Basil Rathbone as Sir Guy of Gisborne); Len Hutton made 364 against Australia at The Oval; the first televised football match, Scotland's 1-0 win over England at Wembley, was shown on the BBC; Neville Chamberlain met Adolf Hitler; the average price of a house in the United Kingdom was £545; Superman made his first appearance in action comics.

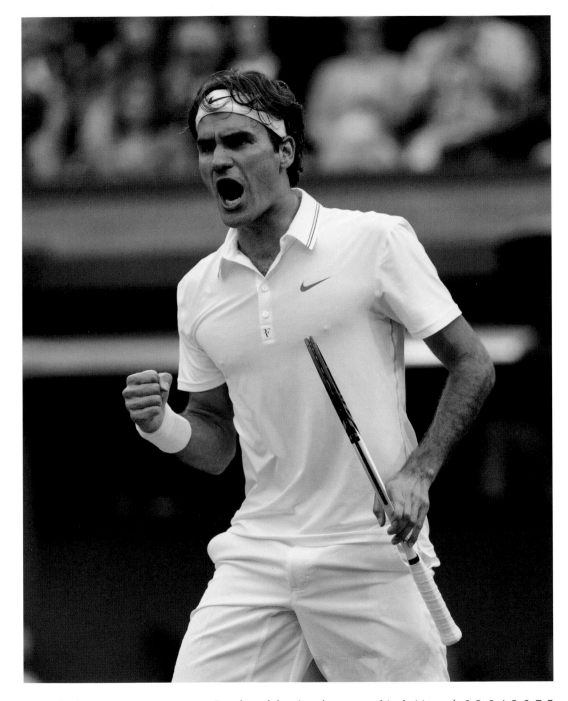

Roger Federer advanced to a record eighth Gentlemen's Singles final at Wimbledon

We had our own Superman now. But the celebration that greeted Andy Murray's 6-3, 6-4, 3-6, 7-5 victory over Jo-Wilfried Tsonga was rightly played down. "Good job, you did really well, what time do you want to practise tomorrow?" – the greeting afforded him by Ivan Lendl, his coach, was entirely the right one. They had not yet achieved what they set out to achieve.

The rest of us were getting ever so slightly giddy and you could not blame us, could you? Murray had played with implacable, imperturbable certainty against the world No.5 from France, who was playing in his second consecutive Wimbledon semi-final. He withstood the expected barrage of tracer bullets from the Tsonga forehand – some of which brushed the lines and others flew harmlessly out of court – he served almost as powerfully and with a good deal more success on the second delivery

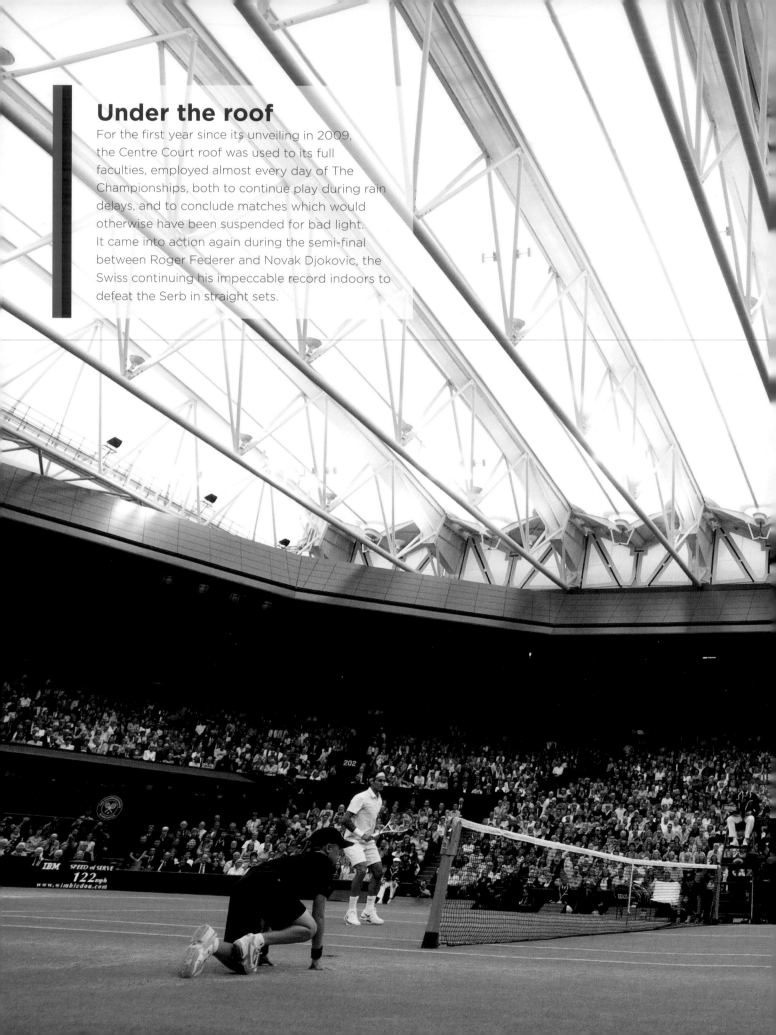

Under the roof

For the first year since its unveiling in 2009, the Centre Court roof was used to its full faculties, employed almost every day of The Championships, both to continue play during rain delays, and to conclude matches which would otherwise have been suspended for bad light. It came into action again during the semi-final between Roger Federer and Novak Djokovic, the Swiss continuing his impeccable record indoors to defeat the Serb in straight sets.

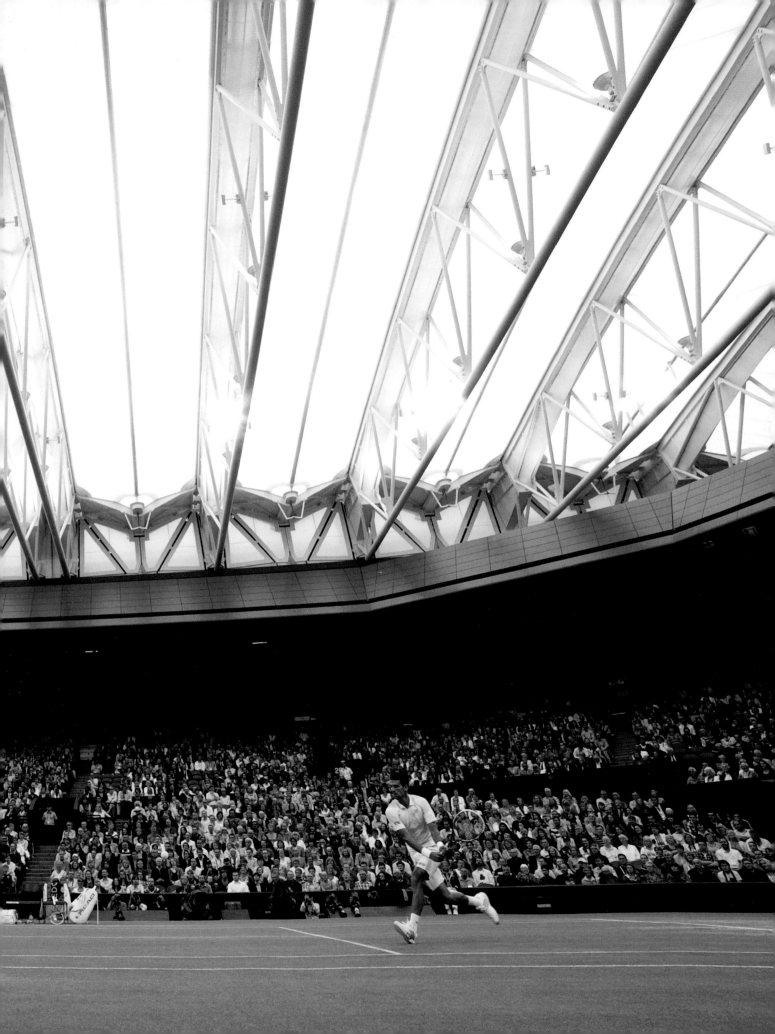

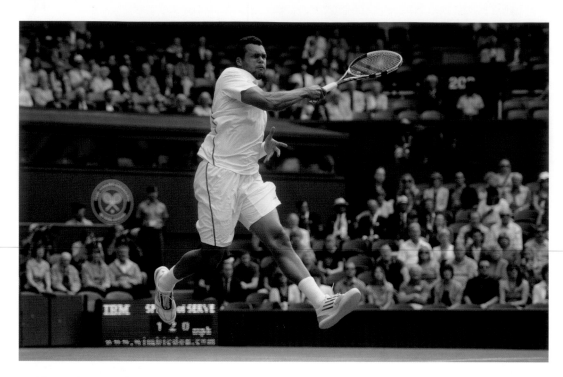

Jo-Wilfried Tsonga was at his bounding best against Andy Murray (far right), with the British No. 1 flinging himself all over the court to repel the Frenchman's attacks

and he made just a dozen unforced errors in achieving the best moment of his sporting life (hopefully, the next would come along in 48 hours).

Of course, it didn't stop here. How could it with Roger Federer in the final? Federer's task in the semi-final had been to try to put Novak Djokovic, the reigning champion, in his place, which was never an easy task. They had not met on grass before, and they played for two sets as if locked in a time warp, rallies fizzing by. It took 24 minutes for Federer to win the first set, just half an hour for Djokovic to respond and level the match. Surely it would not keep going like this?

The third set was one of those classic pieces of tennis theatre. In the sixth game, a double fault by Djokovic gave his opponent break point for 4-2 lead, but he saved that after a 24-stroke rally with a glorious backhand passing shot. There was another Federer break point and another thunderous rally, 26 strokes this time when a would-be backhand winner ballooned over the baseline. And on they went. The set lasted almost as long as the first two combined before the Swiss struck, smacking away an overhead after forcing his opponent into a despairing lob. Djokovic faded, which was so strange for a player who had become a champion of uncrushable resolve. Federer won 6-3, 3-6, 6-4, 6-3.

In Act II, with the roof drawn back to let in the meagre sun, we knew what a considerable task this was for the Scot. He played with an imperious certainty in the opening two sets, at one stage in the second set he had dropped a single point in four service games and, with a couple of his famous drilled backhand returns, had broken Tsonga's serve once more. He went to sleep a bit in the third (well we did not expect a cakewalk, did we?) but came alive again in the fourth, which was to be one of the sets of The Championships.

Murray broke in the fourth game, enticing Tsonga to take on a rather risky backhand volley, risk-taking being his mien. Now a steady service game was required and yet, as the court darkened as the sun dived behind the clouds, Tsonga produced his finest backhand winner to bring up a break chance. The Brit aced him. But on the next break point, a forehand return was just too belligerent and Murray scuffed a backhand response.

At 4-4, Murray gathered his senses. He got to break point but stumbled when trying to reach a drop shot. Then Tsonga tried another, Murray got there, threw up a lob, Tsonga

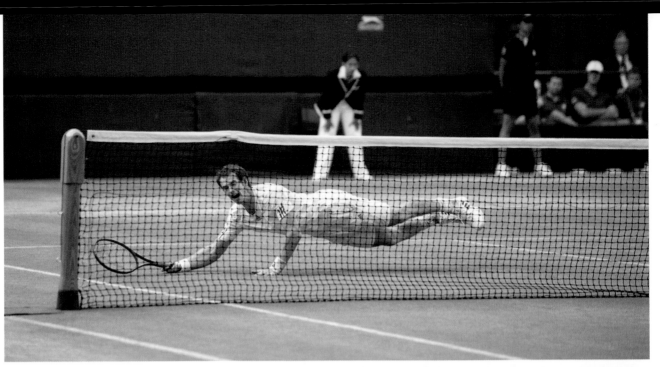

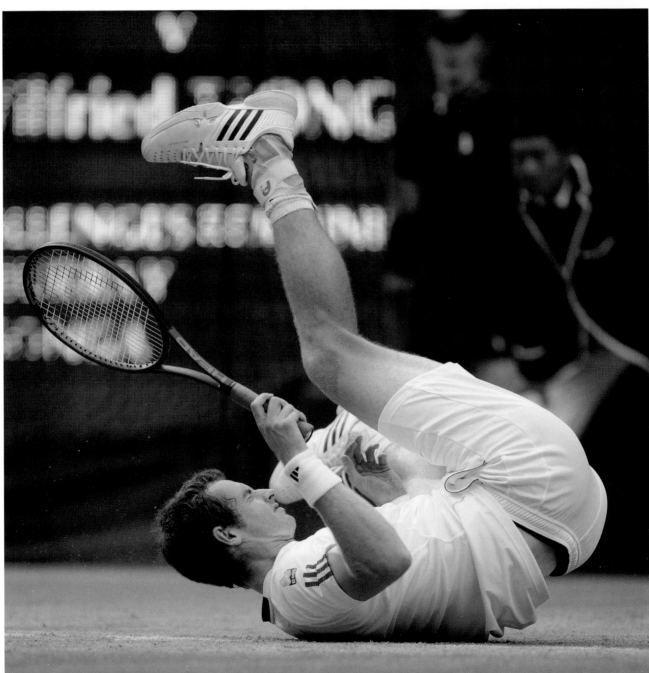

reached it, drilled a shot, Murray dived but the ball landed wide. Then at 5-5 Murray was 15-40 down and staring a fifth set in the face. But on the second break point, a second serve of flimsy length, Tsonga sent a forehand crashing over the baseline and the game was saved.

At 6-5 with Tsonga to serve, most had settled back for a tie-break, but Murray was not in the mood. A forehand winner and he had his opponent at love-30. Tsonga smacked an overhead away, then came in for a suicidal volley and netted. 15-40. On match point Murray saw his forehand return throw up a puff of chalk, and fell to his haunches. Umpire Carlos Ramos said the ball had been called out. Murray challenged. Tsonga knew in his heart that the ball was good. And so it was.

"I'm not the most talented on the tour," Tsonga, the world No.5, said to general incredulity, "but I like to go to the war. I enjoy every time on court." He reckoned Murray might be tired after the workout he gave him. Murray disagreed. While he sounded as if he were in that mythical "good place", relief invaded Murray's every utterance. "It wasn't that tough physically," he reckoned. "It was more mental."

In the *Daily Mail* Martin Samuel paid a glowing and proper tribute to Murray. "Capering around like a buffoon, wise-cracking, bouncing up and down like an excited schoolgirl is not part of the deal," he wrote. "The journey has taken much too long and has taken too much out of him to worry about striking poses.

(Top) *The Murray entourage supports their man*

(Above) *Jo-Wilfried Tsonga was extremely sporting in defeat*

"Just watch the man play and remember where this started. It is not part of nature's deal, Dunblane to SW19. This is against all conception of how it should be done. Credit where it is due. This is the Wimbledon's Gentlemen's final we are talking about on Sunday and somebody from nowhere's here."

I contacted Rafael Nadal — who had beaten Murray in the last two Wimbledon semi-finals and who was on holiday, sunning himself in Sardinia. The line was crackly, but he was happy to chat for a while. I told him the result. "I knew that Andy's chance to reach a final would come again and that, if he had it, he would take it. Now he has to go up against the best of the history. I know what it is like to play Roger on the last day. It is going to be a special afternoon."

David Cameron, the Prime Minister, said he was going to fly the Saltire next to the Union Jack Flag over No.10 Downing Street. Oh, heady days.

WIMBLEDON IN NUMBERS

8
Wimbledon finals for Roger Federer. A record.

First Murray, and now Marray!

They're a bit like London buses British Wimbledon finalists... you wait for ages then two come along at once.

While the nation was cheering Andy Murray on to victory against Jo-Wilfried Tsonga, another British tennis player with a very similar name was slipping quietly under the radar and creating a little bit of history himself. With his partner Freddie Nielsen, the wild card pairing who had only played a handful of tournaments together found themselves in the final of the Gentlemen's Doubles after a sensational victory against the hot favourites and 11-time Grand Slam-winning Bryan brothers.

The remarkable achievement made Marray the first Briton to reach the Gentlemen's Doubles final for 52 years. To say this was something of a surprise is the understatement of The Championships, not least to Marray himself who only had one playing shirt for the whole tournament and had to have it washed after every game.

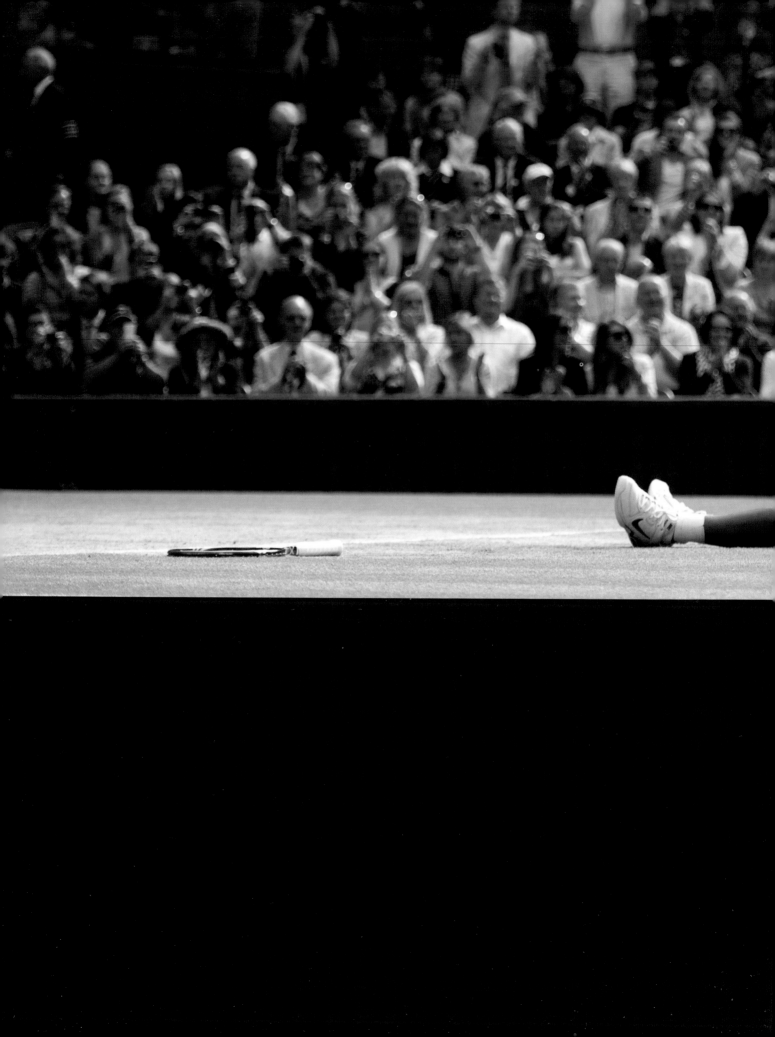

DAY TWELVE

SATURDAY 7 JULY

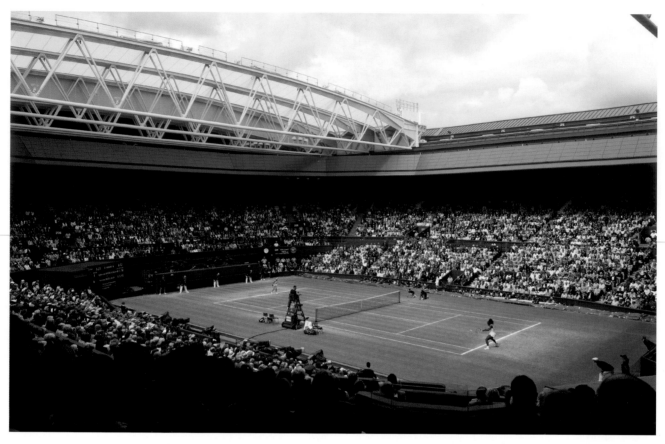

So we had our first British champion for 76 years – light the bonfires, let the fanfares begin... hold on, wait a minute, that was supposed to be tomorrow's story wasn't it?

(Above) In a break from the wet weather, the Ladies' Singles final began with the Centre Court roof open

Agnieszka Radwanska (inset), suffering from a throat infection, was blown away in the first set

At 2pm, it was the Ladies' Singles final, Serena Williams against Agnieszka Radwanska, the girl from Poland who had not been able to speak to the press the day before the match because of a throat infection that, we hoped, would not impinge upon her chances of giving us a splendid climax to The Championships.

Williams had reached her seventh final on the lawns because she was perhaps the most driven player ever to have donned the whites; Radwanska was here by dint of a game that was based on technical efficiency, an increasingly nerveless assurance on the court and an array of strokes that placed her among the finest of point constructors in the sport.

In the *New York Times*, Ben Shpigel prefaced the meeting thus: "This year's women's finalists at Wimbledon play tennis much the same way that Led Zeppelin and Bach made music. Just because Williams prefers to bludgeon her opponents with a mighty serve, that does not make Radwanska's craftiness and consistency any less effective – or, indeed, less appealing. Each style is beautiful to watch, a splendour to behold, an outpouring of superior talent and skill."

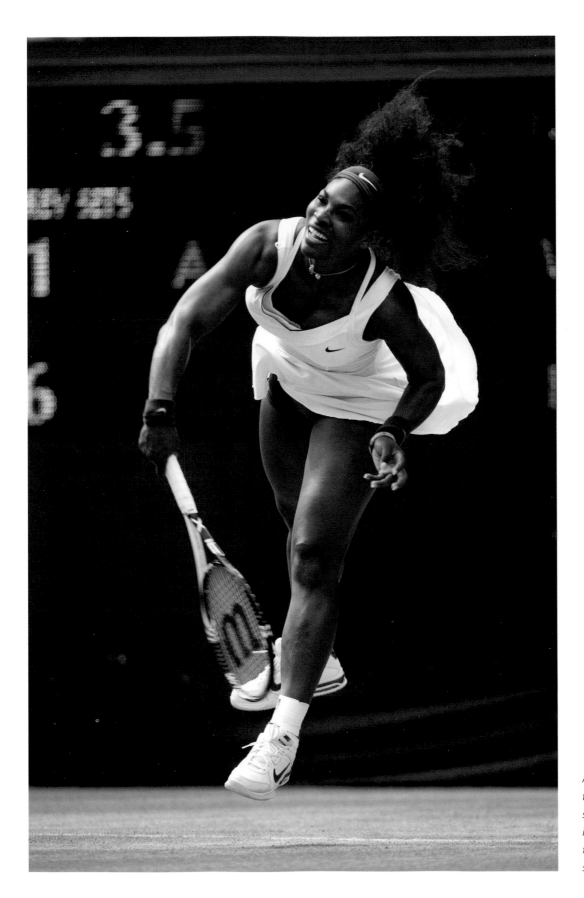

At one point during
the final, Serena
served four aces
in a row, within
the space of 48
seconds

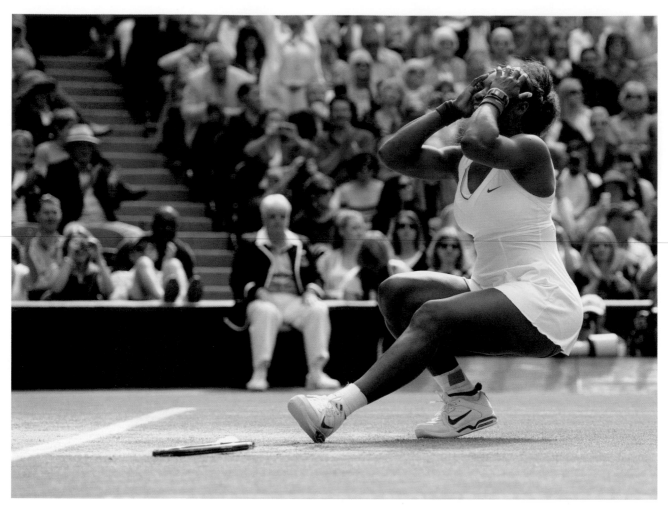

Serena Williams is overcome with emotion at the moment of victory

"We're not looking for power," Radwanska's coach, Tomasz Wiktorowski, said. "I need to use what I have. Aggy is not as big as Vika [Azarenka], Maria [Sharapova], Serena and all those girls. She can't produce as much power as other girls, so we need to find another solution. And that's our idea for tennis."

Williams is only an inch taller than her opponent at 5' 9" but a lot more muscular. The sound the ball makes when it strikes the strings of Williams's racket is almost as loud as Azarenka's grunts, and her serve, at the age of 30, remains as intimidating as it had been in 1999, when she won the first of 13 Grand Slam singles titles. Radwanska had handled fast serves so far this tournament: Camila Giorgi, in the fourth round, touched 114mph and her first-round opponent, Magdalena Rybarikova, hit a 113mph ace.

On the evidence of the first period of the final, Led Zeppelin had it over Bach, for it was a bit of an embarrassment, a one-sided stroll, and the patrons wriggled uncomfortably in their chairs, as Williams stormed into a 5-0 lead and Radwanska appeared helpless in the face of the onslaught. This was not to be another Graf-Zvereva (1988 French Open) 6-0, 6-0 final humbling, was it?

When the Pole squeaked a game but lost the set, it was time for a break, as another in the conveyer belt of showers lining up in the south of England struck SW19. Upon the resumption 25 minutes later, the atmosphere had changed and, spurred by a crowd wanting value for its ticket prices, Radwanska began to trade meaningful shots and, from 4-2 down, fought back to level as there were signs of creakiness in the Williams game. As has happened before in The Championships, she

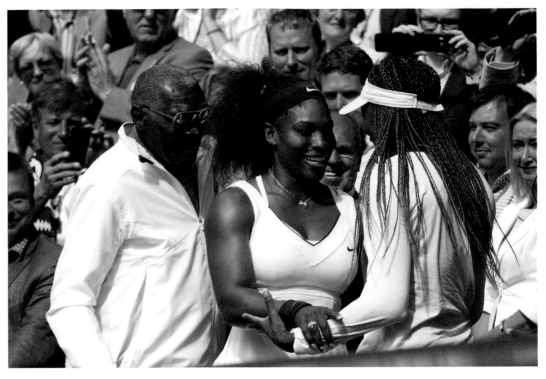

Following in the footsteps of Pat Cash and Rafael Nadal, Williams made her way through the crowd to share the moment with he father and sister, Venus

had a bit of a wobble. To the delight (and amazement) of Centre Court, Radwanska broke serve once more and pocketed the second set. Not only that, she led the final set 2-1. It was here that Williams (metaphorically speaking) hitched up her skirt and thumped down four consecutives aces, to reach 100 for the tournament and serve notice that she did not intend to hesitate a moment longer. A late final surge of five consecutive games brought her a fifth title, becoming the oldest champion since Martina Navratilova 22 years earlier.

"People were thinking, 'Can she do it again?'" Williams said as victory began to sink in. "But now I'm winning titles. I don't hear what people say and quite frankly I don't really care. Everyone's allowed to think what they want, to say what they want. Ultimately, I'm the one out there and I make my own destiny. I've never felt better, I feel really awesome and amazing. Obviously, I would love to be No.1, but if I had to choose now between Grand Slams and rankings, I would choose Grand Slams. I've been No.1, but Grand Slams add up."

Having seen a Ladies' final more competitive than had seemed likely from the outset, the crowd settled back for the first of two novelties in consecutive days, a British man in a final. Jonny Marray, Liverpool-born and Sheffield-raised, had teamed up with Frederick Nielsen of Denmark (grandson of the 1955 singles finalist, Kurt) in Nottingham and they were granted a wild card into The Championships. Twice in the event they had rallied to win in five sets and also beat the American Bryan Brothers, Mike and Bob, the No.2 seeds, in the semi-finals. They may have been persuaded as to the power of destiny.

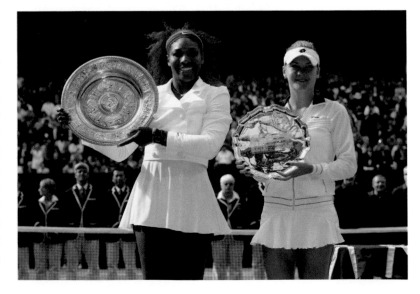

Five alive!

With her three-set win over Agnieszka Radwanska, Serena Williams claimed her fifth Ladies' Singles title at The Championships, equalling her sister Venus, and winning her 14th major singles title in total. Jumping into the air as she clutched the Venus Rosewater Dish for the fifth time, the American could hardly contain her delight. "It's been an unbelievable journey for me," she said. Later in the afternoon, she returned to Centre Court alongside Venus to triumph in the Ladies' Doubles for the fifth time.

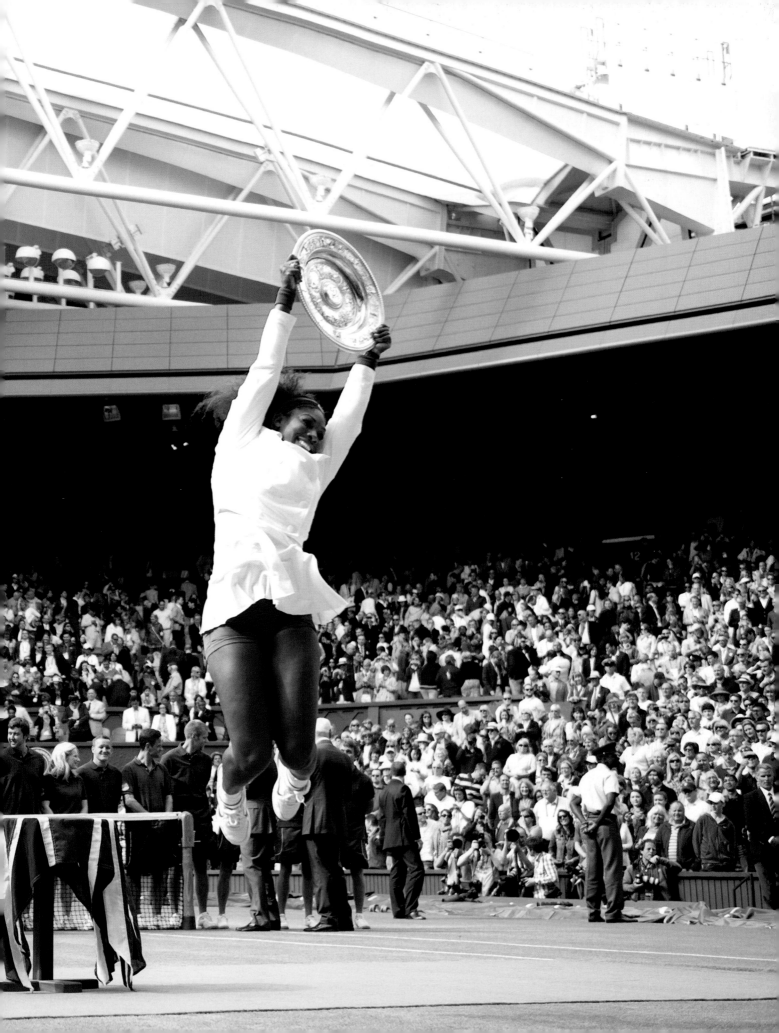

(Right) *Nielsen and Marray celebrate their amazing triumph*

(Below, left to right) *The moment of victory*

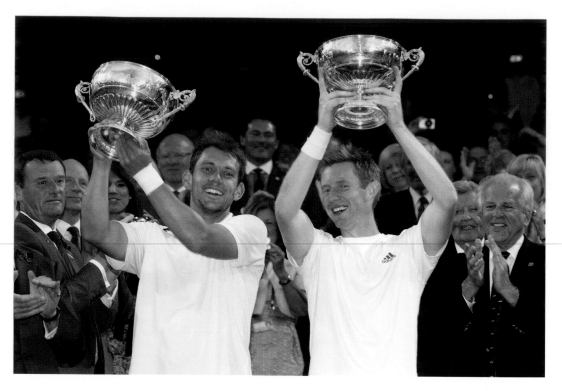

Their opponents, Robert Lindstedt of Sweden and Romania's Horia Tecau, were twice losing finalists at Wimbledon, and after the opening set their anger at such a record was evident. But Marray and Nielsen were instinctive and exuberant, the British player famed for his serve and volleying disposition which sparked against the rock of the Dane's fortitude.

The non-seeded pair brought the final level, and the third set entered a tie-break, which they led 5-0. Then came one of those moments when you rub your eyes and wonder if what you had seen really happened. In his follow-through to a backhand volley, Marray skimmed the top of the net with his racket. Lindstedt and Tecau did not see it, and neither did Eva Asderaki, the umpire who was following the path of the ball. Marray owned up, donated the point, the opposition was roused and almost pegged the lead right back before Marray came up with a thunderous serve on set point.

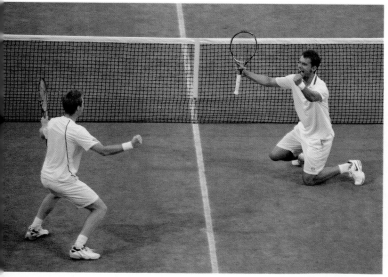

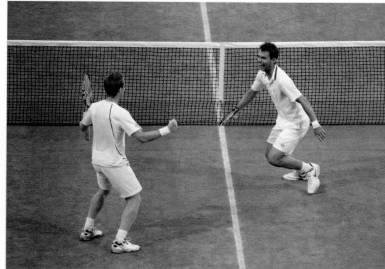

The Brit-Dane pair, with a 5-3 lead, ought to have sewn up the fourth set tie-break, but Marray missed a couple of difficult volleys and the final was back to all-square. "We told each other to stay calm and dig deep," Nielsen said, and so they did, opening up a 3-0 lead in the fifth which gave the 31-year-old Marray the base to serve for glory, which he did to a staggering reception of a 4-6, 6-4, 7-6(5), 6-7(5), 6-3 victory. Pat Hughes and Raymond Tuckey had been the last British doubles champions in the year that Fred Perry last won the singles for the home nation. Marray won it in the same kit he had worn, re-washing it himself, every day of the event, and he woke up the next day with a lovely shiny, silver pot at the bottom of his bed and realised he had not dreamt the whole thing.

There was still time for more tennis, as Serena teamed up with Venus, her sister, to become Ladies' Doubles champions for an historic fifth time, defeating the Czech Republic pair Andrea Hlavackova and Lucie Hradecka 7-5, 6-4. "I couldn't have done it without her," Venus said. "She absolutely inspires me." Serena replied "If I let myself down in the singles, that's okay, but there's no way I want to let Venus down in the doubles. We believe in each other so much, we stay relaxed."

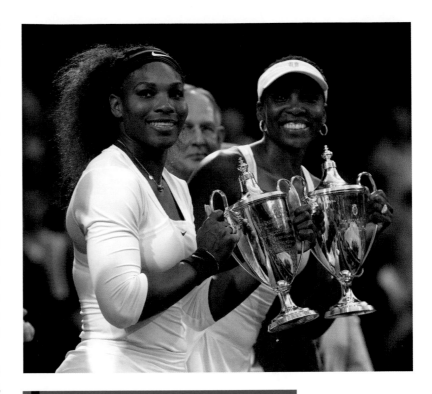

WIMBLEDON IN NUMBERS

102 Aces Serena Williams fired down during The Championships – more than any other player in the fortnight.

Serena made it two Wimbledon titles in one day when she returned to Centre Court with sister Venus in the Ladies' Doubles final

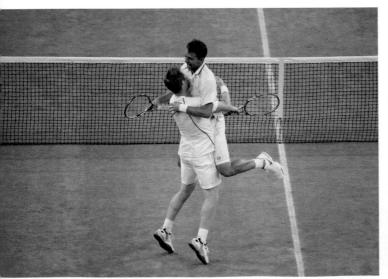

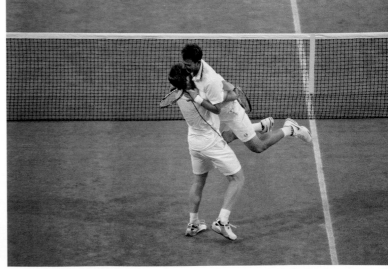

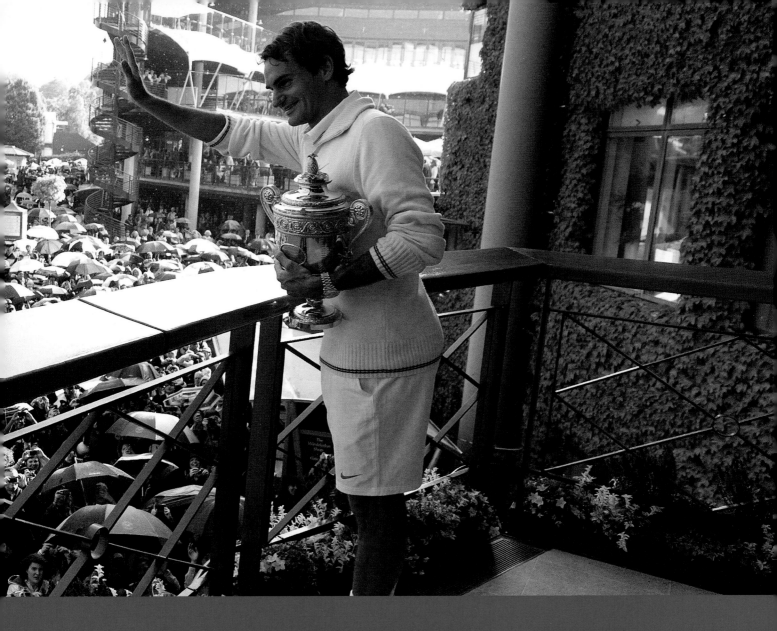

DAY THIRTEEN
SUNDAY 8 JULY

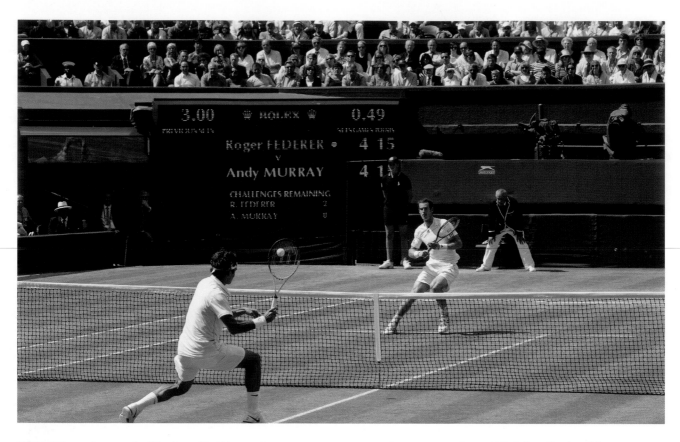

The alarm shrilled at 5.45am. An appearance on *Sportsweek* on BBC Radio had become a norm on the final day of The Championships, but this time, rather than discuss where it had all gone wrong for Andy Murray, we were debating where it all might go right. Not in our lives had there been a morning like it.

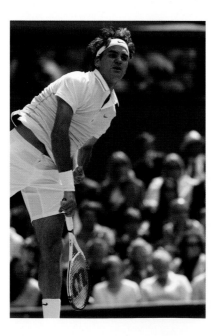

(Above) *The historic final between Roger Federer and Andy Murray began in the sunshine on Centre Court*

One newspaper said the country was praying for its No.1 tennis player and there were those who had said a quiet word, not so much against the six-time champion Roger Federer, but in the hope that our boy would do himself justice, would play to his potential, because if that was the case he certainly had a chance.

On the programme, Mark Petchey, Murray's former coach, was decidedly chipper, as was Tim Henman who was in the fascinating position of being very close friends with Federer's coach Paul Annacone but aching for a British win. Roger Draper, the Chief Executive of the Lawn Tennis Association, was eager to inform how well the sport in Britain was placed to cope, should what we were speaking about actually occur.

It was not the nicest day, in fact it was pouring with rain and the evidence suggested that, even if the match might start without a roof, it would likely have to finish with it closed once again. The forecast was spot on.

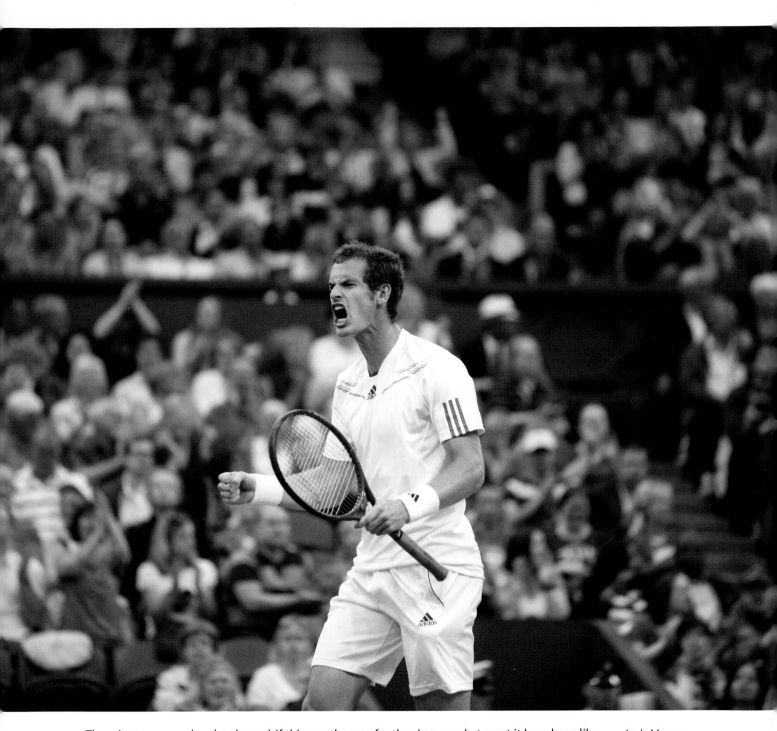

The minutes seemed to drag by and, if this was the case for the viewers, what must it have been like for the two players, especially Murray, who had not woken up in his own bed as a Grand Slam finalist before? Finally, we reached the appointed hour and the two men emerged to a welcome startling in its intensity; it was as if they had been accorded a standing ovation before the performance rather than at its end.

There was another three minutes into the match when, incredibly, Murray broke serve in the opening game; Federer's forehand missing by feet rather than inches. Steady now, people. After 15 minutes, we were back at 2-2. Then, in the ninth game, a backhand service return that smacked the

Andy Murray recorded his first set in a Grand Slam singles final when he won the opening set

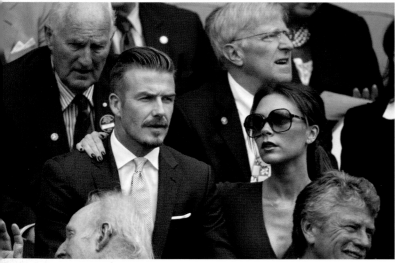

Murraymania

As Murraymania swept the nation, more than 4,000 hardy souls braved torrential showers to claim a coveted viewing spot on Murray Mound, and inside Centre Court the Royal Box was packed with the great and the good of British politics, sport and society. No matter what the vantage point, the overriding sentiment was "Come on Andy!"

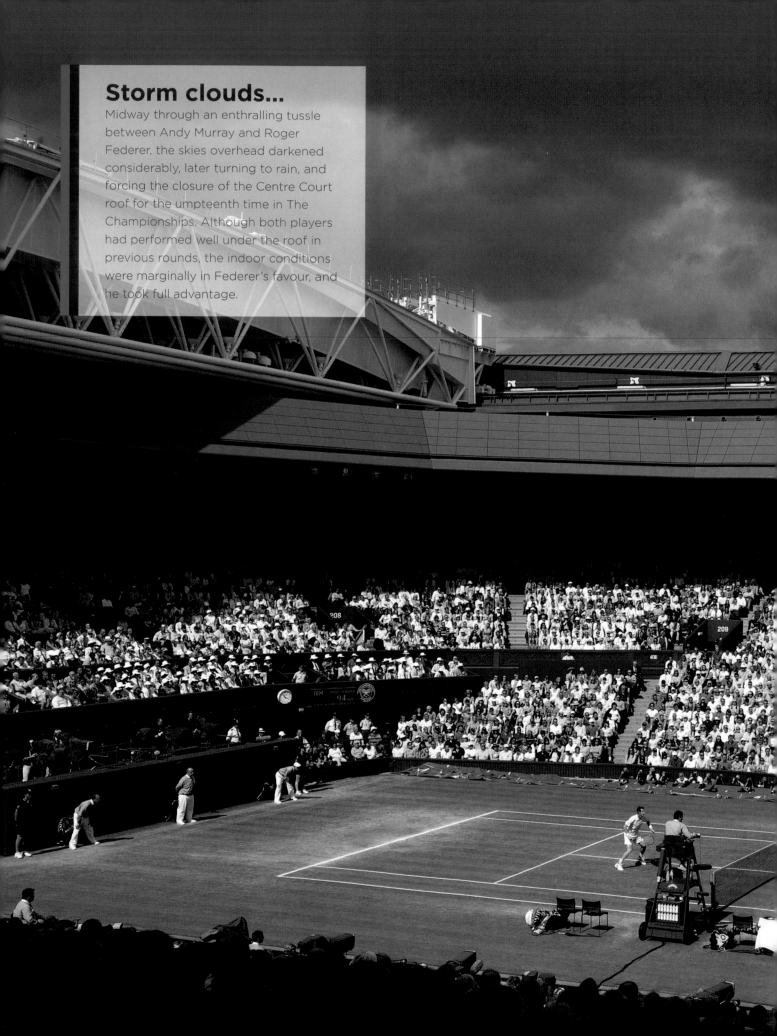

Storm clouds...

Midway through an enthralling tussle between Andy Murray and Roger Federer, the skies overhead darkened considerably, later turning to rain, and forcing the closure of the Centre Court roof for the umpteenth time in The Championships. Although both players had performed well under the roof in previous rounds, the indoor conditions were marginally in Federer's favour, and he took full advantage.

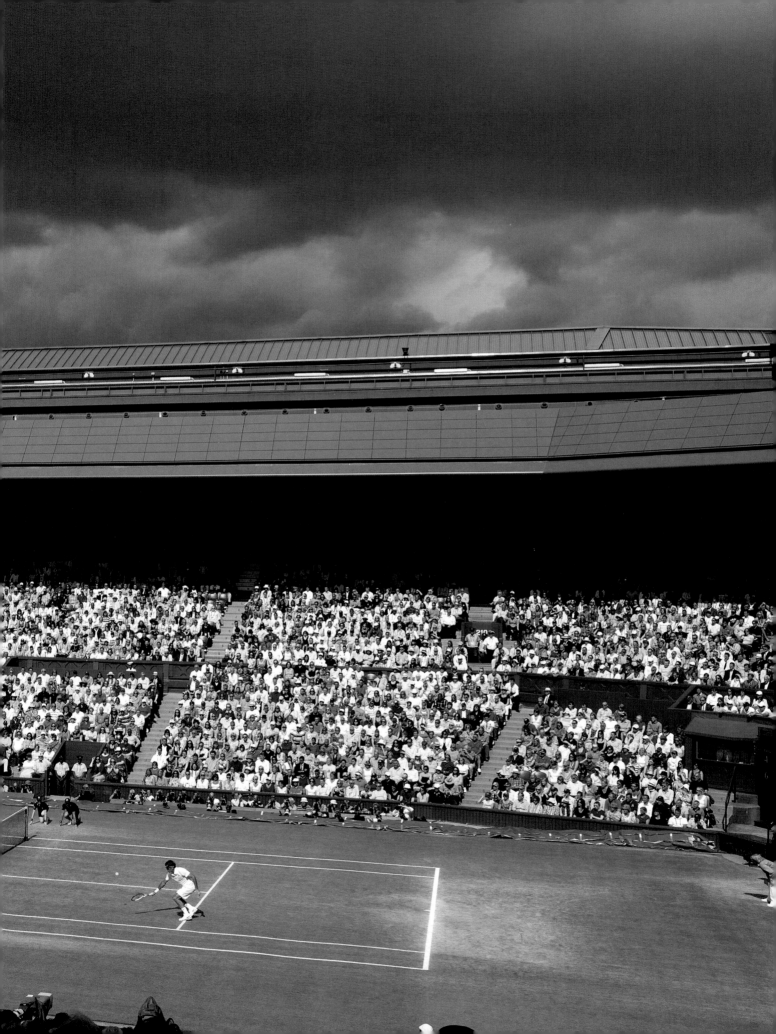

Roger Federer celebrates a record-equalling seventh Gentlemen's Singles title at Wimbledon

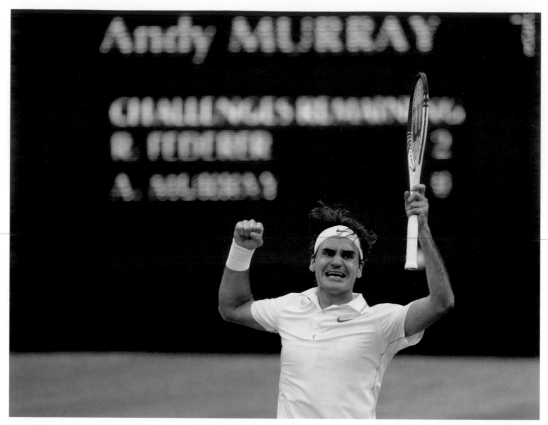

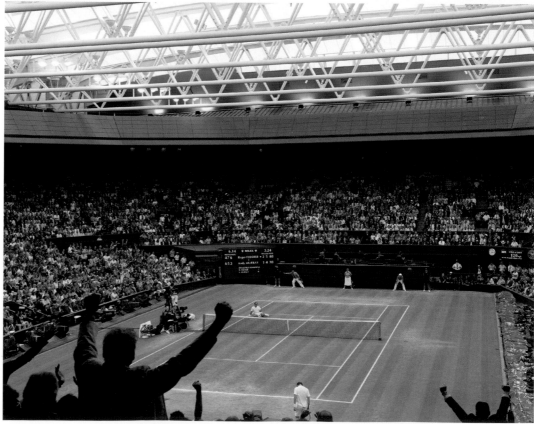

line brought another break point and, this time, Federer netted a forehand. His game was definitely awry. Murray completed the set with a service winner.

In the second set, Murray had four break points (taking none), Federer had two (taking one). If the outcome could have hinged on anything, the British No.1 may well look back to 4-4, 30-40 on the Swiss serve when he had a double-handed backhand to play and enough space to plant a winner. He misjudged it and you had a feeling in the pit of your stomach about what would happen next. Federer did not disappoint, though Murray should have been 40-15 ahead in the 12th game and at least taken us to a tie-break, but he missed a forehand by a country mile and Federer pounced, taking the set with a prodigious backhand stop volley.

At 1-1, 40-0 on Federer's serve in the third set, the skies darkened and the predicted rains arrived. It was time to close the roof once again, and we mused about whether this gave one or the other an advantage. Federer's indoor record is predictably superb (27-1 since 2010) and the moisture that remained in the surface prompted Murray to struggle with his footing.

If there was a single pivot to the contest that stood out above the others, it arrived in the sixth game of the third set with Federer hitting the ball as cleanly and powerfully as he had done the whole

The disappointment for Andy Murray was there for all to see as Roger Federer savoured his moment of victory

tournament. Murray raced to 40-0 but crashed heavily going for a drop shot at 40-30 and, grabbing his first deuce point, Federer made him suffer for the next quarter of an hour with power, placement and intelligence. Murray saved five break points but could not hold on forever, and his final backhand slice in defence, after being dragged across the baseline, fell limply into the net.

A single break in the fourth set would be the critical moment for Federer, arriving in the fifth game, set up by a couple of anxious Murray errors and completed with a backhand crosscourt winner so stunning it reminded one of his half-volley from the baseline when he was the first of four points from going two sets to love down to Andy Roddick in the 2009 final. Though the crowd's chants of "Andy, Andy, Andy" as the final drifted from his grasp were staunch and quite remarkable, they could not lift their man again.

Federer took the final 4-6, 7-5, 6-3, 6-4. The Scot could not have tried any harder, the Swiss can rarely have played better, especially near the end. Suspicions that Federer, without a major title since beating Murray in the final in Melbourne two and a half years earlier, would not rule his sport again were dismissed on his gilded racket in an exhibition of

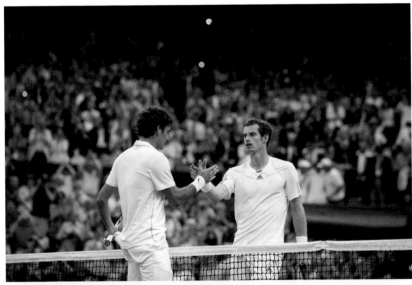

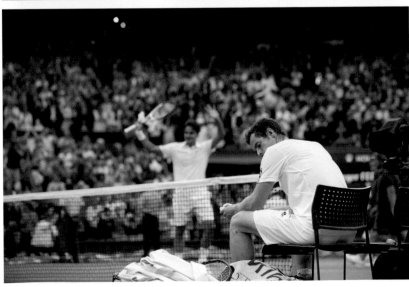

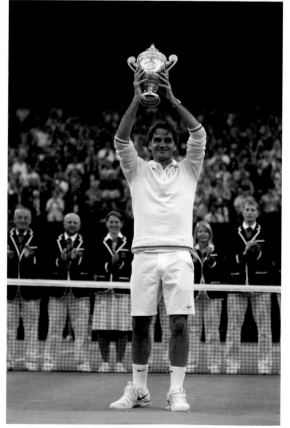

(Above) *Andy Murray struggled to hold back the tears as the BBC attempted a live interview just after the match ended*

(Right) *Roger Federer lifts the famous trophy for the seventh time*

breathtaking, irresistible tennis, certainly indoors, a place where he regards himself as near unbeatable.

Kevin Mitchell in *The Guardian* wrote: "Anyone who cannot spare a drop of sympathy for Murray in defeat either does not recognise genius or should be earning a living in a merchant bank. And anyone who can make his mother cry with a consolation speech of the quality he delivered to a transfixed Centre Court after three hours and 24 minutes of such spirit-draining effort is, as he described himself recently 'a pretty nice person'."

There was no real consolation in moments like these. The enormity of what had just passed did not take long to sink in and the feeling was not good. Summoned from his chair to the announcement as "the runner-up" was one thing, but then to have to say something to the populace, to both stars, Royals, those who love you and those who didn't think they cared that much but suddenly did, had to be very tough indeed.

Seventh Heaven

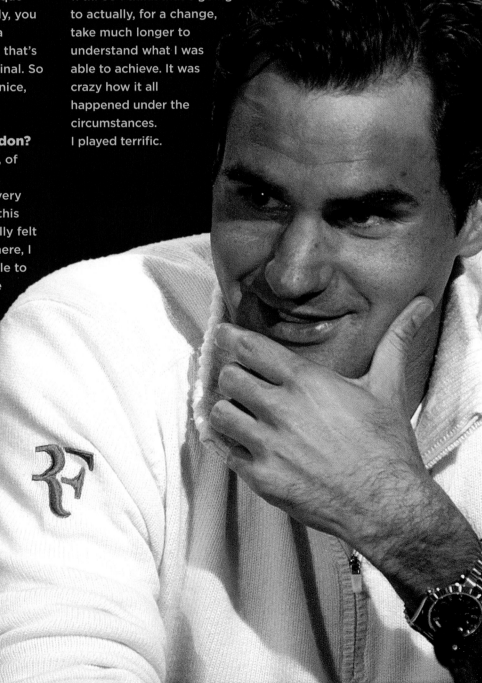

How different does this victory feel because of the circumstances? It was very unusual today...

I think any Grand Slam final, particularly here at Wimbledon, is unusual. You never quite get used to it. Today was unique because of playing Andy. Obviously, you know, being able to play or finish a match under the roof, I don't think that's ever been done before here for a final. So that's been different, as well. And nice, of course.

Do you feel destiny at Wimbledon?

I guess to some degree. You know, of course, I feel better here for some reason. I don't know why. But it's very unique and special in many ways, this tournament. From the get go I really felt sort of I'm supposed to play well here, I guess. Over the years I've been able to keep up a great run. Obviously the last couple of years have been maybe slightly disappointing, but, again, I thought Berdych and Jo both played unbelievable the last couple of years against me. This year I decided in the bigger matches to take it more to my opponent instead of waiting a bit more for the mistakes. This is I guess how you want to win Wimbledon, by going after your shots, believing you can do it, and that's what I was able to do. It's special.

How do you rate this win among all your Grand Slams?

There was so much on the line, so I didn't try to think of the world No.1 ranking or the seventh or the 17th. So I think that's going to actually, for a change, take much longer to understand what I was able to achieve. It was crazy how it all happened under the circumstances. I played terrific.

"I'm getting closer," Murray croaked and by virtue of saying those words, he had to draw inside himself, take a deep breath and pause. He blew out his cheeks. As if facing a Federer forehand (which steadily improved as the final went along) was not hard enough. Murray congratulated the victor, thanked his team (though he said that, if he turned to look at them, the tears would start all over again) and paid tribute to the fans, inside the stadium and those drenched on the hill, for their support.

The Sun's Steve Howard may have been dabbing his eyes with a handkerchief. "There wasn't a dry eye in the house," he wrote. "Andy Murray was in tears, his mum was in tears and his girlfriend was in tears. And most of Centre Court along with them. It was like a waterfall out there. And to think they had closed the roof to keep the rain out."

Federer's tribute back to the challenger was that he recognised Murray had it in him to win a major, although you could be sure he would not want to be on the other side of the net if or when he did. The Swiss remains a consummate artiste and a grand fighter. This was a two-man event, after all, and he deserves the highest praise for his own distinctive performance.

Oh and once they had dried the court surface from all the tears, there was time for a Mixed Doubles final, which turned out to be quite a *tour de force* of its own as the second-seeded Mike Bryan and Lisa Raymond from the United States defeated Leander Paes of India and Russia's Elena Vesnina 6-3, 5-7, 6-4.

WIMBLEDON IN NUMBERS

20 Days between The Championships and the Olympic tennis.

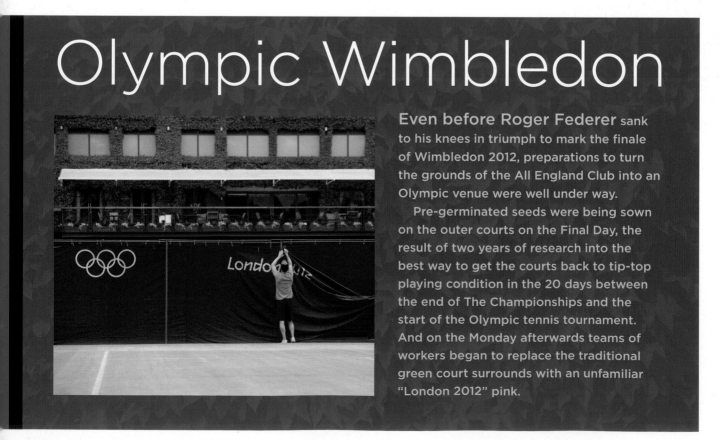

Olympic Wimbledon

Even before Roger Federer sank to his knees in triumph to mark the finale of Wimbledon 2012, preparations to turn the grounds of the All England Club into an Olympic venue were well under way.

Pre-germinated seeds were being sown on the outer courts on the Final Day, the result of two years of research into the best way to get the courts back to tip-top playing condition in the 20 days between the end of The Championships and the start of the Olympic tennis tournament. And on the Monday afterwards teams of workers began to replace the traditional green court surrounds with an unfamiliar "London 2012" pink.

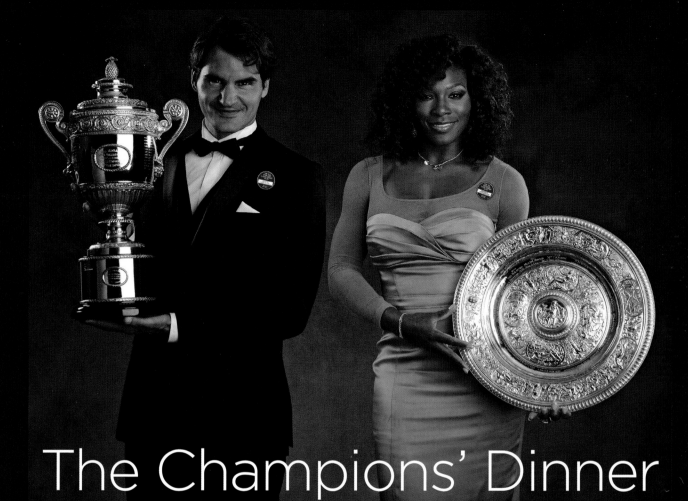

The Champions' Dinner

When the last ball has been struck, the last happy spectator ejected, and the last interview conducted, the champions at Wimbledon have the honour, alongside a series of invited guests, of attending the Champions' Dinner, this year held at the InterContinental Park Lane Hotel.

It is a chance for celebration and reflection on the Wimbledon Fortnight, for players to don their finest threads, and for the Gentlemen's, Ladies' and Junior champions to pose with their assorted trophies.

While Serena Williams, dressed head to toe in gold, joked about the cost of selling her first serve, Roger Federer, in black tie, took time for conversation with AELTC Chairman Philip Brook.

Wild card doubles champions Jonathan Marray and Frederik Nielsen had also dressed up for the occasion, taking the time for a photo with the singles trophies.

Wimbledon 2012

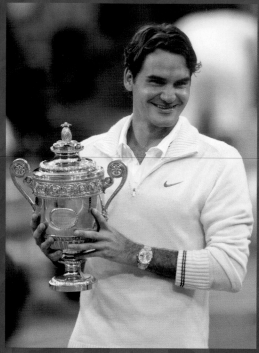

Roger Federer
The Gentlemen's Singles

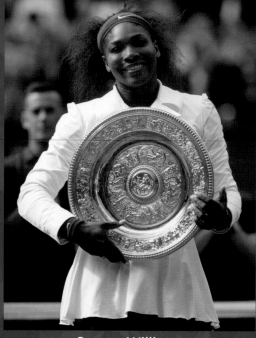

Serena Williams
The Ladies' Singles

Jonathan Marray & Frederik Nielsen
The Gentlemen's Doubles

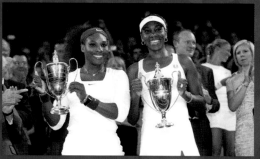

Serena Williams & Venus Williams
The Ladies' Doubles

Mike Bryan & Lisa Raymond
The Mixed Doubles

Greg Rusedski & Fabrice Santoro
The Gentlemen's Invitation Doubles

The Champions

Filip Peliwo
The Boys' Singles

Eugenie Bouchard
The Girls' Singles

Andrew Harris & Nick Kyrgios
The Boys' Doubles

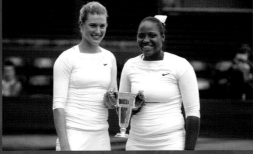

Eugenie Bouchard & Taylor Townsend
The Girls' Doubles

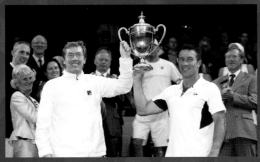

Pat Cash & Mark Woodforde
The Gentlemen's Senior Invitational Doubles

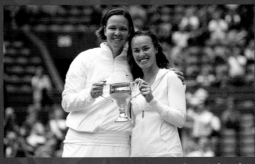

Lindsay Davenport & Martina Hingis
The Ladies' Invitation Doubles

Tom Egberink & Michael Jeremiasz
The Gentlemen's Wheelchair Doubles

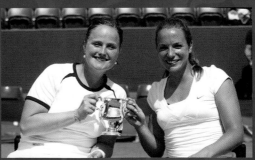

Jiske Griffioen & Aniek Van Koot
The Ladies' Wheelchair Doubles

EVENT I – THE GENTLEMEN'S SINGLES CHAMPIONSHIP 2012
Holder: NOVAK DJOKOVIC

The Champion will become the holder, for the year only, of the CHALLENGE CUP presented by The All England Lawn Tennis and Croquet Club in 1887. The Champion will receive a silver three-quarter size replica of the Challenge Cup. A Silver Salver will be presented to the Runner-up and a Bronze Medal to each defeated semi-finalist. The matches will be the best of five sets.

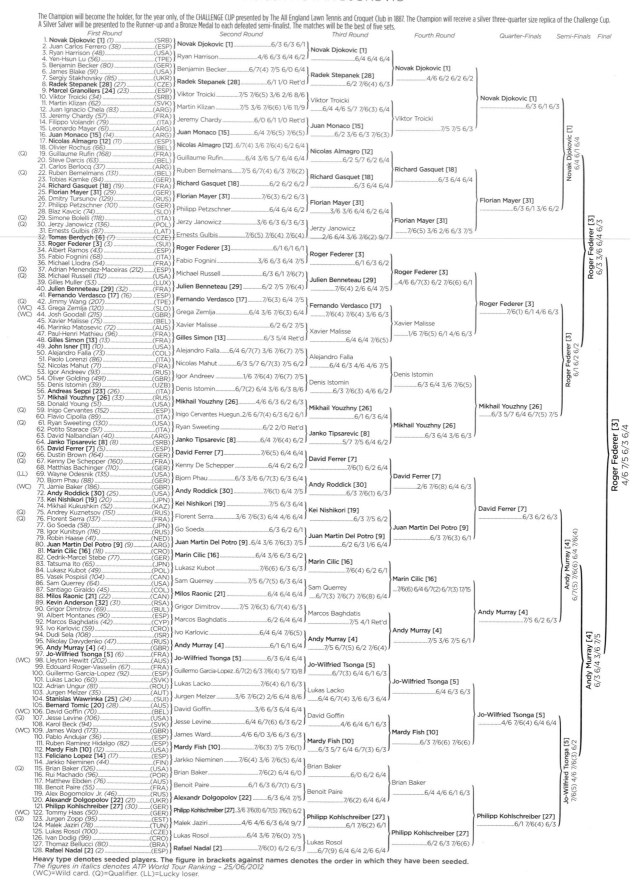

Heavy type denotes seeded players. The figure in brackets against names denotes the order in which they have been seeded.
The figures in italics denotes ATP World Tour Ranking – 25/06/2012
(WC)=Wild card. (Q)=Qualifier. (LL)=Lucky loser.

EVENT III – THE LADIES' SINGLES CHAMPIONSHIP 2012
Holder: PETRA KVITOVA

The Champion will become the holder, for the year only, of the CHALLENGE TROPHY presented by The All England Lawn Tennis and Croquet Club in 1886. The Champion will receive a silver three-quarter size replica of the Trophy. A Silver Salver will be presented to the Runner-up and a Bronze Medal to each defeated semi-finalist. The matches will be the best of three sets.

First Round	Second Round	Third Round	Fourth Round	Quarter-Finals	Semi-Finals	Final

1. **Maria Sharapova [1]** *(1)* (RUS)
2. Anastasia Rodionova *(133)* (AUS)
(Q) 3. Vesna Dolonc *(206)* (SRB)
4. Tsvetana Pironkova *(38)* (BUL)
5. Su-Wei Hsieh *(63)* (TPE)
(WC) 6. Virginie Razzano *(91)* (FRA)
7. Stephanie Foretz Gacon *(75)* (FRA)
8. **Monica Niculescu [29]** *(33)* (ROU)
9. **Petra Cetkovska [23]** *(25)* (CZE)
10. Vania King *(61)* (USA)
11. Sloane Stephens *(59)* (USA)
(Q) 12. Karolina Pliskova *(119)* (CZE)
13. Bojana Jovanovski *(117)* (SRB)
14. Eleni Daniilidou *(88)* (GRE)
15. Petra Martic *(45)* (CRO)
16. **Sabine Lisicki [15]** *(15)* (GER)
17. **Vera Zvonareva [12]** *(12)* (RUS)
18. Mona Barthel *(39)* (GER)
19. Edina Gallovits-Hall *(107)* (ROU)
20. Silvia Soler-Espinosa *(67)* (ESP)
21. Kai-Chen Chang *(111)* (TPE)
22. Andrea Hlavackova *(90)* (CZE)
23. Kim Clijsters *(47)* (BEL)
24. **Jelena Jankovic [18]** *(21)* (SRB)
25. **Christina McHale [28]** *(32)* (USA)
(WC) 26. Johanna Konta *(212)* (GBR)
27. Lesia Tsurenko *(99)* (UKR)
28. Mathilde Johansson *(81)* (FRA)
29. Ekaterina Makarova *(44)* (RUS)
30. Alberta Brianti *(113)* (ITA)
31. Lucie Hradecka *(68)* (CZE)
32. **Angelique Kerber [8]** *(8)* (GER)
33. **Agnieszka Radwanska [3]** *(3)* (POL)
34. Magdalena Rybarikova *(122)* (SVK)
35. Venus Williams *(58)* (USA)
36. Elena Vesnina *(79)* (RUS)
37. Iveta Benesova *(55)* (CZE)
38. Heather Watson *(103)* (GBR)
39. Jamie Lee Hampton *(100)* (USA)
40. **Daniela Hantuchova [27]** *(29)* (SVK)
41. **Nadia Petrova [20]** *(20)* (RUS)
(Q) 42. Maria Elena Camerin *(189)* (ITA)
43. Timea Babos *(69)* (HUN)
(WC) 44. Melanie Oudin *(123)* (USA)
45. Tamarine Tanasugarn *(115)* (THA)
46. Anna Tatishvili *(73)* (GEO)
(Q) 47. Camila Giorgi *(145)* (ITA)
48. **Flavia Pennetta [16]** *(17)* (ITA)
49. **Na Li [11]** *(11)* (CHN)
50. Ksenia Pervak *(41)* (KAZ)
51. Sorana Cirstea *(52)* (ROU)
52. Pauline Parmentier *(70)* (FRA)
(WC) 53. Naomi Broady *(228)* (GBR)
54. Lourdes Dominguez Lino *(71)* (ESP)
55. Alexandra Cadantu *(84)* (ROU)
56. **Maria Kirilenko [17]** *(19)* (RUS)
57. **Shuai Peng [30]** *(34)* (CHN)
(Q) 58. Sandra Zaniewska *(160)* (POL)
59. Jarmila Gajdosova *(76)* (AUS)
60. Ayumi Morita *(85)* (JPN)
61. Arantxa Rus *(72)* (NED)
(LL) 62. Misaki Doi *(105)* (JPN)
63. Carla Suarez Navarro *(40)* (ESP)
64. **Samantha Stosur [5]** *(5)* (AUS)
65. **Serena Williams [6]** *(6)* (USA)
66. Barbora Zahlavova Strycova *(62)* (CZE)
67. Johanna Larsson *(92)* (SWE)
(Q) 68. Melinda Czink *(98)* (HUN)
69. Vera Dushevina *(94)* (RUS)
70. Aleksandra Wozniak *(56)* (CAN)
71. Stephanie Dubois *(109)* (CAN)
72. **Jie Zheng [25]** *(27)* (CHN)
73. **Lucie Safarova [19]** *(22)* (CZE)
74. Kiki Bertens *(86)* (NED)
75. Chanelle Scheepers *(43)* (RSA)
(WC) 76. Yaroslava Shvedova *(65)* (KAZ)
77. Laura Pous-Tio *(102)* (ESP)
78. Anne Keothavong *(77)* (GBR)
(Q) 79. Coco Vandeweghe *(132)* (USA)
80. **Sara Errani [10]** *(10)* (ITA)
81. **Dominika Cibulkova [13]** *(13)* (SVK)
82. Klara Zakopalova *(31)* (CZE)
83. Olga Govortsova *(95)* (BLR)
(Q) 84. Annika Beck *(169)* (GER)
85. Polona Hercog *(46)* (SLO)
(Q) 86. Kristyna Pliskova *(148)* (CZE)
(WC) 87. Laura Robson *(117)* (GBR)
88. **Francesca Schiavone [24]** *(26)* (ITA)
89. **Anastasia Pavlyuchenkova [31]** *(30)* (RUS)
90. Sofia Arvidsson *(48)* (SWE)
91. Patricia Mayr-Achleitner *(93)* (AUT)
92. Varvara Lepchenko *(53)* (USA)
93. Elena Baltacha *(101)* (GBR)
94. Karin Knapp *(112)* (ITA)
95. Akgul Amanmuradova *(96)* (UZB)
96. **Petra Kvitova [4]** *(4)* (CZE)
97. **Caroline Wozniacki [7]** *(7)* (DEN)
98. Tamira Paszek *(37)* (AUT)
99. Alize Cornet *(60)* (FRA)
100. Nina Bratchikova *(89)* (RUS)
101. Greta Arn *(104)* (HUN)
102. Galina Voskoboeva *(57)* (KAZ)
103. Yanina Wickmayer *(36)* (BEL)
104. **Svetlana Kuznetsova [32]** *(35)* (RUS)
105. **Roberta Vinci [21]** *(23)* (ITA)
(WC) 106. Ashleigh Barty *(258)* (AUS)
107. Urszula Radwanska *(54)* (POL)
108. Marina Erakovic *(49)* (NZL)
(Q) 109. Mirjana Lucic *(129)* (CRO)
110. Alexandra Panova *(74)* (RUS)
111. Casey Dellacqua *(108)* (AUS)
112. **Marion Bartoli [9]** *(9)* (FRA)
113. **Ana Ivanovic [14]** *(14)* (SRB)
114. Maria Jose Martinez Sanchez *(51)* (ESP)
115. Kimiko Date-Krumm *(82)* (JPN)
116. Kateryna Bondarenko *(66)* (UKR)
117. Anastasiya Yakimova *(110)* (BLR)
118. Mandy Minella *(83)* (LUX)
119. Shahar Peer *(50)* (ISR)
120. **Julia Goerges [22]** *(24)* (GER)
121. **Anabel Medina Garrigues [26]** *(28)* (ESP)
122. Simona Halep *(42)* (ROU)
(Q) 123. Jana Cepelova *(178)* (SVK)
(Q) 124. Kristina Mladenovic *(157)* (FRA)
125. Irina-Camelia Begu *(64)* (ROU)
126. Romina Oprandi *(87)* (SUI)
127. Irina Falconi *(78)* (USA)
128. **Victoria Azarenka [2]** *(2)* (BLR)

Second Round

Maria Sharapova [1] 6/2 6/3
Tsvetana Pironkova 5/7 6/0 7/5
Su-Wei Hsieh 6/2 6/4
Stephanie Foretz Gacon 6/4 3/6 6/3
Petra Cetkovska [23] 6/4 6/2
Sloane Stephens 6/2 6/2
Bojana Jovanovski 5/7 6/3 2/0 Ret'd
Sabine Lisicki [15] 6/4 6/2
Vera Zvonareva [12] 2/6 7/6(3) 6/4
Silvia Soler-Espinosa 4/6 6/4 10/8
Andrea Hlavackova 6/1 6/2
Kim Clijsters 6/2 6/4
Christina McHale [28] 6/7(4) 6/2 10/8
Mathilde Johansson 3/6 6/0 6/3
Ekaterina Makarova 6/2 3/6 6/3
Angelique Kerber [8] 6/4 6/1
Agnieszka Radwanska [3] 6/3 6/3
Elena Vesnina 6/1 6/3
Heather Watson 6/2 6/1
Jamie Lee Hampton 6/4 7/6(1)
Nadia Petrova [20] 6/0 6/2
Timea Babos 6/4 4/6 6/3
Anna Tatishvili 6/4 6/2
Camila Giorgi 6/4 6/3
Na Li [11] 6/3 6/1
Sorana Cirstea 6/3 6/4
Lourdes Dominguez Lino 6/4 7/6(4)
Maria Kirilenko [17] 6/3 6/1
Shuai Peng [30] 6/2 6/7(3) 6/3
Ayumi Morita 6/4 6/3
Arantxa Rus 7/5 6/3
Samantha Stosur [5] 6/1 6/3
Serena Williams [6] 6/2 6/4
Melinda Czink 6/0 6/2
Aleksandra Wozniak 6/2 7/5
Jie Zheng [25] 4/6 6/4 6/3
Kiki Bertens 6/3 6/0
Yaroslava Shvedova 7/6(5) 7/6(5)
Anne Keothavong 6/3 6/3
Sara Errani [10] 6/1 6/3
Klara Zakopalova 6/4 6/1
Olga Govortsova 6/3 3/6 6/3
Kristyna Pliskova 6/2 6/2
Francesca Schiavone [24] 2/6 6/4 6/4
Anastasia Pavlyuchenkova [31] 6/1 6/2
Varvara Lepchenko 6/2 6/3
Elena Baltacha 4/6 6/4 6/0
Petra Kvitova [4] 6/4 6/4
Tamira Paszek 5/7 7/6(4) 6/4
Alize Cornet 6/0 7/6(1)
Galina Voskoboeva 6/2 6/2
Yanina Wickmayer 6/2 6/3
Roberta Vinci [21] 6/2 6/4
Marina Erakovic 6/4 4/4
Mirjana Lucic 4/6 6/3 6/4
Marion Bartoli [9] 6/2 6/4
Ana Ivanovic [14] 6/3 3/6 6/3
Kateryna Bondarenko 5/7 6/3 6/3
Anastasiya Yakimova 4/6 6/3 6/3
Julia Goerges [22] 6/2 6/2
Anabel Medina Garrigues [26] 3/6 6/1 6/2
Jana Cepelova 6/3 3/6 6/1
Romina Oprandi 7/6(3) 6/4
Victoria Azarenka [2] 6/1 6/4

Third Round

Maria Sharapova [1] 7/6(3) 6/7(3) 6/0
Su-Wei Hsieh 6/4 6/1
Sloane Stephens 7/6(3) 4/6 6/3
Sabine Lisicki [15] 3/6 6/2 8/6
Vera Zvonareva [12] 6/1 3/6 6/1
Kim Clijsters 6/3 6/3
Christina McHale [28] 7/5 7/5
Angelique Kerber [8] 7/5 6/3
Agnieszka Radwanska [3] 6/2 6/1
Heather Watson 6/1 6/4
Nadia Petrova [20] 6/4 6/7(3) 9/7
Camila Giorgi 6/3 6/1
Maria Kirilenko [17] 6/1 6/2
Shuai Peng [30] 7/6(4) 6/3
Serena Williams [6] 6/1 6/4
Jie Zheng [25] 6/4 6/2
Yaroslava Shvedova 6/4 6/4
Sara Errani [10] 6/1 6/1
Klara Zakopalova 2/6 6/1 6/2
Francesca Schiavone [24] 6/4 6/4
Varvara Lepchenko 7/6(4) 6/4
Petra Kvitova [4] 6/0 6/4
Tamira Paszek 6/2 6/1
Yanina Wickmayer 4/6 6/3 8/6
Roberta Vinci [21] 6/4 6/3
Mirjana Lucic 7/6(4) 7/6(3)
Ana Ivanovic [14] 6/3 7/6(3)
Julia Goerges [22] 7/6(3) 6/2
Jana Cepelova 7/7 7/6(5) 6/3
Victoria Azarenka [2] 6/2 6/0

Fourth Round

Maria Sharapova [1] 6/1 6/4
Sabine Lisicki [15] 7/6(5) 1/6 6/2
Kim Clijsters 6/3 4/3 Ret'd
Angelique Kerber [8] 6/2 6/3
Agnieszka Radwanska [3] 6/0 6/2
Camila Giorgi 6/3 7/6(6)
Maria Kirilenko [17] 6/3 6/1
Serena Williams [6] 6/7(5) 6/2 9/7
Yaroslava Shvedova 6/0 6/4
Francesca Schiavone [24] 6/0 6/4
Petra Kvitova [4] 6/1 6/0
Tamira Paszek 2/6 7/6(4) 7/5
Roberta Vinci [21] 7/6(4) 7/6(3)
Ana Ivanovic [14] 3/6 6/3 6/4
Victoria Azarenka [2] 6/3 6/3

Quarter-Finals

Sabine Lisicki [15] 6/4 6/3
Angelique Kerber [8] 6/1 6/1
Agnieszka Radwanska [3] 6/2 6/3
Maria Kirilenko [17] 6/1 6/7(6) 6/3
Serena Williams [6] 6/1 2/6 7/5
Petra Kvitova [4] 4/6 7/5 6/1
Tamira Paszek 6/2 6/2
Victoria Azarenka [2] 6/1 6/0

Semi-Finals

Angelique Kerber [8] 6/3 6/7(7) 7/5
Agnieszka Radwanska [3] 6/3 6/4
Serena Williams [6] 6/3 7/5
Victoria Azarenka [2] 6/3 7/6(4)

Final

Agnieszka Radwanska [3] 7/5 4/6 7/5
Serena Williams [6] 6/3 7/6(6)

Serena Williams [6] 6/1 5/7 6/2

Heavy type denotes seeded players. The figure in brackets against names denotes the order in which they have been seeded.
The figure in italics denotes WTA Ranking 25/06/2012
(WC)=Wild card. (Q)=Qualifier. (LL)=Lucky loser.

EVENT II – THE GENTLEMEN'S DOUBLES CHAMPIONSHIP 2012
Holders: BOB BRYAN & MIKE BRYAN

The Champions will become the holders, for the year only, of the CHALLENGE CUPS presented by the OXFORD UNIVERSITY LAWN TENNIS CLUB in 1884 and the late SIR HERBERT WILBERFORCE in 1937.
The Champions will receive a silver three-quarter size replica of the Challenge Cup. A Silver Salver will be presented to each of the Runners-up, and a Bronze Medal to each defeated semi-finalist.
The matches will be the best of five sets.

First Round	Second Round	Third Round	Quarter-Finals	Semi-Finals	Final

1. Max Mirnyi (BLR) & **Daniel Nestor** (CAN)[1]
 Max Mirnyi & Daniel Nestor [1]
2. Michael Russell (USA) & Donald Young (USA)
 4/6 6/0 6/2 6/1

3. Carsten Ball (AUS) & Thomaz Bellucci (BRA)
 Daniele Bracciali & Julian Knowle
4. **Daniele Bracciali** (ITA) & **Julian Knowle** (AUT)
 7/5 7/6(8) 6/3

Daniele Bracciali & Julian Knowle
............6/4 6/4 6/4

5. Juan Ignacio Chela (ARG) & Eduardo Schwank (ARG)
 Juan Ignacio Chela & Eduardo Schwank
6. Alex Bogomolov Jr. (RUS) & Dudi Sela (ISR)
 6/3 6/4 6/2

7. Julien Benneteau (FRA) & Nicolas Mahut (FRA)
 Andre Sa & Bruno Soares [16]
8. **Andre Sa** (BRA) & **Bruno Soares** (BRA)[16]
 6/7(3) 6/4 6/3 7/6(5)

Juan Ignacio Chela & Eduardo Schwank
...........6/4 6/4 6/7(5) 4/6 6/3

Daniele Bracciali & Julian Knowle
..........7/5 7/5 6/1

9. **Santiago Gonzalez** (MEX) & **Christopher Kas** (GER)[12]
 Santiago Gonzalez & Christopher Kas [12]
(WC) 10. Liam Broady (GBR) & Oliver Golding (GBR)
 7/6(2) 4/6 6/3 6/4

11. Steve Darcis (BEL) & Olivier Rochus (BEL)
 Steve Darcis & Olivier Rochus
(Q) 12. Lewis Burton (GBR) & George Morgan (GBR)
 4/6 7/5 7/6(3) 6/4

Steve Darcis & Olivier Rochus
...........6/1 6/1 6/4

13. Sergiy Stakhovsky (UKR) & Dmitry Tursunov (RUS)
 Sanchai Ratiwatana & Sonchat Ratiwatana
(LL) 14. Sanchai Ratiwatana (THA) & Sonchat Ratiwatana (THA) ...
 6/7(3) 6/3 3/6 6/3 6/4

Robert Lindstedt & Horia Tecau [5]
...........6/2 7/6(3) 7/6(2)

15. Lukas Dlouhy (CZE) & Michal Mertinak (SVK)
 Robert Lindstedt & Horia Tecau [5]
16. **Robert Lindstedt** (SWE) & **Horia Tecau** (ROU)[5]
 7/6(7) 7/6(5) 7/6(4)

Robert Lindstedt & Horia Tecau [5]
...........6/4 7/5 7/6(4)

Robert Lindstedt & Horia Tecau [5]
6/4 6/2 6/4

17. **Leander Paes** (IND) & **Radek Stepanek** (CZE)[4]
 Leander Paes & Radek Stepanek [4]
(LL) 18. Colin Ebelthite (AUS) & John Peers (AUS)
 6/2 6/4 6/2

19. Jonathan Erlich (ISR) & Andy Ram (ISR)
 Jonathan Erlich & Andy Ram
20. Treat Conrad Huey (PHI) & Dominic Inglot (GBR)
 4/6 6/3 2/6 7/6(6) 9/7

Leander Paes & Radek Stepanek [4]
...........6/2 6/4 7/6(5)

21. Martin Klizan (SVK) & Lukas Lacko (SVK)
 Martin Emmrich & Michael Kohlmann
22. Martin Emmrich (GER) & Michael Kohlmann (GER)
 6/7(4) 6/4 4/6 7/6(4) 7/5

Ivan Dodig & Marcelo Melo [15]
...........6/3 7/6(4) 6/3

23. Ashley Fisher (AUS) & Jordan Kerr (AUS)
 Ivan Dodig & Marcelo Melo [15]
24. **Ivan Dodig** (CRO) & **Marcelo Melo** (BRA)[15]
 6/7(4) 6/4 6/4 6/3

Ivan Dodig & Marcelo Melo [15]
...........4/6 6/3 6/4 6/7(2) 8/6

25. **Jurgen Melzer** (AUT) & **Philipp Petzschner** (GER)[10]
 Jurgen Melzer & Philipp Petzschner [10]
26. Carlos Berlocq (ARG) & Leonardo Mayer (ARG)
 4/6 7/6(0) 3/6 6/3 6/4

27. Yen-Hsun Lu (TPE) & Alexander Waske (GER)
 Yen-Hsun Lu & Alexander Waske
28. Xavier Malisse (BEL) & Dick Norman (BEL)
 7/5 3/6 6/3 6/4

Jurgen Melzer & Philipp Petzschner [10]
...........6/3 6/4 6/7(6) 6/2

Jurgen Melzer & Philipp Petzschner [10]
...........6/4 6/4 5/7 6/7(9) 16/14

29. Mikhail Elgin (RUS) & Denis Istomin (UZB)
 Mikhail Elgin & Denis Istomin
30. Pablo Andujar (ESP) & Guillermo Garcia-Lopez (ESP)
 6/4 6/3 6/2

Mikhail Elgin & Denis Istomin
...........7/5 7/6(4) 6/3

31. Marcel Felder (URU) & Malek Jaziri (TUN)
 Mahesh Bhupathi & Rohan Bopanna [7]
32. **Mahesh Bhupathi** (IND) & **Rohan Bopanna** (IND)[7]
 6/0 7/6(1) 6/2

Jurgen Melzer & Philipp Petzschner [10]
7/5 6/2 3/6 6/3

Robert Lindstedt & Horia Tecau [5]
6/4 6/7(10) 6/4 6/3

33. **Aisam-Ul-Haq Qureshi** (PAK) & **Jean-Julien Rojer** (NED) ..[8]
 Aisam-Ul-Haq Qureshi & Jean-Julien Rojer [8]
(WC) 34. Josh Goodall (GBR) & James Ward (GBR)
 7/6(3) 6/2 6/4

35. Flavio Cipolla (ITA) & Fabio Fognini (ITA)
 Bobby Reynolds & Izak Van Der Merwe
(Q) 36. Bobby Reynolds (USA) & Izak Van Der Merwe (RSA)
 7/5 4/6 6/1 6/7(5) 6/3

Aisam-Ul-Haq Qureshi & Jean-Julien Rojer [8]
...........6/3 6/7(5) 6/4 6/4

37. Ivo Karlovic (CRO) & Frank Moser (GER)
 Ivo Karlovic & Frank Moser
38. Matthew Ebden (AUS) & Ryan Harrison (USA)
 3/6 6/3 6/4 7/6(3)

Jonathan Marray & Frederik Nielsen
...........6/3 6/3 6/2

39. (WC) Jonathan Marray (GBR) & Frederik Nielsen (DEN)
 Jonathan Marray & Frederik Nielsen
40. **Marcel Granollers** (ESP) & **Marc Lopez** (ESP)[9]
 6/7(3) 6/4 7/6(4) 2/6 7/5

Jonathan Marray & Frederik Nielsen
...........7/6(5) 7/6(4) 6/7(4) 5/7 7/5

41. **Colin Fleming** (GBR) & **Ross Hutchins** (GBR)[13]
 Mikhail Kukushkin & Lukas Rosol
42. Mikhail Kukushkin (KAZ) & Lukas Rosol (CZE)
 3/6 4/6 6/2 7/6(5) 6/3

James Cerretani & Edouard Roger-Vasselin
...........6/4 2/6 3/6 6/3 6/4

43. James Cerretani (USA) & Edouard Roger-Vasselin (FRA)
 James Cerretani & Edouard Roger-Vasselin
44. Paolo Lorenzi (ITA) & Benoit Paire (FRA)
 6/4 7/6(4) 7/6(7)

James Cerretani & Edouard Roger-Vasselin
...........6/4 6/4 3/6 6/7(10) 6/4

45. James Blake (USA) & Sam Querrey (USA)
 David Marrero & Andreas Seppi
46. David Marrero (ESP) & Andreas Seppi (ITA)
 3/6 6/3 3/6 6/3 6/2

David Marrero & Andreas Seppi
...........7/6(3) 6/4 7/5

47. Johan Brunstrom (SWE) & Philipp Marx (GER)
 Johan Brunstrom & Philipp Marx
48. **Mariusz Fyrstenberg** (POL) & **Marcin Matkowski** (POL)..[3]
 6/4 6/2 6/7(1) 7/6(2)

Jonathan Marray & Frederik Nielsen
7/6(5) 7/6(4) 6/7(3) 2/6 6/2

49. **Alexander Peya** (AUT) & **Nenad Zimonjic** (SRB)[6]
 Chris Guccione & Lleyton Hewitt
(WC) 50. Chris Guccione (AUS) & Lleyton Hewitt (AUS)
 7/6(3) 7/6(3) 3/6 7/6(3)

51. Benjamin Becker (GER) & Cedrik-Marcel Stebe (GER)
 Benjamin Becker & Cedrik-Marcel Stebe
52. Juan Sebastian Cabal (COL) & Robert Farah (COL)
 6/3 1/6 6/3 6/4

Chris Guccione & Lleyton Hewitt
...........6/4 5/7 4/6 6/2 9/7

53. Paul Hanley (AUS) & Mark Knowles (BAH)
 Scott Lipsky & Rajeev Ram
54. Scott Lipsky (USA) & Rajeev Ram (USA)
 3/6 6/4 3/6 6/4 7/5

Scott Lipsky & Rajeev Ram
...........7/5 4/6 4/6 6/3 6/4

55. Dustin Brown (GER) & Oliver Marach (AUT)
 Dustin Brown & Oliver Marach
56. **Frantisek Cermak** (CZE) & **Filip Polasek** (SVK)[11]
 6/2 6/2 1/6 2/6 7/5

Scott Lipsky & Rajeev Ram
...........6/4 3/6 6/4 6/4

Bob Bryan & Mike Bryan [2]
6/4 7/6(9) 6/7(4) 7/6(5)

57. **Eric Butorac** (USA) & **Jamie Murray** (GBR)[14]
 Eric Butorac & Jamie Murray [14]
(Q) 58. Andre Begemann (GER) & Igor Zelenay (SVK)
 7/6(5) 7/6(3) 4/6 7/6(4)

59. Arnaud Clement (FRA) & Michael Llodra (FRA)
 Arnaud Clement & Michael Llodra
60. Ruben Ramirez Hidalgo (ESP) & Albert Ramos (ESP)
 6/2 6/2 6/7(4) 6/0

Arnaud Clement & Michael Llodra
...........6/3 7/5 6/4

61. (WC) Jamie Delgado (GBR) & Kenneth Skupski (GBR)
 Jamie Delgado & Kenneth Skupski
(Q) 62. Matthias Bachinger (GER) & Tobias Kamke (GER)
 6/3 5/7 6/3 6/4

Bob Bryan & Mike Bryan [2]
...........7/6(2) 6/0 6/2

63. Robin Haase (NED) & Jarkko Nieminen (FIN)
 Bob Bryan & Mike Bryan [2]
64. **Bob Bryan** (USA) & **Mike Bryan** (USA)[2]
 6/3 6/2 6/4

Bob Bryan & Mike Bryan [2]
5/7 6/3 5/7 6/4 6/4

Jonathan Marray & Frederik Nielsen
6/4 7/6(9) 6/7(4) 7/6(5)

Heavy type denotes seeded players. The figure in brackets against names denotes the order in which they have been seeded.
(WC)=Wild card. (Q)=Qualifier. (LL)=Lucky loser.

EVENT IV – THE LADIES' DOUBLES CHAMPIONSHIP 2012
Holders: KVETA PESCHKE & KATARINA SREBOTNIK

The Champions will become the holders, for the year only, of the CHALLENGE CUPS presented by H.R.H. PRINCESS MARINA, DUCHESS OF KENT, the late President of The All England Lawn Tennis and Croquet Club in 1949 and The All England Lawn Tennis and Croquet Club 2001. The Champions will receive a silver three-quarter size replica of the Challenge Cup. A Silver Salver will be presented to each of the Runners-up and a Bronze Medal to each defeated semi-finalist. The matches will be the best of three sets.

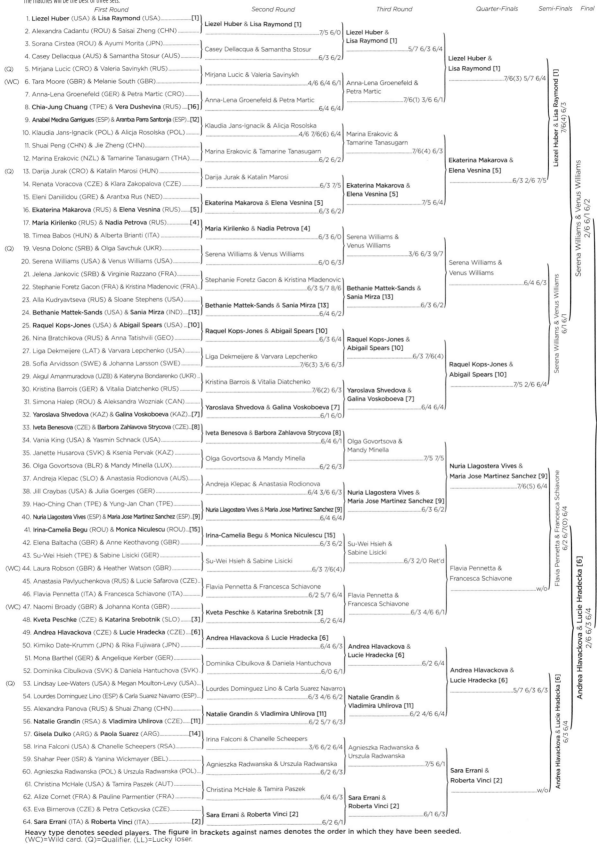

First Round	Second Round	Third Round	Quarter-Finals	Semi-Finals	Final

1. Liezel Huber (USA) & Lisa Raymond (USA)......[1]
2. Alexandra Cadantu (ROU) & Saisai Zheng (CHN)
3. Sorana Cirstea (ROU) & Ayumi Morita (JPN)
4. Casey Dellacqua (AUS) & Samantha Stosur (AUS)
(Q) 5. Mirjana Lucic (CRO) & Valeria Savinykh (RUS)
(WC) 6. Tara Moore (GBR) & Melanie South (GBR)
7. Anna-Lena Groenefeld (GER) & Petra Martic (CRO)
8. Chia-Jung Chuang (TPE) & Vera Dushevina (RUS)[16]
9. Anabel Medina Garrigues (ESP) & Arantxa Parra Santonja (ESP)..[12]
10. Klaudia Jans-Ignacik (POL) & Alicja Rosolska (POL)
11. Shuai Peng (CHN) & Jie Zheng (CHN)
12. Marina Erakovic (NZL) & Tamarine Tanasugarn (THA)
(Q) 13. Darija Jurak (CRO) & Katalin Marosi (HUN)
14. Renata Voracova (CZE) & Klara Zakopalova (CZE)
15. Eleni Daniilidou (GRE) & Arantxa Rus (NED)
16. Ekaterina Makarova (RUS) & Elena Vesnina (RUS)[5]
17. Maria Kirilenko (RUS) & Nadia Petrova (RUS)......[4]
18. Timea Babos (HUN) & Alberta Brianti (ITA)
(Q) 19. Vesna Dolonc (SRB) & Olga Savchuk (UKR)
20. Serena Williams (USA) & Venus Williams (USA)
21. Jelena Jankovic (SRB) & Virginie Razzano (FRA)
22. Stephanie Foretz Gacon (FRA) & Kristina Mladenovic (FRA)
23. Alla Kudryavtseva (RUS) & Sloane Stephens (USA)
24. Bethanie Mattek-Sands (USA) & Sania Mirza (IND)......[13]
25. Raquel Kops-Jones (USA) & Abigail Spears (USA)......[10]
26. Nina Bratchikova (RUS) & Anna Tatishvili (GEO)
27. Liga Dekmeijere (LAT) & Varvara Lepchenko (USA)
28. Sofia Arvidsson (SWE) & Johanna Larsson (SWE)
29. Akgul Amanmuradova (UZB) & Kateryna Bondarenko (UKR)
30. Kristina Barrois (GER) & Vitalia Diatchenko (RUS)
31. Simona Halep (ROU) & Aleksandra Wozniak (CAN)
32. Yaroslava Shvedova (KAZ) & Galina Voskoboeva (KAZ)...[7]
33. Iveta Benesova (CZE) & Barbora Zahlavova Strycova (CZE)...[8]
34. Vania King (USA) & Yasmin Schnack (USA)
35. Janette Husarova (SVK) & Ksenia Pervak (KAZ)
36. Olga Govortsova (BLR) & Mandy Minella (LUX)
37. Andreja Klepac (SLO) & Anastasia Rodionova (AUS)
38. Jill Craybas (USA) & Julia Goerges (GER)
39. Hao-Ching Chan (TPE) & Yung-Jan Chan (TPE)
40. Nuria Llagostera Vives (ESP) & Maria Jose Martinez Sanchez (ESP)..[9]
41. Irina-Camelia Begu (ROU) & Monica Niculescu (ROU)...[15]
42. Elena Baltacha (GBR) & Anne Keothavong (GBR)
43. Su-Wei Hsieh (TPE) & Sabine Lisicki (GER)
(WC) 44. Laura Robson (GBR) & Heather Watson (GBR)
45. Anastasia Pavlyuchenkova (RUS) & Lucie Safarova (CZE)
46. Flavia Pennetta (ITA) & Francesca Schiavone (ITA)
(WC) 47. Naomi Broady (GBR) & Johanna Konta (GBR)
48. Kveta Peschke (CZE) & Katarina Srebotnik (SLO)......[3]
49. Andrea Hlavackova (CZE) & Lucie Hradecka (CZE)....[6]
50. Kimiko Date-Krumm (JPN) & Rika Fujiwara (JPN)
51. Mona Barthel (GER) & Angelique Kerber (GER)
52. Dominika Cibulkova (SVK) & Daniela Hantuchova (SVK)
(Q) 53. Lindsay Lee-Waters (USA) & Megan Moulton-Levy (USA)
54. Lourdes Dominguez Lino (ESP) & Carla Suarez Navarro (ESP)
55. Alexandra Panova (RUS) & Shuai Zhang (CHN)
56. Natalie Grandin (RSA) & Vladimira Uhlirova (CZE)...[11]
57. Gisela Dulko (ARG) & Paola Suarez (ARG)......[14]
58. Irina Falconi (USA) & Chanelle Scheepers (RSA)
59. Shahar Peer (ISR) & Yanina Wickmayer (BEL)
60. Agnieszka Radwanska (POL) & Urszula Radwanska (POL)
61. Christina McHale (USA) & Tamira Paszek (AUT)
62. Alize Cornet (FRA) & Pauline Parmentier (FRA)
63. Eva Birnerova (CZE) & Petra Cetkovska (CZE)
64. Sara Errani (ITA) & Roberta Vinci (ITA)......[2]

Second Round
- Liezel Huber & Lisa Raymond [1] — 7/5 6/0
- Casey Dellacqua & Samantha Stosur — 6/3 6/2
- Mirjana Lucic & Valeria Savinykh — 4/6 6/4 6/1
- Anna-Lena Groenefeld & Petra Martic — 6/4 6/4
- Klaudia Jans-Ignacik & Alicja Rosolska — 4/6 7/6(6) 6/1
- Marina Erakovic & Tamarine Tanasugarn — 6/2 6/2
- Darija Jurak & Katalin Marosi — 6/3 7/5
- Ekaterina Makarova & Elena Vesnina [5] — 6/3 6/2
- Maria Kirilenko & Nadia Petrova [4] — 6/3 6/0
- Serena Williams & Venus Williams — 6/0 6/3
- Stephanie Foretz Gacon & Kristina Mladenovic — 6/3 5/7 8/6
- Bethanie Mattek-Sands & Sania Mirza [13] — 6/4 6/2
- Raquel Kops-Jones & Abigail Spears [10] — 6/3 6/4
- Liga Dekmeijere & Varvara Lepchenko — 7/6(3) 3/6 6/3
- Kristina Barrois & Vitalia Diatchenko — 7/6(2) 6/3
- Yaroslava Shvedova & Galina Voskoboeva [7] — 6/1 6/0
- Iveta Benesova & Barbora Zahlavova Strycova [8] — 6/4 6/1
- Olga Govortsova & Mandy Minella — 6/2 6/0
- Andreja Klepac & Anastasia Rodionova — 6/4 3/6 6/3
- Nuria Llagostera Vives & Maria Jose Martinez Sanchez [9] — 6/4 6/4
- Irina-Camelia Begu & Monica Niculescu [15] — 6/3 6/2
- Su-Wei Hsieh & Sabine Lisicki — 6/3 7/6(4)
- Flavia Pennetta & Francesca Schiavone — 6/2 5/7 6/4
- Kveta Peschke & Katarina Srebotnik [3] — 6/2 6/4
- Andrea Hlavackova & Lucie Hradecka [6] — 6/4 6/2
- Dominika Cibulkova & Daniela Hantuchova — 6/0 6/1
- Lourdes Dominguez Lino & Carla Suarez Navarro — 6/3 4/6 6/2
- Natalie Grandin & Vladimira Uhlirova [11] — 6/2 5/7 6/3
- Irina Falconi & Chanelle Scheepers — 3/6 6/2 6/4
- Agnieszka Radwanska & Urszula Radwanska — 6/2 6/2
- Christina McHale & Tamira Paszek — 6/4 6/3
- Sara Errani & Roberta Vinci [2] — 6/2 6/1

Third Round
- Liezel Huber & Lisa Raymond [1] — 5/7 6/3 6/4
- Anna-Lena Groenefeld & Petra Martic — 7/6(1) 3/6 6/1
- Marina Erakovic & Tamarine Tanasugarn — 7/6(4) 6/3
- Ekaterina Makarova & Elena Vesnina [5] — 7/5 6/4
- Serena Williams & Venus Williams — 3/6 6/3 9/7
- Bethanie Mattek-Sands & Sania Mirza [13] — 6/3 6/2
- Raquel Kops-Jones & Abigail Spears [10] — 6/3 7/6(4)
- Yaroslava Shvedova & Galina Voskoboeva [7] — 6/4 6/4
- Olga Govortsova & Mandy Minella — 7/5 7/5
- Nuria Llagostera Vives & Maria Jose Martinez Sanchez [9] — 6/3 6/2
- Su-Wei Hsieh & Sabine Lisicki — 6/3 2/0 Ret'd
- Flavia Pennetta & Francesca Schiavone — 6/3 4/6 6/1
- Andrea Hlavackova & Lucie Hradecka [6] — 6/2 6/4
- Natalie Grandin & Vladimira Uhlirova [11] — 6/2 4/6 6/4
- Agnieszka Radwanska & Urszula Radwanska — 7/5 6/1
- Sara Errani & Roberta Vinci [2] — 6/1 6/3

Quarter-Finals
- Liezel Huber & Lisa Raymond [1] — 7/6(3) 5/7 6/4
- Ekaterina Makarova & Elena Vesnina [5] — 6/3 2/6 7/5
- Serena Williams & Venus Williams — 6/4 6/3
- Raquel Kops-Jones & Abigail Spears [10] — 7/5 2/6 6/4
- Nuria Llagostera Vives & Maria Jose Martinez Sanchez [9] — 7/6(5) 6/4
- Flavia Pennetta & Francesca Schiavone — w/o
- Andrea Hlavackova & Lucie Hradecka [6] — 5/7 6/3 6/3
- Sara Errani & Roberta Vinci [2] — w/o

Semi-Finals
- Liezel Huber & Lisa Raymond [1] — 7/6(4) 6/3
- Serena Williams & Venus Williams — 6/1 6/1
- Flavia Pennetta & Francesca Schiavone — 6/2 6/7(O) 6/4
- Andrea Hlavackova & Lucie Hradecka [6] — 6/3 6/4

Final
- Serena Williams & Venus Williams — 2/6 6/1 6/2
- Andrea Hlavackova & Lucie Hradecka [6] — 2/6 6/3 6/4

Heavy type denotes seeded players. The figure in brackets against names denotes the order in which they have been seeded.
(WC)=Wild card. (Q)=Qualifier. (LL)=Lucky loser.

56 | 5

147

EVENT V – THE MIXED DOUBLES CHAMPIONSHIP 2012
Holders: JURGEN MELZER & IVETA BENESOVA

The Champions will become the holders, for the year only, of the CHALLENGE CUPS presented by members of the family of the late Mr. S. H. SMITH in 1949 and The All England Lawn Tennis and Croquet Club in 2001. The Champions will receive a silver three-quarter size replica of the Challenge Cup. A Silver Salver will be presented to each of the Runners-up and a Bronze Medal to each defeated semi-finalist. The matches will be the best of three sets.

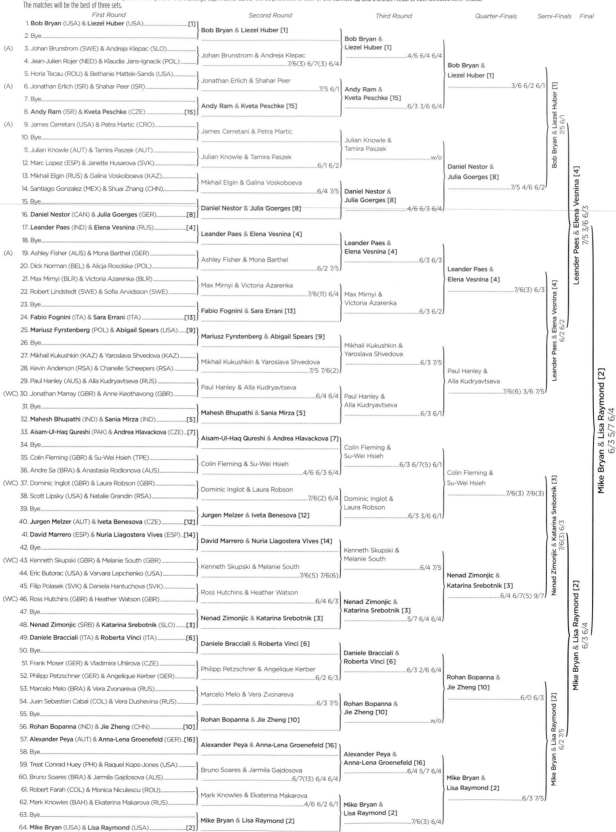

Heavy type denotes seeded players. The figure in brackets against names denotes the order in which they have been seeded.
(A)=Alternate. (WC)=Wild card.

EVENT VI – THE GENTLEMEN'S INVITATION DOUBLES 2012
Holders: JACCO ELTINGH & PAUL HAARHUIS

The Champions will become the holders, for the year only, of a Cup presented by The All England Lawn Tennis and Croquet Club. The Champions will receive a silver three-quarter size Cup. A Silver Medal will be presented to each of the Runners-up. The matches will be the best of three sets. If a match should reach one set all a 10 point tie-break will replace the third set.

GROUP A	Jacco Eltingh (NED) & Paul Haarhuis (NED)	Justin Gimelstob (USA) & Todd Martin (USA)	Goran Ivanisevic (CRO) & Cedric Pioline (FRA)	Greg Rusedski (GBR) & Fabrice Santoro (FRA)	WINS	LOSSES	FINAL
Jacco Eltingh (NED) & Paul Haarhuis (NED)		6/4 6/4 W	6/2 6/3 W	5/7 6/2 [7/10] L	2	1	
Justin Gimelstob (USA) & Todd Martin (USA)	4/6 4/6 L		3/6 6/7(4) L	5/7 4/6 L	0	3	Greg Rusedski & Fabrice Santoro
Goran Ivanisevic (CRO) & Cedric Pioline (FRA)	2/6 3/6 L	6/3 7/6(4) W		3/6 4/6 L	1	2	
Greg Rusedski (GBR) & Fabrice Santoro (FRA)	7/5 2/6 [10/7] W	7/5 6/4 W	6/3 6/4 W		3	0	

GROUP B	Jonas Bjorkman (SWE) & Todd Woodbridge (AUS)	Thomas Enqvist (SWE) & Mark Philippoussis (AUS)	Wayne Ferreira (RSA) & Chris Wilkinson (GBR)	Richard Krajicek (NED) & Mark Petchey (GBR)	WINS	LOSSES	FINAL
Jonas Bjorkman (SWE) & Todd Woodbridge (AUS)		5/7 2/6 L	4/6 6/1 [10/12] L	6/2 4/6 [10/8] W	1	2	
Thomas Enqvist (SWE) & Mark Philippoussis (AUS)	7/5 6/2 W		6/3 6/4 W	6/3 6/4 W	3	0	Thomas Enqvist & Mark Philippoussis
Wayne Ferreira (RSA) & Chris Wilkinson (GBR)	6/4 1/6 [12/10] W	3/6 4/6 L		6/4 1/6 [6/10] L	1	2	
Richard Krajicek (NED) & Mark Petchey (GBR)	2/6 6/4 [8/10] L	3/6 4/6 L	4/6 6/1 [10/6] W		1	2	

Overall Final: Greg Rusedski & Fabrice Santoro 6/7(3) 6/4 [11/9]

This event will be played on a 'round robin' basis. 8 invited pairs have been divided into 2 groups and each pair in each group will play one another. The winning pair from each group will play a final round as indicated above. If matches should be equal in any group, the head to head result between the two pairs with the same number of wins will determine the winning pair of the group.

EVENT VII – THE GENTLEMEN'S SENIOR INVITATION DOUBLES 2012
Holders: PAT CASH & MARK WOODFORDE

The Champions will become the holders, for the year only, of a Cup presented by The All England Lawn Tennis and Croquet Club. The Champions will receive a silver half-size Cup. A Silver Medal will be presented to each of the Runners-up. The matches will be the best of three sets. If a match should reach one set all a 10 point tie-break will replace the third set.

GROUP A	Mansour Bahrami (IRI) & Henri Leconte (FRA)	Pat Cash (AUS) & Mark Woodforde (AUS)	Patrick McEnroe (USA) & Joakim Nystrom (SWE)	Peter McNamara (AUS) & Paul McNamee (AUS)	WINS	LOSSES	FINAL
Mansour Bahrami (IRI) & Henri Leconte (FRA)		5/7 3/6 L	7/5 5/7 [9/11] L	7/6(2) 6/4 W	1	2	
Pat Cash (AUS) & Mark Woodforde (AUS)	7/5 6/3 W		6/3 6/1 W	6/3 6/2 W	3	0	Pat Cash & Mark Woodforde
Patrick McEnroe (USA) & Joakim Nystrom (SWE)	5/7 7/5 [11/9] W	3/6 1/6 L		6/7(3) 7/6(4) [10/6] W	2	1	
Peter McNamara (AUS) & Paul McNamee (AUS)	6/7(2) 4/6 L	3/6 2/6 L	7/6(3) 6/7(4) [6/10] L		0	3	

GROUP B	Jeremy Bates (GBR) & Anders Jarryd (SWE)	Darren Cahill (AUS) & Brad Gilbert (USA)	Andrew Castle (GBR) & Guy Forget (FRA)	Kevin Curren (USA) & Johan Kriek (USA)	WINS	LOSSES	FINAL
Jeremy Bates (GBR) & Anders Jarryd (SWE)		6/4 6/1 W	6/2 6/4 W	6/3 6/4 W	3	0	
Darren Cahill (AUS) & Brad Gilbert (USA)	4/6 1/6 L		3/6 1/6 L	6/3 4/6 [9/11] L	0	3	Jeremy Bates & Anders Jarryd
Andrew Castle (GBR) & Guy Forget (FRA)	2/6 4/6 L	6/3 6/1 W		4/6 6/1 [10/6] W	2	1	
Kevin Curren (USA) & Johan Kriek (USA)	3/6 4/6 L	3/6 6/4 [11/9] W	6/4 1/6 [6/10] L		1	2	

Overall Final: Pat Cash & Mark Woodforde 6/3 6/4

This event will be played on a 'round robin' basis. 8 invited pairs have been divided into 2 groups and each pair in each group will play one another. The winning pair from each group will play a final round as indicated above. If matches should be equal in any group, the head to head result between the two pairs with the same number of wins will determine the winning pair of the group.

ALPHABETICAL LIST – INVITATION DOUBLES EVENTS

GENTLEMEN
Bjorkman, Jonas *(Sweden)*
Eltingh, Jacco *(Netherlands)*
Enqvist, Thomas *(Sweden)*
Ferreira, Wayne *(South Africa)*
Gimelstob, Justin *(USA)*
Haarhuis, Paul *(Netherlands)*
Ivanisevic, Goran *(Croatia)*
Krajicek, Richard *(Netherlands)*
Martin, Todd *(USA)*
Petchey, Mark *(Great Britain)*
Philippoussis, Mark *(Australia)*
Pioline, Cedric *(France)*
Rusedski, Greg *(Great Britain)*
Santoro, Fabrice *(France)*
Wilkinson, Chris *(Great Britain)*
Woodbridge, Todd *(Australia)*

LADIES
Ahl, Lucie *(Great Britain)*
Appelmans, Sabine *(Belgium)*
Austin, Tracy *(USA)*
Davenport, Lindsay *(USA)*
Hingis, Martina *(Switzerland)*
Majoli, Iva *(Croatia)*
Martinez, Conchita *(Spain)*
Navratilova, Martina *(USA)*
Novotna, Jana *(Czech Republic)*
Rinaldi, Kathy *(USA)*
Schett, Barbara *(Austria)*
Smith, Samantha *(Great Britain)*
Sukova, Helena *(Czech Republic)*
Tauziat, Nathalie *(France)*
Temesvari, Andrea *(Hungary)*
Zvereva, Natasha *(Belarus)*

ALPHABETICAL LIST – GENTLEMEN'S SENIOR INVITATION DOUBLES EVENT
Bahrami, Mansour *(Iran)*
Bates, Jeremy *(Great Britain)*
Cahill, Darren *(Australia)*
Cash, Pat *(Australia)*
Castle, Andrew *(Great Britain)*
Curren, Kevin *(USA)*
Forget, Guy *(France)*
Gilbert, Brad *(USA)*
Jarryd, Anders *(Sweden)*
Kriek, Johan *(USA)*
Leconte, Henri *(France)*
McEnroe, Patrick *(USA)*
McNamara, Peter *(Australia)*
McNamee, Paul *(Australia)*
Nystrom, Joakim *(Sweden)*
Woodforde, Mark *(Australia)*

EVENT VIII – THE LADIES' INVITATION DOUBLES 2012
Holders: LINDSAY DAVENPORT & MARTINA HINGIS

The Champions will become the holders, for the year only, of a Cup presented by The All England Lawn Tennis and Croquet Club. The Champions will receive a silver three-quarter size Cup. A Silver Medal will be presented to each of the Runners-up. The matches will be the best of three sets. If a match should reach one set all a 10 point tie-break will replace the third set.

GROUP A	Lucie Ahl (GBR) & Samantha Smith (GBR)	Lindsay Davenport (USA) & Martina Hingis (SUI)	Iva Majoli (CRO) & Natasha Zvereva (BLR)	Helena Sukova (CZE) & Andrea Temesvari (HUN)	WINS	LOSSES	FINAL
Lucie Ahl (GBR) & Samantha Smith (GBR)		W/O L	4/6 2/6 L	3/6 3/6 L	0	3	
Lindsay Davenport (USA) & Martina Hingis (SUI)	W/O W		6/3 6/4 W	6/2 6/3 W	3	0	Lindsay Davenport & Martina Hingis
Iva Majoli (CRO) & Natasha Zvereva (BLR)	6/4 6/2 W	3/6 4/6 L		6/2 6/4 W	2	1	
Helena Sukova (CZE) & Andrea Temesvari (HUN)	6/3 6/3 W	2/6 3/6 L	2/6 4/6 L		1	2	

GROUP B	Sabine Appelmans (BEL) & Barbara Schett (AUT)	Tracy Austin (USA) & Kathy Rinaldi (USA)	Conchita Martinez (ESP) & Nathalie Tauziat (FRA)	Martina Navratilova (USA) & Jana Novotna (CZE)	WINS	LOSSES	FINAL
Sabine Appelmans (BEL) & Barbara Schett (AUT)		1/6 2/6 L	3/6 4/6 L	4/6 6/3 [8/10] L	0	3	
Tracy Austin (USA) & Kathy Rinaldi (USA)	6/1 6/2 W		6/1 4/6 [7/10] L	2/6 2/6 L	1	2	Martina Navratilova & Jana Novotna
Conchita Martinez (ESP) & Nathalie Tauziat (FRA)	6/3 6/4 W	1/6 6/4 [10/7] W		0/6 2/6 L	2	1	
Martina Navratilova (USA) & Jana Novotna (CZE)	6/4 3/6 [10/8] W	6/2 6/2 W	6/0 6/2 W		3	0	

Final: Lindsay Davenport & Martina Hingis 6/3 6/2

This event will be played on a 'round robin' basis. 8 invited pairs have been divided into 2 groups and each pair in each group will play one another. The winning pair from each group will play a final round as indicated above. If matches should be equal in any group, the head to head result between the two pairs with the same number of wins will determine the winning pair of the group.

EVENT IX – THE WHEELCHAIR GENTLEMEN'S DOUBLES 2012
Holders: MAIKEL SCHEFFERS & RONALD VINK

The Champions will receive Silver Salvers. The matches will be the best of three tie-break sets.

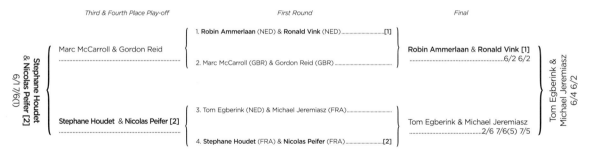

Third & Fourth Place Play-off — Marc McCarroll & Gordon Reid ; Stephane Houdet & Nicolas Peifer [2] 6/1 7/6(1)

First Round
1. **Robin Ammerlaan** (NED) & **Ronald Vink** (NED) [1]
2. Marc McCarroll (GBR) & Gordon Reid (GBR)
3. Tom Egberink (NED) & Michael Jeremiasz (FRA)
4. **Stephane Houdet** (FRA) & **Nicolas Peifer** (FRA) [2]

Final
Robin Ammerlaan & Ronald Vink [1]6/2 6/2
Tom Egberink & Michael Jeremiasz2/6 7/6(5) 7/5

Tom Egberink & Michael Jeremiasz 6/4 6/2

Heavy type denotes seeded players. The figure in brackets against names denotes the order in which they have been seeded.

EVENT X – THE WHEELCHAIR LADIES' DOUBLES 2012
Holders: ESTHER VERGEER & SHARON WALRAVEN

The Champions will receive Silver Salvers. The matches will be the best of three tie-break sets.

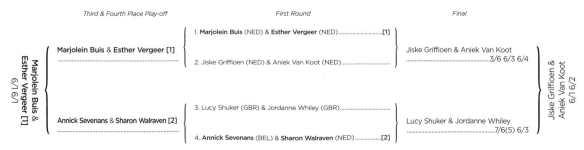

Third & Fourth Place Play-off — Marjolein Buis & Esther Vergeer [1] ; Annick Sevenans & Sharon Walraven [2]
Marjolein Buis & Esther Vergeer [1] 6/1 6/1

First Round
1. **Marjolein Buis** (NED) & **Esther Vergeer** (NED) [1]
2. Jiske Griffioen (NED) & Aniek Van Koot (NED)
3. Lucy Shuker (GBR) & Jordanne Whiley (GBR)
4. **Annick Sevenans** (BEL) & **Sharon Walraven** (NED) [2]

Final
Jiske Griffioen & Aniek Van Koot3/6 6/3 6/4
Lucy Shuker & Jordanne Whiley7/6(5) 6/3

Jiske Griffioen & Aniek Van Koot 6/1 6/2

Heavy type denotes seeded players. The figure in brackets against names denotes the order in which they have been seeded.

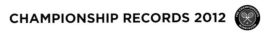

EVENT XI – THE BOYS' SINGLES CHAMPIONSHIP 2012
Holder: LUKE SAVILLE

The Champion will become the holder, for the year only, of a Cup presented by The All England Lawn Tennis and Croquet Club. The Champion will receive a three-quarter size Cup and the Runner-up will receive a Salver.
The matches will be best of three sets.

First Round	Second Round	Third Round	Quarter-Finals	Semi-Finals	Final
1. Luke Saville [1] (1)(AUS)	Luke Saville [1]6/1 6/4				
2. Laurent Lokoli (44)(FRA)		Luke Saville [1]			
3. Daniel Santos (48)(PER)	Stefan Vinti6/0 6/46/4 6/2			
(Q) 4. Stefan Vinti (60)(ITA)			Luke Saville [1]		
5. Luke Bambridge (39)(GBR)	Luke Bambridge6/1 6/4	7/6(4) 6/4		
6. Vaclav Safranek (29)(CZE)		Luke Bambridge			
(Q) 7. Maximilian Marterer (53)(GER)	Maximilian Marterer6/4 6/46/3 6/4			
8. Noah Rubin [14] (15)(USA)				Luke Saville [1]	
9. Joshua Ward-Hibbert [12] (12)(GBR)	Elias Ymer6/0 2/0 Ret'd		7/5 5/4 Ret'd	
(Q) 10. Elias Ymer (49)(SWE)		Thai-Son Kwiatkowski			
(Q) 11. Thai-Son Kwiatkowski (63)(USA)	Thai-Son Kwiatkowski6/4 3/6 6/46/4 6/2			
12. Max De Vroome (25)(NED)			Nikola Milojevic [6]		
13. Mikael Torpegaard (35)(DEN)	Matteo Donati6/4 4/6 6/2	4/6 6/3 6/2		
14. Matteo Donati (38)(ITA)		Nikola Milojevic [6]			
15. Gabriel Friedrich (30)(BRA)	Nikola Milojevic [6]5/7 6/4 6/47/5 6/4			Luke Saville [1]
16. Nikola Milojevic [6] (6)(SRB)					6/3 6/4
17. Gianluigi Quinzi [3] (3)(ITA)	Gianluigi Quinzi [3]6/3 6/1				
(Q) 18. Hassan Ndayishimiye (58)(BDI)		Gianluigi Quinzi [3]			
19. Christian Garin (34)(CHI)	Christian Garin1/6 7/5 6/06/1 6/7(9) 8/6			
(WC) 20. Evan Hoyt (98)(GBR)			Gianluigi Quinzi [3]		
21. Mathias Bourgue (40)(FRA)	Mathias Bourgue6/7(4) 6/4 14/12	6/1 3/1 Ret'd		
22. Alexios Halebian (51)(USA)		Julien Cagnina [13]			
(WC) 23. Tommy Bennett (415)(GBR)	Julien Cagnina [13]6/3 4/6 6/46/4 6/7(2) 6/3			
24. Julien Cagnina [13] (13)(BEL)				Gianluigi Quinzi [3]	
25. Mateo Nicolas Martinez [10] (10) ...(ARG)	Mateo Nicolas Martinez [10] ...6/2 6/2		6/3 6/1	
26. Connor Farren (54)(USA)		Nick Kyrgios			
27. Markos Kalovelonis (41)(GRE)	Nick Kyrgios6/2 6/27/6(6) 6/4			
28. Nick Kyrgios (18)(AUS)			Nick Kyrgios		
(WC) 29. Peter Ashley (155)(GBR)	Pol Toledo Bague6/4 6/2	7/5 6/2		
(Q) 30. Pol Toledo Bague (75)(ESP)		Kaichi Uchida [7]			
31. Lucas Gomez (74)(MEX)	Kaichi Uchida [7]6/1 6/26/4 6/1			
32. Kaichi Uchida [7] (7)(JPN)					
33. Liam Broady [5] (5)(GBR)	Liam Broady [5]6/3 7/6(2)				
34. Filip Bergevi (46)(SWE)		Liam Broady [5]			
(Q) 35. Stefan Kozlov (67)(USA)	Stefan Kozlov5/7 6/2 6/16/7(3) 6/0 6/4			
36. Daniel Masur (79)(GER)			Enzo Couacaud		
(WC) 37. Myles Orton (194)(GBR)	Karim Hossam1/6 6/3 8/6	7/6(4) 6/3		
38. Karim Hossam (23)(EGY)		Enzo Couacaud			
(WC) 39. Enzo Couacaud (47)(FRA)	Enzo Couacaud6/1 3/6 6/46/3 6/4			
40. Andrew Harris [9] (9)(AUS)				Filip Peliwo [4]	
41. MacKenzie McDonald [15] (16)(USA)	Pietro Licciardi6/4 2/6 6/4		6/4 1/6 6/3	
42. Pietro Licciardi (55)(ITA)		Pietro Licciardi			
43. Wayne Montgomery (32)(RSA)	Herkko Pollanen7/6(7) 7/57/6(4) 6/2			
44. Herkko Pollanen (21)(FIN)			Filip Peliwo [4]		
(WC) 45. Clay Crawford (250)(GBR)	Yoshihito Nishioka6/4 6/3	6/2 6/2		
46. Yoshihito Nishioka (20)(JPN)		Filip Peliwo [4]			
47. Albert Alcaraz Ivorra (36)(ESP)	Filip Peliwo [4]7/6(5) 6/36/2 6/1			Filip Peliwo [4]
48. Filip Peliwo [4] (4)(CAN)					7/5 6/4
49. Mitchell Krueger [8] (8)(USA)	Mitchell Krueger [8]4/6 7/6(6) 10/8				
50. Kyle Edmund (28)(GBR)		Mitchell Krueger [8]			
51. Juan Ignacio Galarza (24)(ARG)	Borna Coric6/3 6/06/3 7/6(8)			
52. Borna Coric (27)(CRO)			Mitchell Krueger [8]		
53. Anton Desyatnik (45)(RUS)	Anton Desyatnik7/6(1) 6/4	7/6(7) 6/4		
(WC) 54. Scott Clayton (106)(GBR)		Stefano Napolitano [11]			
55. Maxime Hamou (57)(FRA)	Stefano Napolitano [11]6/1 6/16/7(4) 7/5 6/3			
56. Stefano Napolitano [11] (11)(ITA)				Mitchell Krueger [8]	
57. Frederico Ferreira Silva [16] (17)(POR)	Frederico Ferreira Silva [16]6/4 6/4		6/2 7/6(5)	
(Q) 58. Marek Routa (79)(CZE)		Frederico Ferreira Silva [16]			
59. Jordan Thompson (31)(AUS)	Jordan Thompson6/2 6/26/1 6/2			
(WC) 60. Jonny O'Mara (131)(GBR)			Kimmer Coppejans [2]		
61. Pedja Krstin (37)(SRB)	Pedja Krstin7/5 6/2	6/1 6/7(4) 6/4		
62. Spencer Papa (26)(USA)		Kimmer Coppejans [2]			
63. Eduard Esteve Lobato (50)(ESP)	Kimmer Coppejans [2]6/4 6/36/3 7/6(3)			
64. Kimmer Coppejans [2] (2)(BEL)					

Heavy type denotes seeded players. The figure in brackets against names denotes the order in which they have been seeded. The Committee reserves the right to alter the seeding order in the event of withdrawals. (WC) = Wild card. (Q) = Qualifier. (LL) = Lucky Loser.

EVENT XII – THE BOYS' DOUBLES CHAMPIONSHIP 2012
Holders: GEORGE MORGAN & MATE PAVIC

The Champions will become the holders, for the year only, of a Cup presented by The All England Lawn Tennis and Croquet Club. The Champions will receive a three-quarter size Cup and the Runners-up will receive Silver Salvers.
The matches will be best of three sets.

First Round	Second Round	Quarter-Finals	Semi-Finals	Final
1. Filip Peliwo (CAN) & Gianluigi Quinzi (ITA)[1]	Filip Peliwo & Gianluigi Quinzi [1]6/4 6/2	Filip Peliwo & Gianluigi Quinzi [1]		
(WC) 2. Peter Ashley (GBR) & Clay Crawford (GBR)7/5 6/2		
3. Temur Ismailov (UZB) & Markos Kalovelonis (GRE)	Temur Ismailov & Markos Kalovelonis ..7/6(6) 7/6(6)			
4. Pol Toledo Bague (ESP) & Elias Ymer (SWE)			Juan Ignacio Galarza & Mateo Nicolas Martinez [6]	
5. Jay Andrijic (AUS) & Yoshihito Nishioka (JPN)...........	Jay Andrijic & Yoshihito Nishioka6/4 5/7 [10-5]	Juan Ignacio Galarza & Mateo Nicolas Martinez [6]7/6(2) 7/6(0)	
6. Max De Vroome (NED) & Frederico Ferreira Silva (POR)...	6/4 6/2		
7. Daniel Masur (GER) & Vaclav Safranek (CZE)..............	Juan Ignacio Galarza & Mateo Nicolas Martinez [6]..6/4 7/5			
8. Juan Ignacio Galarza (ARG) & Mateo Nicolas Martinez (ARG) ..[6]				
9. Andrew Harris (AUS) & Nick Kyrgios (AUS)[4]	Andrew Harris & Nick Kyrgios [4]6/1 7/5	Andrew Harris & Nick Kyrgios [4]		Andrew Harris & Nick Kyrgios [4]
10. Borna Coric (CRO) & Pedja Krstin (SRB)6/2 7/6(2)		6/2 6/1
11. Gabriel Friedrich (BRA) & Daniel Santos (PER)	Gabriel Friedrich & Daniel Santos6/4 3/6 [10-7]		Andrew Harris & Nick Kyrgios [4]	
(WC) 12. Scott Clayton (GBR) & Jonny O'Mara (GBR)7/6(7) 7/5	
13. Luke Bambridge (GBR) & Kaichi Uchida (JPN)..........	Luke Bambridge & Kaichi Uchida4/6 6/4 [10-8]	Luke Bambridge & Kaichi Uchida		
14. Mathias Bourgue (FRA) & Laurent Lokoli (FRA).........	6/3 6/4		
15. Kevin Kaczynski (GER) & Maximilian Marterer (GER)	MacKenzie McDonald & Spencer Papa [8] ..7/6(5) 5/7 [10-6]			
16. MacKenzie McDonald (USA) & Spencer Papa (USA)[8]				
17. Luke Saville (AUS) & Jordan Thompson (AUS)[5]	Luke Saville & Jordan Thompson [5]7/5 6/1	Luke Saville & Jordan Thompson [5]		Andrew Harris & Nick Kyrgios [4]
18. Christian Garin (CHI) & Lucas Gomez (MEX)...........	6/0 6/3		6/2 6/4
19. Bar Tzuf Botzer (ISR) & Connor Farren (USA)	Bar Tzuf Botzer & Connor Farren7/6(7) 6/4		Matteo Donati & Pietro Licciardi	
(WC) 20. Tommy Bennett (GBR) & Joshua Sapwell (GBR)7/5 6/2	
21. Albert Alcaraz Ivorra (ESP) & Eduard Esteve Lobato (ESP)...	Matteo Donati & Pietro Licciardi6/4 6/4	Matteo Donati & Pietro Licciardi		
22. Matteo Donati (ITA) & Pietro Licciardi (ITA)..........	7/6(4) 6/3		
23. Stefan Kozlov (USA) & Thai-Son Kwiatkowski (USA)	Stefan Kozlov & Thai-Son Kwiatkowskiw/o			
24. Julien Cagnina (BEL) & Mitchell Krueger (USA)[3]				
25. Kyle Edmund (GBR) & Stefano Napolitano (ITA)[7]	Evan Hoyt & Wayne Montgomery5/7 6/4 [10-7]	Evan Hoyt & Wayne Montgomery		Matteo Donati & Pietro Licciardi 7/6(4) 7/6(5)
(WC) 26. Evan Hoyt (GBR) & Wayne Montgomery (RSA)5/7 6/2 [10-4]		
27. Anton Desyatnik (RUS) & Marat Deviatiarov (UKR)	Anton Desyatnik & Marat Deviatiarov7/5 6/3		Evan Hoyt & Wayne Montgomery	
28. Karim Hossam (EGY) & Hassan Ndayishimiye (BDI)4/6 6/4 [10-7]	
29. Herkko Pollanen (FIN) & Stefan Vinti (ITA)	Filip Bergevi & Mikael Torpegaard6/4 6/1	Filip Bergevi & Mikael Torpegaard		
30. Filip Bergevi (SWE) & Mikael Torpegaard (DEN)........	7/5 4/6 [10-5]		
31. Alexios Halebian (USA) & Noah Rubin (USA)...........	Liam Broady & Joshua Ward-Hibbert [2] ..7/6(7) 4/6 [10-8]			
32. Liam Broady (GBR) & Joshua Ward-Hibbert (GBR)..[2]				

Heavy type denotes seeded players. The figure in brackets against names denotes the order in which they have been seeded. The Committee reserves the right to alter the seeding order in the event of withdrawals. (WC) = Wild cards. (A) = Alternates.

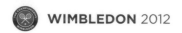

EVENT XIII – THE GIRLS' SINGLES CHAMPIONSHIP 2012
Holder: ASHLEIGH BARTY

The Champion will become the holder, for the year only, of a Cup presented by The All England Lawn Tennis and Croquet Club. The Champion will receive a three-quarter size Cup and the Runner-up will receive a Salver. The matches will be best of three sets.

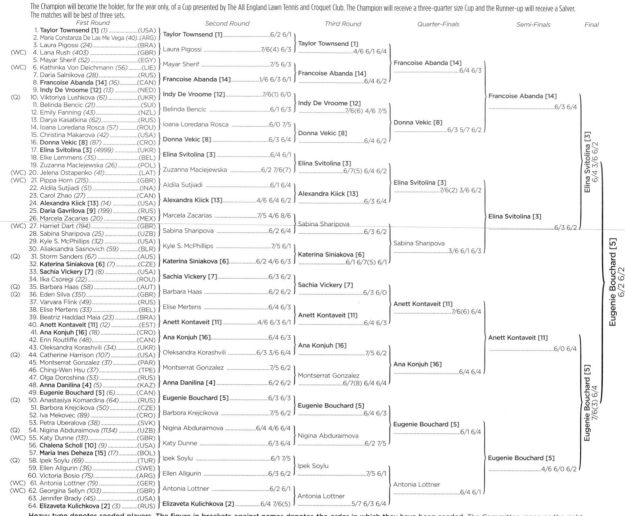

First Round

1. **Taylor Townsend [1]** (1) ..(USA)
2. Maria Constanza De Las Me Vega (40)..(ARG)
3. Laura Pigossi (24) ..(BRA)
(WC) 4. Lana Rush (403) ..(GBR)
5. Mayar Sherif (52) ..(EGY)
(WC) 6. Kathinka Von Deichmann (56) ..(LIE)
7. Daria Salnikova (28) ..(RUS)
8. **Francoise Abanda [14]** (16) ..(CAN)
9. **Indy De Vroome [12]** (13) ..(NED)
(Q) 10. Viktoriya Lushkova (61) ..(UKR)
11. Belinda Bencic (21) ..(SUI)
12. Emily Fanning (43) ..(NZL)
13. Darya Kasatkina (62) ..(RUS)
14. Ioana Loredana Rosca (57) ..(ROU)
15. Christina Makarova (42) ..(USA)
16. **Donna Vekic [8]** (87) ..(CRO)
17. **Elina Svitolina [3]** (4999) ..(UKR)
18. Elke Lemmens (35) ..(BEL)
19. Zuzanna Maciejewska (26) ..(POL)
(WC) 20. Jelena Ostapenko (41) ..(LAT)
(WC) 21. Pippa Horn (215) ..(GBR)
22. Aldila Sutjiadi (51) ..(INA)
23. Carol Zhao (27) ..(CAN)
24. **Alexandra Kiick [13]** (14) ..(USA)
25. **Daria Gavrilova [9]** (199) ..(RUS)
26. Marcela Zacarias (20) ..(MEX)
(WC) 27. Harriet Dart (194) ..(GBR)
28. Sabina Sharipova (25) ..(UZB)
29. Kyle S. McPhillips (32) ..(USA)
30. Aliaksandra Sasnovich (59) ..(BLR)
(Q) 31. Storm Sanders (67) ..(AUS)
32. **Katerina Siniakova [6]** (7) ..(CZE)
33. **Sachia Vickery [7]** (8) ..(USA)
34. Ilka Csoregi (22) ..(ROU)
(Q) 35. Barbara Haas (58) ..(AUT)
(Q) 36. Eden Silva (351) ..(GBR)
37. Varvara Flink (49) ..(RUS)
38. Elise Mertens (33) ..(BEL)
39. Beatriz Haddad Maia (23) ..(BRA)
40. **Anett Kontaveit [11]** (12) ..(EST)
41. **Ana Konjuh [16]** (18) ..(CRO)
42. Erin Routliffe (48) ..(CAN)
43. Oleksandra Korashvili (34) ..(UKR)
(Q) 44. Catherine Harrison (107) ..(USA)
45. Montserrat Gonzalez (31) ..(PAR)
46. Ching-Wen Hsu (37) ..(TPE)
47. Olga Doroshina (53) ..(RUS)
48. **Anna Danilina [4]** (5) ..(KAZ)
49. **Eugenie Bouchard [5]** (6) ..(CAN)
(Q) 50. Anastasiya Komardina (64) ..(RUS)
51. Barbora Krejcikova (50) ..(CZE)
52. Iva Mekovec (89) ..(CRO)
53. Petra Uberalova (38) ..(SVK)
(Q) 54. Nigina Abduraimova (1134) ..(UZB)
(WC) 55. Katy Dunne (131) ..(GBR)
56. **Chalena Scholl [10]** (9) ..(USA)
57. **Maria Ines Deheza [15]** (17) ..(BOL)
(Q) 58. Ipek Soylu (69) ..(TUR)
59. Ellen Allgurin (36) ..(SWE)
60. Victoria Bosio (75) ..(ARG)
(WC) 61. Antonia Lottner (19) ..(GER)
(WC) 62. Georgina Sellyn (103) ..(GBR)
63. Jennifer Brady (45) ..(USA)
64. **Elizaveta Kulichkova [2]** (3) ..(RUS)

Second Round

- Taylor Townsend [1] 6/2 6/1
- Laura Pigossi 7/6(4) 6/3
- Mayar Sherif 7/5 6/3
- Francoise Abanda [14] 1/6 6/3 6/1
- Indy De Vroome [12] 7/6(1) 6/0
- Belinda Bencic 6/1 6/3
- Ioana Loredana Rosca 6/0 7/5
- Donna Vekic [8] 6/3 6/4
- Elina Svitolina [3] 6/4 6/1
- Zuzanna Maciejewska 6/2 7/6(7)
- Aldila Sutjiadi 6/1 6/4
- Alexandra Kiick [13] 4/6 6/4 6/2
- Marcela Zacarias 7/5 4/6 8/6
- Sabina Sharipova 6/2 6/4
- Kyle S. McPhillips 7/5 6/1
- Katerina Siniakova [6] 6/2 4/6 6/3
- Sachia Vickery [7] 6/3 6/2
- Barbara Haas 6/2 6/2
- Elise Mertens 6/4 6/3
- Anett Kontaveit [11] 4/6 6/3 6/2
- Ana Konjuh [16] 6/4 6/3
- Oleksandra Korashvili 6/3 3/6 6/4
- Montserrat Gonzalez 7/5 6/2
- Anna Danilina [4] 6/2 6/2
- Eugenie Bouchard [5] 6/3 6/3
- Barbora Krejcikova 7/5 6/2
- Nigina Abduraimova 6/4 4/6 6/4
- Katy Dunne 6/3 6/4
- Ipek Soylu 6/1 7/5
- Ellen Allgurin 6/3 6/2
- Antonia Lottner 6/2 6/1
- Elizaveta Kulichkova [2] 6/4 7/6(5)

Third Round

- Taylor Townsend [1] 4/6 6/1 6/4
- Francoise Abanda [14] 6/4 6/2
- Indy De Vroome [12] 7/6(6) 4/6 7/5
- Donna Vekic [8] 6/4 6/2
- Elina Svitolina [3] 6/7(5) 6/4 6/2
- Alexandra Kiick [13] 6/3 6/4
- Sabina Sharipova 6/3 6/2
- Katerina Siniakova [6] 6/1 6/7(5) 6/1
- Sachia Vickery [7] 6/3 6/0
- Anett Kontaveit [11] 6/4 6/3
- Ana Konjuh [16] 7/5 6/2
- Montserrat Gonzalez 6/7(8) 6/4 6/4
- Eugenie Bouchard [5] 6/4 6/3
- Nigina Abduraimova 6/2 7/5
- Ipek Soylu 7/5 6/1
- Antonia Lottner 5/7 6/3 6/4

Quarter-Finals

- Francoise Abanda [14] 6/4 6/3
- Donna Vekic [8] 6/3 5/7 6/2
- Elina Svitolina [3] 7/6(2) 3/6 6/2
- Sabina Sharipova 3/6 6/1 6/3
- Anett Kontaveit [11] 7/6(6) 6/4
- Ana Konjuh [16] 6/4 6/4
- Eugenie Bouchard [5] 6/1 6/4
- Antonia Lottner 6/4 6/1

Semi-Finals

- Francoise Abanda [14] 6/3 6/4
- Elina Svitolina [3] 6/3 6/2
- Anett Kontaveit [11] 6/0 6/4
- Eugenie Bouchard [5] 4/6 6/0 6/2

Final

- Elina Svitolina [3] 6/4 3/6 6/2
- Eugenie Bouchard [5] 7/6(3) 6/4

Champion: Eugenie Bouchard [5] 6/2 6/2

Heavy type denotes seeded players. The figure in brackets against names denotes the order in which they have been seeded. The Committee reserves the right to alter the seeding order in the event of withdrawals. (WC) = Wild card. (Q) = Qualifier. LL = Lucky Loser.

EVENT XIV – THE GIRLS' DOUBLES CHAMPIONSHIP 2012
Holders: EUGENIE BOUCHARD & GRACE MIN

The Champions will become the holders, for the year only, of a Cup presented by The All England Lawn Tennis and Croquet Club. The Champions will receive three-quarter size Cup and the Runners-up will receive Silver Salvers. The matches will be best of three sets.

First Round

1. **Eugenie Bouchard** (CAN) & **Taylor Townsend** (USA) **[1]**
2. Victoria Bosio (ARG) & Maria Constanza De Las Me Vega (ARG)
3. Mayar Sherif (EGY) & Aldila Sutjiadi (INA)
4. Viktoriya Lushkova (UKR) & Petra Uberalova (SVK)
5. Ilka Csoregi (ROU) & Jelena Ostapenko (LAT)
(WC) 6. Sarah Beth Askew (GBR) & Katy Dunne (GBR)
7. Barbara Haas (AUT) & Sabina Sharipova (UZB)
8. **Anna Danilina** (KAZ) & **Beatriz Haddad Maia** (BRA) **[6]**
9. **Francoise Abanda** (CAN) & **Sachia Vickery** (USA) **[4]**
10. Adrijana Lekaj (CRO) & Storm Sanders (AUS)
11. Varvara Flink (RUS) & Antonia Lottner (GER)
(WC) 12. Lana Rush (GBR) & Georgina Sellyn (GBR)
13. Elke Lemmens (BEL) & Elise Mertens (BEL)
14. Darya Kasatkina (RUS) & Anastasiya Komardina (RUS)
15. Jennifer Brady (USA) & Kyle S. McPhillips (USA)
16. **Montserrat Gonzalez** (PAR) & **Chalena Scholl** (USA) **[8]**
17. **Belinda Bencic** (SUI) & **Ana Konjuh** (CRO) **[7]**
(WC) 18. Jasmine Amber Asghar (GBR) & Eden Silva (GBR)
19. Emily Fanning (NZL) & Oleksandra Korashvili (UKR)
20. Aliaksandra Sasnovich (BLR) & Donna Vekic (CRO)
21. Alexandra Kiick (USA) & Carol Zhao (CAN)
22. Erin Routliffe (CAN) & Daria Salnikova (RUS)
23. Catherine Harrison (USA) & Christina Makarova (USA)
24. **Maria Ines Deheza** (BOL) & **Elizaveta Kulichkova** (RUS) **[3]**
25. **Indy De Vroome** (NED) & **Anett Kontaveit** (EST) **[5]**
26. Ellen Allgurin (SWE) & Rebecca Peterson (SWE)
27. Barbora Krejcikova (CZE) & Ioana Loredana Rosca (ROU)
28. Zuzanna Maciejewska (POL) & Camilla Rosatello (ITA)
(WC) 29. Harriet Dart (GBR) & Pippa Horn (GBR)
30. Olga Doroshina (RUS) & Katerina Siniakova (CZE)
31. Laura Pigossi (BRA) & Marcela Zacarias (MEX)
32. **Daria Gavrilova** (RUS) & **Elina Svitolina** (UKR) **[2]**

Second Round

- Eugenie Bouchard & Taylor Townsend [1] 6/1 6/0
- Viktoriya Lushkova & Petra Uberalova 4/6 6/3 [10-8]
- Ilka Csoregi & Jelena Ostapenko 6/3 6/4
- Anna Danilina & Beatriz Haddad Maia [6] 6/0 6/2
- Francoise Abanda & Sachia Vickery [4] 6/1 6/2
- Varvara Flink & Antonia Lottner 6/2 6/1
- Elke Lemmens & Elise Mertens 4/6 6/1 [10-3]
- Montserrat Gonzalez & Chalena Scholl [8] 7/6(3) 0/6 [11-9]
- Belinda Bencic & Ana Konjuh [7] 6/1 6/2
- Emily Fanning & Oleksandra Korashvili 6/4 3/6 [10-8]
- Erin Routliffe & Daria Salnikova 7/6(4) 4/6 [10-7]
- Maria Ines Deheza & Elizaveta Kulichkova [3] 6/4 7/5
- Indy De Vroome & Anett Kontaveit [5] 6/4 3/6 [10-8]
- Barbora Krejcikova & Ioana Loredana Rosca 6/3 6/4
- Olga Doroshina & Katerina Siniakova 6/3 6/1
- Daria Gavrilova & Elina Svitolina [2] 3/6 6/3 [10-6]

Quarter-Finals

- Eugenie Bouchard & Taylor Townsend [1] 6/1 6/4
- Anna Danilina & Beatriz Haddad Maia [6] 7/6(2) 5/7 [10-8]
- Francoise Abanda & Sachia Vickery [4] 6/7(3) 7/6(3) [10-7]
- Elke Lemmens & Elise Mertens 7/6(4) 6/3
- Belinda Bencic & Ana Konjuh [7] 6/1 6/4
- Erin Routliffe & Daria Salnikova 6/4 6/3
- Indy De Vroome & Anett Kontaveit [5] 1/6 6/2 [10-4]
- Daria Gavrilova & Elina Svitolina [2] 6/2 7/6(6)

Semi-Finals

- Eugenie Bouchard & Taylor Townsend [1] 6/3 6/4
- Francoise Abanda & Sachia Vickery [4] 6/2 7/5
- Belinda Bencic & Ana Konjuh [7] 6/4 6/3
- Daria Gavrilova & Elina Svitolina [2] 6/4 2/6 [10-8]

Final

- Eugenie Bouchard & Taylor Townsend [1] 7/6(4) 7/5
- Belinda Bencic & Ana Konjuh [7] 5/7 7/6/3 6/1

Champions: Eugenie Bouchard & Taylor Townsend [1] 6/4 6/3

Heavy type denotes seeded players. The figure in brackets against names denotes the order in which they have been seeded. The Committee reserves the right to alter the seeding order in the event of withdrawals. (WC) = Wild cards. (A) = Alternates.

ROLL OF HONOUR
GENTLEMEN'S SINGLES CHAMPIONS & RUNNERS-UP

1877	S.W.Gore *W.C.Marshall*	1903	H.L.Doherty *F.L.Riseley*	1933	J.H.Crawford *H.E.Vines*	1965	R.Emerson *F.S.Stolle*
1878	P.F.Hadow *S.W.Gore*	1904	H.L.Doherty *F.L.Riseley*	1934	F.J.Perry *J.H.Crawford*	1966	M.Santana *R.D.Ralston*
* 1879	J.T.Hartley *V.St.L.Goold*	1905	H.L.Doherty *N.E.Brookes*	1935	F.J.Perry *G.von Cramm*	1967	J.D.Newcombe *W.P.Bungert*
1880	J.T.Hartley *H.F.Lawford*	1906	H.L.Doherty *F.L.Riseley*	1936	F.J.Perry *G.von Cramm*	1968	R.Laver *A.D.Roche*
1881	W.Renshaw *J.T.Hartley*	* 1907	N.E.Brookes *A.W.Gore*	* 1937	J.D.Budge *G.von Cramm*	1969	R.Laver *J.D.Newcombe*
1882	W.Renshaw *E.Renshaw*	* 1908	A.W.Gore *H.Roper Barrett*	1938	J.D.Budge *H.W.Austin*	1970	J.D.Newcombe *K.R.Rosewall*
1883	W.Renshaw *E.Renshaw*	1909	A.W.Gore *M.J.G.Ritchie*	* 1939	R.L.Riggs *E.T.Cooke*	1971	J.D.Newcombe *S.R.Smith*
1884	W.Renshaw *H.F.Lawford*	1910	A.F.Wilding *A.W.Gore*	* 1946	Y.Petra *G.E.Brown*	* 1972	S.R.Smith *I.Nastase*
1885	W.Renshaw *H.F.Lawford*	1911	A.F.Wilding *H.Roper Barrett*	1947	J.Kramer *T.Brown*	* 1973	J.Kodes *A.Metreveli*
1886	W.Renshaw *H.F.Lawford*	1912	A.F.Wilding *A.W.Gore*	* 1948	R.Falkenburg *J.E.Bromwich*	1974	J.S.Connors *K.R.Rosewall*
* 1887	H.F.Lawford *E.Renshaw*	1913	A.F.Wilding *M.E.McLoughlin*	1949	F.R.Schroeder *J.Drobny*	1975	A.R.Ashe *J.S.Connors*
1888	E.Renshaw *H.F.Lawford*	1914	N.E.Brookes *A.F.Wilding*	* 1950	B.Patty *F.A.Sedgman*	1976	B.Borg *I.Nastase*
1889	W.Renshaw *E.Renshaw*	1919	G.L.Patterson *N.E.Brookes*	1951	R.Savitt *K.McGregor*	1977	B.Borg *J.S.Connors*
1890	W.J.Hamilton *W.Renshaw*	1920	W.T.Tilden *G.L.Patterson*	1952	F.A.Sedgman *J.Drobny*	1978	B.Borg *J.S.Connors*
* 1891	W.Baddeley *J.Pim*	1921	W.T.Tilden *B.I.C.Norton*	* 1953	V.Seixas *K.Nielsen*	1979	B.Borg *R.Tanner*
1892	W.Baddeley *J.Pim*	*† 1922	G.L.Patterson *R.Lycett*	1954	J.Drobny *K.R.Rosewall*	1980	B.Borg *J.P.McEnroe*
1893	J.Pim *W.Baddeley*	* 1923	W.M.Johnston *F.T.Hunter*	1955	T.Trabert *K.Nielsen*	1981	J.P.McEnroe *B.Borg*
1894	J.Pim *W.Baddeley*	* 1924	J.Borotra *R.Lacoste*	* 1956	L.A.Hoad *K.R.Rosewall*	1982	J.S.Connors *J.P.McEnroe*
* 1895	W.Baddeley *W.V.Eaves*	1925	R.Lacoste *J.Borotra*	1957	L.A.Hoad *A.J.Cooper*	1983	J.P.McEnroe *C.J.Lewis*
1896	H.S.Mahony *W.Baddeley*	* 1926	J.Borotra *H.Kinsey*	* 1958	A.J.Cooper *N.A.Fraser*	1984	J.P.McEnroe *J.S.Connors*
1897	R.F.Doherty *H.S.Mahony*	1927	H.Cochet *J.Borotra*	* 1959	A.Olmedo *R.Laver*	1985	B.Becker *K.Curren*
1898	R.F.Doherty *H.L.Doherty*	1928	R.Lacoste *H.Cochet*	* 1960	N.A.Fraser *R.Laver*	1986	B.Becker *I.Lendl*
1899	R.F.Doherty *A.W.Gore*	* 1929	H.Cochet *J.Borotra*	1961	R.Laver *C.R.McKinley*	1987	P.Cash *I.Lendl*
1900	R.F.Doherty *S.H.Smith*	1930	W.T.Tilden *W.Allison*	1962	R.Laver *M.F.Mulligan*	1988	S.Edberg *B.Becker*
1901	A.W.Gore *R.F.Doherty*	* 1931	S.B.Wood *F.X.Shields*	* 1963	C.R.McKinley *F.S.Stolle*	1989	B.Becker *S.Edberg*
1902	H.L.Doherty *A.W.Gore*	1932	H.E.Vines *H.W.Austin*	1964	R.Emerson *F.S.Stolle*	1990	S.Edberg *B.Becker*

1991	M.Stich *B.Becker*
1992	A.Agassi *G.Ivanisevic*
1993	P.Sampras *J.Courier*
1994	P.Sampras *G.Ivanisevic*
1995	P.Sampras *B.Becker*
1996	R.Krajicek *M.Washington*
1997	P.Sampras *C.Pioline*
1998	P.Sampras *G.Ivanisevic*
1999	P.Sampras *A.Agassi*
2000	P.Sampras *P.Rafter*
2001	G.Ivanisevic *P.Rafter*
2002	L.Hewitt *D.Nalbandian*
2003	R.Federer *M.Philippoussis*
2004	R.Federer *A.Roddick*
2005	R.Federer *A.Roddick*
2006	R.Federer *R.Nadal*
2007	R.Federer *R.Nadal*
2008	R.Nadal *R.Federer*
2009	R.Federer *A.Roddick*
2010	R.Nadal *T.Berdych*
2011	N.Djokovic *R.Nadal*
2012	R.Federer *A.Murray*

For the years 1913, 1914 and 1919-1923 inclusive the above records include the "World's Championships on Grass" granted to The Lawn Tennis Association by The International Lawn Tennis Federation.
This title was then abolished and commencing in 1924 they became The Official Lawn Tennis Championships recognised by The International Lawn Tennis Federation.
Prior to 1922 the holders in the Singles Events and Gentlemen's Doubles did not compete in The Championships but met the winners of these events in the Challenge Rounds.
† Challenge Round abolished: holders subsequently played through.
* The holder did not defend the title.

ROLL OF HONOUR
LADIES' SINGLES CHAMPIONS & RUNNERS-UP

Year	Champion	Runner-up
1884	Miss M.Watson	*Miss L.Watson*
1885	Miss M.Watson	*Miss B.Bingley*
1886	Miss B.Bingley	*Miss M.Watson*
1887	Miss L.Dod	*Miss B.Bingley*
1888	Miss L.Dod	*Mrs.G.W.Hillyard*
*1889	Mrs.G.W.Hillyard	*Miss L.Rice*
*1890	Miss L.Rice	*Miss M.Jacks*
*1891	Miss L.Dod	*Mrs.G.W.Hillyard*
1892	Miss L.Dod	*Mrs.G.W.Hillyard*
1893	Miss L.Dod	*Mrs.G.W.Hillyard*
*1894	Mrs.G.W.Hillyard	*Miss E.L.Austin*
*1895	Miss C.Cooper	*Miss H.Jackson*
1896	Miss C.Cooper	*Mrs.W.H.Pickering*
1897	Mrs.G.W.Hillyard	*Miss C.Cooper*
*1898	Miss C.Cooper	*Miss L Martin*
1899	Mrs.G.W.Hillyard	*Miss C.Cooper*
1900	Mrs.G.W.Hillyard	*Miss C.Cooper*
1901	Mrs.A.Sterry	*Mrs.G.W.Hillyard*
1902	Miss M.E.Robb	*Mrs.A.Sterry*
*1903	Miss D.K.Douglass	*Miss E.W.Thomson*
1904	Miss D.K.Douglass	*Mrs.A.Sterry*
1905	Miss M.Sutton	*Miss D.K.Douglass*
1906	Miss D.K.Douglass	*Miss M.Sutton*
1907	Miss M.Sutton	*Mrs.Lambert Chambers*
*1908	Mrs.A.Sterry	*Miss A.M.Morton*
*1909	Miss D.P.Boothby	*Miss A.M.Morton*
1910	Mrs.Lambert Chambers	*Miss D.P.Boothby*
1911	Mrs.Lambert Chambers	*Miss D.P.Boothby*
*1912	Mrs.D.R.Larcombe	*Mrs.A.Sterry*
*1913	Mrs.Lambert Chambers	*Mrs.R.J.McNair*
1914	Mrs.Lambert Chambers	*Mrs.D.R.Larcombe*
1919	Miss S.Lenglen	*Mrs.Lambert Chambers*
1920	Miss S.Lenglen	*Mrs.Lambert Chambers*
1921	Miss S.Lenglen	*Miss E.Ryan*
†1922	Miss S.Lenglen	*Mrs.F.Mallory*
1923	Miss S.Lenglen	*Miss K.McKane*
1924	Miss K.McKane	*Miss H.Wills*
1925	Miss S.Lenglen	*Miss J.Fry*
1926	Mrs.L.A.Godfree	*Miss L.de Alvarez*
1927	Miss H.Wills	*Miss L.de Alvarez*
1928	Miss H.Wills	*Miss L.de Alvarez*
1929	Miss H.Wills	*Miss H.H.Jacobs*
1930	Mrs.F.S.Moody	*Miss E.Ryan*
*1931	Miss C.Aussem	*Miss H.Krahwinkel*
*1932	Mrs.F.S.Moody	*Miss H.H.Jacobs*
1933	Mrs.F.S.Moody	*Miss D.E.Round*
*1934	Miss D.E.Round	*Miss H.H.Jacobs*
1935	Mrs.F.S.Moody	*Miss H.H.Jacobs*
*1936	Miss H.H.Jacobs	*Miss S.Sperling*
1937	Mrs D.E.Round	*Miss J.Jedrzejowska*
*1938	Mrs.F.S.Moody	*Miss H.H.Jacobs*
*1939	Miss A.Marble	*Miss K.E.Stammers*
*1946	Miss P.Betz	*Miss L.Brough*
*1947	Miss M.Osborne	*Miss D.Hart*
1948	Miss L.Brough	*Miss D.Hart*
1949	Miss L.Brough	*Mrs.W.du Pont*
1950	Miss L.Brough	*Mrs.W.du Pont*
1951	Miss D.Hart	*Miss S.Fry*
1952	Miss M.Connolly	*Miss L.Brough*
1953	Miss M.Connolly	*Miss D.Hart*
1954	Miss M.Connolly	*Miss L.Brough*
*1955	Miss L.Brough	*Mrs.J.G.Fleitz*
1956	Miss S.Fry	*Miss A.Buxton*
*1957	Miss A.Gibson	*Miss D.R.Hard*
1958	Miss A.Gibson	*Miss A.Mortimer*
*1959	Miss M.E.Bueno	*Miss D.R.Hard*
1960	Miss M.E.Bueno	*Miss S.Reynolds*
*1961	Miss A.Mortimer	*Miss C.C.Truman*
1962	Mrs.J.R.Susman	*Mrs.V.Sukova*
*1963	Miss M.Smith	*Miss B.J.Moffitt*
1964	Miss M.E.Bueno	*Miss M.Smith*
1965	Miss M.Smith	*Miss M.E.Bueno*
1966	Mrs.L.W.King	*Miss M.E.Bueno*
1967	Mrs.L.W.King	*Mrs.P.F.Jones*
1968	Mrs.L.W.King	*Miss J.A.M.Tegart*
1969	Mrs.P.F.Jones	*Mrs.L.W.King*
*1970	Mrs.B.M.Court	*Mrs.L.W.King*
1971	Miss E.F.Goolagong	*Mrs.B.M.Court*
1972	Mrs.L.W.King	*Miss E.F.Goolagong*
1973	Mrs.L.W.King	*Miss C.M.Evert*
1974	Miss C.M.Evert	*Mrs.O.Morozova*
1975	Mrs.L.W.King	*Mrs.R.Cawley*
*1976	Miss C.M.Evert	*Mrs.R.Cawley*
1977	Miss S.V.Wade	*Miss B.F.Stove*
1978	Miss M.Navratilova	*Miss C.M.Evert*
1979	Miss M.Navratilova	*Mrs.J.M.Lloyd*
1980	Mrs.R.Cawley	*Mrs.J.M.Lloyd*
*1981	Mrs.J.M.Lloyd	*Miss H.Mandlikova*
1982	Miss M.Navratilova	*Mrs.J.M.Lloyd*
1983	Miss M.Navratilova	*Miss A.Jaeger*
1984	Miss M.Navratilova	*Mrs.J.M.Lloyd*
1985	Miss M.Navratilova	*Mrs.J.M.Lloyd*
1986	Miss M.Navratilova	*Miss H.Mandlikova*
1987	Miss M.Navratilova	*Miss S.Graf*
1988	Miss S.Graf	*Miss M.Navratilova*
1989	Miss S.Graf	*Miss M.Navratilova*
1990	Miss M.Navratilova	*Miss Z.Garrison*
1991	Miss S.Graf	*Miss G.Sabatini*
1992	Miss S.Graf	*Miss M.Seles*
1993	Miss S.Graf	*Miss J.Novotna*
1994	Miss C.Martinez	*Miss M.Navratilova*
1995	Miss S.Graf	*Miss A.Sanchez Vicario*
1996	Miss S.Graf	*Miss A.Sanchez Vicario*
*1997	Miss M.Hingis	*Miss J.Novotna*
1998	Miss J.Novotna	*Miss N.Tauziat*
1999	Miss L.A.Davenport	*Miss S.Graf*
2000	Miss V.Williams	*Miss L.A.Davenport*
2001	Miss V.Williams	*Miss J.Henin*
2002	Miss S.Williams	*Miss V.Williams*
2003	Miss S.Williams	*Miss V.Williams*
2004	Miss M.Sharapova	*Miss S.Williams*
2005	Miss V.Williams	*Miss L.Davenport*
2006	Miss A.Mauresmo	*Mrs J.Henin-Hardenne*
2007	Miss V.Williams	*Miss M.Bartoli*
2008	Miss V.Williams	*Miss S.Williams*
2009	Miss S.Williams	*Miss V.Williams*
2010	Miss S.Williams	*Miss V.Zvonareva*
2011	Miss P.Kvitova	*Miss M.Sharapova*
2012	Miss S.Williams	*Miss A.Radwanska*

MAIDEN NAMES OF LADIES' CHAMPIONS (In the tables the following have been recorded in both married and single identities)

Married name	Maiden name
Mrs. R. Cawley	Miss E. F. Goolagong
Mrs. Lambert Chambers	Miss D. K. Douglass
Mrs. B. M. Court	Miss M. Smith
Mrs. B. C. Covell	Miss P. L. Howkins
Mrs. D. E. Dalton	Miss J. A. M. Tegart
Mrs. W. du Pont	Miss M. Osborne
Mrs. L. A. Godfree	Miss K. McKane
Mrs. H. F. Gourlay Cawley	Miss H. F. Gourlay
Mrs. J. Henin-Hardenne	Miss J. Henin
Mrs. G. W. Hillyard	Miss B. Bingley
Mrs. P. F. Jones	Miss A. S. Haydon
Mrs. L. W. King	Miss B. J. Moffitt
Mrs. M. R. King	Miss P. E. Mudford
Mrs. D. R. Larcombe	Miss E. W. Thomson
Mrs. J. M. Lloyd	Miss C. M. Evert
Mrs. F. S. Moody	Miss H. Wills
Mrs. O. Morozova	Miss O. Morozova
Mrs. L. E. G. Price	Miss S. Reynolds
Mrs. G. E. Reid	Miss K. Melville
Mrs. P. D. Smylie	Miss E. M. Sayers
Frau. S. Sperling	Fraulein H. Krahwinkel
Mrs. A. Sterry	Miss C. Cooper
Mrs. J. R. Susman	Miss K. Hantze

ROLL OF HONOUR
GENTLEMEN'S DOUBLES CHAMPIONS & RUNNERS-UP

1879	L.R.Erskine and H.F.Lawford *F.Durant and G.E.Tabor*		1925	J.Borotra and R.Lacoste *J.Hennessey and R.Casey*		1973	J.S.Connors and I.Nastase *J.R.Cooper and N.A.Fraser*

1879 L.R.Erskine and H.F.Lawford
F.Durant and G.E.Tabor

1880 W.Renshaw and E.Renshaw
O.E.Woodhouse and C.J.Cole

1881 W.Renshaw and E.Renshaw
W.J.Down and H.Vaughan

1882 J.T.Hartley and R.T.Richardson
J.G.Horn and C.B.Russell

1883 C.W.Grinstead and C.E.Welldon
C.B.Russell and R.T.Milford

1884 W.Renshaw and E.Renshaw
E. W.Lewis and E.L Williams

1885 W.Renshaw and E.Renshaw
C.E.Farrer and A.J.Stanley

1886 W.Renshaw and E.Renshaw
C. E.Farrer and A.J.Stanley

1887 P.Bowes-Lyon and H.W.W.Wilberforce
J.H.Crispe and E.Barratt Smith

1888 W.Renshaw and E.Renshaw
P Bowes-Lyon and H.W.W.Wilberforce

1889 W.Renshaw and E.Renshaw
E. W.Lewis and G.W.Hillyard

1890 J.Pim and F.O.Stoker
E.W.Lewis and G.W.Hillyard

1891 W.Baddeley and H.Baddeley
J.Pim and F.O.Stoker

1892 H.S.Barlow and E.W.Lewis
W.Baddeley and H. Baddeley

1893 J.Pim and F.O.Stoker
E.W.Lewis and H.S.Barlow

1894 W.Baddeley and H.Baddeley
H.S.Barlow and C.H.Martin

1895 W.Baddeley and H.Baddeley
E.W.Lewis and W.V.Eaves

1896 W.Baddeley and H.Baddeley
R.F.Doherty and H.A.Nisbet

1897 R.F.Doherty and H.L.Doherty
W.Baddeley and H.Baddeley

1898 R.F.Doherty and H.L .Doherty
H.A.Nisbet and C.Hobart

1899 R.F.Doherty and H.L.Doherty
H.A.Nisbet and C.Hobart

1900 R.F.Doherty and H.L.Doherty
H.Roper Barrett and H.A.Nisbet

1901 R.F.Doherty and H.L.Doherty
Dwight Davis and Holcombe Ward

1902 S.H.Smith and F.L.Riseley
R.F.Doherty and H.L.Doherty

1903 R.F.Doherty and H.L.Doherty
S.H.Smith and F.L.Riseley

1904 R.F.Doherty and H.L.Doherty
S.H.Smith and F.L.Riseley

1905 R.F.Doherty and H.L.Doherty
S.H.Smith and F.L.Riseley

1906 S.H.Smith and F.L.Riseley
R.F.Doherty and H.L.Doherty

1907 N.E.Brookes and A.F.Wilding
B.C.Wright and K.H.Behr

1908 A.F.Wilding and M.J.G.Ritchie
A.W.Gore and H.Roper Barrett

1909 A.W.Gore and H.Roper Barrett
S.N.Doust and H.A.Parker

1910 A.F.Wilding and M.J.G.Ritchie
A.W.Gore and H.Roper Barrett

1911 M.Decugis and A.H.Gobert
M.J.G.Ritchie and A.F.Wilding

1912 H.Roper Barrett and C.P.Dixon
M.Decugis and A.H.Gobert

1913 H.Roper Barrett and C.P.Dixon
F.W.Rahe and H.Kleinschroth

1914 N.E.Brookes and A.F.Wilding
H.Roper Barrett and C.P.Dixon

1919 R.V.Thomas and P.O'Hara-Wood
R.Lycett and R.W.Heath

1920 R.N.Williams and C.S.Garland
A.R.F.Kingscote and J.C.Parke

1921 R.Lycett and M.Woosnam
F.G.Lowe and A.H.Lowe

1922 R.Lycett and J.O.Anderson
G.L.Patterson and P.O'Hara-Wood

1923 R.Lycett and L.A.Godfree
Count de Gomar and E.Flaquer

1924 F.T.Hunter and V.Richards
R.N.Williams and W.M.Washburn

1925 J.Borotra and R.Lacoste
J.Hennessey and R.Casey

1926 H.Cochet and J.Brugnon
V.Richards and H.Kinsey

1927 F.T.Hunter and W.T.Tilden
J.Brugnon and H.Cochet

1928 H.Cochet and J.Brugnon
G.L.Patterson and J.B.Hawkes

1929 W.Allison and J.Van Ryn
J.C.Gregory and I.G.Collins

1930 W.Allison and J.Van Ryn
J.H.Doeg and G.M.Lott

1931 G.M Lott and J.Van Ryn
H.Cochet and J.Brugnon

1932 J.Borotra and J.Brugnon
G.P.Hughes and F.J.Perry

1933 J.Borotra and J.Brugnon
R.Nunoi and J.Satoh

1934 G.M.Lott and L.R.Stoefen
J.Borotra and J.Brugnon

1935 J.H.Crawford and A.K.Quist
W.Allison and J.Van Ryn

1936 G.P.Hughes and C.R.D.Tuckey
C.E.Hare and F.H.D.Wilde

1937 J.D.Budge and G.Mako
G.P.Hughes and C.R.D.Tuckey

1938 J.D.Budge and G.Mako
H.Henkel and G.von Metaxa

1939 R.L.Riggs and E.T.Cooke
C.E.Hare and F.H.D.Wilde

1946 T.Brown and J.Kramer
G.E.Brown and D.Pails

1947 R.Falkenburg and J.Kramer
A.J.Mottram and O.W.Sidwell

1948 J.E.Bromwich and F.A.Sedgman
T.Brown and G.Mulloy

1949 R.Gonzales and F.Parker
G.Mulloy and F.R.Schroeder

1950 J.E.Bromwich and A.K.Quist
G.E.Brown and O.W Sidwell

1951 K.McGregor and F.A.Sedgman
J.Drobny and E.W.Sturgess

1952 K.McGregor and F.A.Sedgman
V.Seixas and E.W.Sturgess

1953 L.A.Hoad and K.R.Rosewall
R.N.Hartwig and M.G.Rose

1954 R.N.Hartwig and M.G.Rose
V.Seixas and T.Trabert

1955 R.N.Hartwig and L.A.Hoad
N.A.Fraser and K.R.Rosewall

1956 L.A.Hoad and K.R.Rosewall
N.Pietrangeli and O.Sirola

1957 G.Mulloy and B.Patty
N.A.Fraser and L.A.Hoad

1958 S.Davidson and U.Schmidt
A.J.Cooper and N.A.Fraser

1959 R.Emerson and N.A.Fraser
R.Laver and R.Mark

1960 R.H.Osuna and R.D.Ralston
M.G.Davies and R.K.Wilson

1961 R.Emerson and N.A.Fraser
R.A.J.Hewitt and F.S.Stolle

1962 R.A.J.Hewitt and F.S.Stolle
B.Jovanovic and N.Pilic

1963 R.H.Osuna and A.Palafox
J.C.Barclay and P.Darmon

1964 R.A.J.Hewitt and F.S.Stolle
R.Emerson and K.N.Fletcher

1965 J.D.Newcombe and A.D.Roche
K.N.Fletcher and R.A.J.Hewitt

1966 K.N.Fletcher and J.D.Newcombe
W.W.Bowrey and O.K.Davidson

1967 R.A.J.Hewitt and F.D.McMillan
R.Emerson and K.N.Fletcher

1968 J.D.Newcombe and A.D.Roche
K.R.Rosewall and F.S.Stolle

1969 J.D.Newcombe and A.D.Roche
T.S.Okker and M.C.Reissen

1970 J.D.Newcombe and A.D.Roche
K.R.Rosewall and F.S.Stolle

1971 R.S.Emerson and R.G.Laver
A.R.Ashe and R.D.Ralston

1972 R.A.J.Hewitt and F.D.McMillan
S.R.Smith and E.J.van Dillen

1973 J.S.Connors and I.Nastase
J.R.Cooper and N.A.Fraser

1974 J.D.Newcombe and A.D.Roche
R.C.Lutz and S.R.Smith

1975 V.Gerulaitis and A.Mayer
C.Dowdeswell and A.J.Stone

1976 B.E.Gottfried and R.Ramirez
R.L.Case and G.Masters

1977 R.L.Case and G.Masters
J.G.Alexander and P.C.Dent

1978 R.A.J.Hewitt and F.D.McMillan
P.Fleming and J.P.McEnroe

1979 P.Fleming and J.P .McEnroe
B.E.Gottfried and R.Ramirez

1980 P.McNamara and P.McNamee
R.C.Lutz and S.R.Smith

1981 P.Fleming and J.P.McEnroe
R.C.Lutz and S.R.Smith

1982 P.McNamara and P.McNamee
P.Fleming and J.P.McEnroe

1983 P.Fleming and J.P McEnroe
T.E.Gullikson and T.R.Gullikson

1984 P.Fleming and J.P.McEnroe
P.Cash and P.McNamee

1985 H.P.Guenthardt and B.Taroczy
P.Cash and J.B.Fitzgerald

1986 J.Nystrom and M.Wilander
G.Donnelly and P.Fleming

1987 K.Flach and R.Seguso
S.Casal and E.Sanchez

1988 K.Flach and R.Seguso
J.B.Fitzgerald and A.Jarryd

1989 J.B.Fitzgerald and A.Jarryd
R.Leach and J.Pugh

1990 R.Leach and J.Pugh
P.Aldrich and D.T.Visser

1991 J.B.Fitzgerald and A.Jarryd
J.Frana and L.Lavalle

1992 J.P.McEnroe and M.Stich
J.Grabb and R.A.Reneberg

1993 T.A.Woodbridge and M.Woodforde
G.Connell and P.Galbraith

1994 T.A.Woodbridge and M.Woodforde
G.Connell and P.Galbraith

1995 T.A.Woodbridge and M.Woodforde
R.Leach and S.Melville

1996 T.A.Woodbridge and M.Woodforde
B.Black and G.Connell

1997 T.A.Woodbridge and M.Woodforde
J.Eltingh and P.Haarhuis

1998 J.Eltingh and P.Haarhuis
T.A.Woodbridge and M.Woodforde

1999 M.Bhupathi and L.Paes
P.Haarhuis and J.Palmer

2000 T.A.Woodbridge and M.Woodforde
P.Haarhuis and S.Stolle

2001 D.Johnson and J.Palmer
J.Novak and D.Rikl

2002 J.Bjorkman and T.A Woodbridge
M.Knowles and D.Nestor

2003 J.Bjorkman and T.A Woodbridge
M.Bhupathi and M.Mirnyi

2004 J.Bjorkman and T.A Woodbridge
J.Knowle and N.Zimonjic

2005 S.Huss and W.Moodie
B.Bryan and M.Bryan

2006 B.Bryan and M.Bryan
F.Santoro and N.Zimonjic

2007 A.Clement and M.Llodra
B.Bryan and M.Bryan

2008 D.Nestor and N.Zimonjic
J.Bjorkman and K.Ullyett

2009 D.Nestor and N.Zimonjic
B.Bryan and M.Bryan

2010 J.Melzer and P.Petzschner
R.Lindstedt and H.Tecau

2011 B.Bryan and M.Bryan
R.Lindstedt and H.Tecau

2012 J.Marray and F.Nielsen
R.Linstedt and H.Tecau

ROLL OF HONOUR
LADIES' DOUBLES CHAMPIONS & RUNNERS-UP

1913 Mrs.R.J.McNair and Miss D.P.Boothby
Mrs.A.Sterry and Mrs.Lambert Chambers

1914 Miss E.Ryan and Miss A.M.Morton
Mrs.D.R.Larcombe and Mrs.F.J.Hannam

1919 Miss S.Lenglen and Miss E.Ryan
Mrs.Lambert Chambers and Mrs.D.R.Larcombe

1920 Miss S.Lenglen and Miss E.Ryan
Mrs.Lambert Chambers and Mrs.D.R.Larcombe

1921 Miss S.Lenglen and Miss E.Ryan
Mrs.A.E.Beamish and Mrs.G.E.Peacock

1922 Miss S.Lenglen and Miss E.Ryan
Mrs.A.D.Stocks and Miss K.McKane

1923 Miss S.Lenglen and Miss E.Ryan
Miss J.Austin and Miss E.L.Colyer

1924 Mrs.H.Wightman and Miss H.Wills
Mrs.B.C.Covell and Miss K.McKane

1925 Miss S.Lenglen and Miss E.Ryan
Mrs.A.V.Bridge and Mrs.C.G.McIlquham

1926 Miss E.Ryan and Miss M.K.Browne
Mrs.L.A.Godfree and Miss E.L.Colyer

1927 Miss H.Wills and Miss E.Ryan
Miss E.L.Heine and Mrs.G.E.Peacock

1928 Mrs.Holcroft-Watson and Miss P.Saunders
Miss E.H.Harvey and Miss E.Bennett

1929 Mrs.Holcroft-Watson and Mrs.L.R.C.Michell
Mrs.B.C.Covell and Mrs.D.C.Shepherd-Barron

1930 Mrs.F.S.Moody and Miss E.Ryan
Miss E.Cross and Miss S.Palfrey

1931 Mrs.D.C.Shepherd-Barron and Miss P.E.Mudford
Miss D.Metaxa and Miss J.Sigart

1932 Miss D.Metaxa and Miss J.Sigart
Miss E.Ryan and Miss H.H.Jacobs

1933 Mrs.R.Mathieu and Miss E.Ryan
Miss F.James and Miss A.M.Yorke

1934 Mrs.R.Mathieu and Miss E.Ryan
Mrs.D.Andrus and Mrs.S.Henrotin

1935 Miss F.James and Miss K.E.Stammers
Mrs.R.Mathieu and Mrs S.Sperling

1936 Miss F.James and Miss K.E.Stammers
Mrs.S.P.Fabyan and Miss H.H.Jacobs

1937 Mrs.R.Mathieu and Miss A.M.Yorke
Mrs.M.R.King and Mrs.J.B.Pittman

1938 Mrs.S.P.Fabyan and Miss A.Marble
Mrs.R.Mathieu and Miss A.M.Yorke

1939 Mrs S.P.Fabyan and Miss A.Marble
Miss H.H.Jacobs and Miss A.M.Yorke

1946 Miss L.Brough and Miss M.Osborne
Miss P.Betz and Miss D.Hart

1947 Miss D.Hart and Mrs.P.C.Todd
Miss L.Brough and Miss M.Osborne

1948 Miss L.Brough and Mrs.W.du Pont
Miss D.Hart and Mrs.P.C.Todd

1949 Miss L.Brough and Mrs.W.du Pont
Miss G.Moran and Mrs.P.C.Todd

1950 Miss L.Brough and Mrs.W.du Pont
Miss S.Fry and Miss D.Hart

1951 Miss S.Fry and Miss D.Hart
Miss L.Brough and Mrs.W.du Pont

1952 Miss S.Fry and Miss D.Hart
Miss L.Brough and Miss M.Connolly

1953 Miss S.Fry and Miss D.Hart
Miss M.Connolly and Miss J.Sampson

1954 Miss L.Brough and Mrs.W.du Pont
Miss S.Fry and Miss D.Hart

1955 Miss A.Mortimer and Miss J.A.Shilcock
Miss S.J.Bloomer and Miss P.E.Ward

1956 Miss A.Buxton and Miss A.Gibson
Miss F.Muller and Miss D.G.Seeney

1957 Miss A.Gibson and Miss D.R.Hard
Mrs.K.Hawton and Mrs.T.D.Long

1958 Miss M.E.Bueno and Miss A.Gibson
Mrs.W.du Pont and Miss M.Varner

1959 Miss J.Arth and Miss D.R.Hard
Mrs.J.G.Fleitz and Miss C.C.Truman

1960 Miss M.E.Bueno and Miss D.R.Hard
Miss S.Reynolds and Miss R.Schuurman

1961 Miss K.Hantze and Miss B.J.Moffitt
Miss J.Lehane and Miss M.Smith

1962 Miss B.J.Moffitt and Mrs.J.R.Susman
Mrs.L.E.G.Price and Miss R.Schuurman

1963 Miss M.E.Bueno and Miss D.R.Hard
Miss R.A.Ebbern and Miss M.Smith

1964 Miss M.Smith and Miss L.R.Turner
Miss B.J.Moffitt and Mrs.J.R.Susman

1965 Miss M.E.Bueno and Miss B.J.Moffitt
Miss F.Durr and Miss J.LieVrig

1966 Miss M.E.Bueno and Miss N.Richey
Miss M.Smith and Miss J.A.M.Tegart

1967 Miss R.Casals and Mrs.L.W.King
Miss M.E.Bueno and Miss N.Richey

1968 Miss R.Casals and Mrs.L.W.King
Miss F.Durr and Mrs.P.F.Jones

1969 Mrs.B.M.Court and Miss J.A.M.Tegart
Miss P.S.A.Hogan and Miss M.Michel

1970 Miss R.Casals and Mrs.L.W.King
Miss F.Durr and Miss S.V.Wade

1971 Miss R.Casals and Mrs.L.W.King
Mrs.B.M.Court and Miss E.F.Goolagong

1972 Mrs.L.W.King and Miss B.F.Stove
Mrs.D.E.Dalton and Miss F.Durr

1973 Miss R.Casals and Mrs.L.W.King
Miss F.Durr and Miss B.F.Stove

1974 Miss E.F.Goolagong and Miss M.Michel
Miss H.F.Gourlay and Miss K.M.Krantzcke

1975 Miss A.Kiyomura and Miss K.Sawamatsu
Miss F.Durr and Miss B.F.Stove

1976 Miss C.M.Evert and Miss M.Navratilova
Mrs.L.W.King and Miss B.F.Stove

1977 Mrs.H.F.Gourlay Cawley and Miss J.C.Russell
Miss M.Navratilova and Miss B.F .Stove

1978 Mrs.G.E.Reid and Miss.W.M.Turnbull
Miss M.Jausovec and Miss V.Ruzici

1979 Mrs.L.W.King and Miss M.Navratilova
Miss B.F.Stove and Miss W.M.Turnbull

1980 Miss K.Jordan and Miss A.E.Smith
Miss R.Casals and Miss W.M.Turnbull

1981 Miss M.Navratilova and Miss P.H.Shriver
Miss K.Jordan and Miss A.E.Smith

1982 Miss M.Navratilova and Miss P.H.Shriver
Miss K.Jordan and Miss A.E.Smith

1983 Miss M.Navratilova and Miss P.H.Shriver
Miss R.Casals and Miss W.M.Turnbull

1984 Miss M.Navratilova and Miss P.H.Shriver
Miss K.Jordan and Miss A.E.Smith

1985 Miss K.Jordan and Mrs.P.D.Smylie
Miss M.Navratilova and Miss P.H.Shriver

1986 Miss M.Navratilova and Miss P.H.Shriver
Miss H.Mandlikova and Miss W.M.Turnbull

1987 Miss C.Kohde-Kilsch and Miss H.Sukova
Miss B.Nagelsen and Mrs.P.D.Smylie

1988 Miss S.Graf and Miss G.Sabatini
Miss L.Savchenko and Miss N.Zvereva

1989 Miss J.Novotna and Miss H.Sukova
Miss L.Savchenko and Miss N.Zvereva

1990 Miss J.Novotna and Miss H.Sukova
Miss K.Jordan and Mrs.P.D.Smylie

1991 Miss L.Savchenko and Miss N.Zvereva
Miss G.Fernandez and Miss J.Novotna

1992 Miss G.Fernandez and Miss N.Zvereva
Miss J.Novotna and Mrs.L.Savchenko-Neiland

1993 Miss G.Fernandez and Miss N.Zvereva
Mrs.L.Neiland and Miss J.Novotna

1994 Miss G.Fernandez and Miss N.Zvereva
Miss J.Novotna and Miss A.Sanchez Vicario

1995 Miss J.Novotna and Miss A.Sanchez Vicario
Miss G.Fernandez and Miss N.Zvereva

1996 Miss M.Hingis and Miss H.Sukova
Miss M.J.McGrath and Mrs.L.Neiland

1997 Miss G.Fernandez and Miss N.Zvereva
Miss N.J.Arendt and Miss M.M.Bollegraf

1998 Miss M.Hingis and Miss J.Novotna
Miss L.A.Davenport and Miss N.Zvereva

1999 Miss L.A.Davenport and Miss C.Morariu
Miss M.de Swardt and Miss E.Tatarkova

2000 Miss S.Williams and Miss V.Williams
Mrs J.Halard-Decugis and Miss A.Sugiyama

2001 Miss L.M.Raymond and Miss R.P.Stubbs
Miss K.Clijsters and Miss A.Sugiyama

2002 Miss S.Williams and Miss V.Williams
Miss V.Ruano Pascual and Miss P.Suarez

2003 Miss K.Clijsters and Miss A.Sugiyama
Miss V.Ruano Pascual and Miss P.Suarez

2004 Miss C.Black and Miss R.P.Stubbs
Mrs L.Huber and Miss A.Sugiyama

2005 Miss C.Black and Mrs L.Huber
Miss S.Kuznetsova and Miss A.Muresmo

2006 Miss Z.Yan and Miss J.Zheng
Miss V.Ruano Pascual and Miss P.Suarez

2007 Miss C.Black and Mrs L.Huber
Miss K.Srebotnik and Miss A.Sugiyama

2008 Miss S.Williams and Miss V.Williams
Miss L.M.Raymond and Miss S.Stosur

2009 Miss S.Williams and Miss V.Williams
Miss S.Stosur and Miss R.P.Stubbs

2010 Miss V.King and Miss Y.Shvedova
Miss E.Vesnina and Miss V.Zvonareva

2011 Miss K.Peschke and Miss K.Srebotnik
Miss S.Lisicki and Miss S.Stosur

2012 Miss S.Williams and Miss V.Williams
Miss A.Hlavackova and Miss L.Hradecka

ROLL OF HONOUR
MIXED DOUBLES CHAMPIONS & RUNNERS-UP

1913 H.Crisp and Mrs.C.O.Tuckey	
J.C.Parke and Mrs.D.R.Larcombe	
1914 J.C.Parke and Mrs.D.R.Larcombe	
A.F.Wilding and Miss M.Broquedis	
1919 R.Lycett and Miss E.Ryan	
A.D.Prebble and Mrs.Lambert Chambers	
1920 G.L.Patterson and Miss S.Lenglen	
R.Lycett and Miss E.Ryan	
1921 R.Lycett and Miss E.Ryan	
M.Woosnam and Miss P.L.Howkins	
1922 P.O'Hara-Wood and Miss S.Lenglen	
R.Lycett and Miss E.Ryan	

1913 H.Crisp and Mrs.C.O.Tuckey
J.C.Parke and Mrs.D.R.Larcombe

1914 J.C.Parke and Mrs.D.R.Larcombe
A.F.Wilding and Miss M.Broquedis

1919 R.Lycett and Miss E.Ryan
A.D.Prebble and Mrs.Lambert Chambers

1920 G.L.Patterson and Miss S.Lenglen
R.Lycett and Miss E.Ryan

1921 R.Lycett and Miss E.Ryan
M.Woosnam and Miss P.L.Howkins

1922 P.O'Hara-Wood and Miss S.Lenglen
R.Lycett and Miss E.Ryan

1923 R.Lycett and Miss E.Ryan
L.S.Deane and Mrs.D.C.Shepherd-Barron

1924 J.B.Gilbert and Miss K.McKane
L.A.Godfree and Mrs.D.C.Shepherd-Barron

1925 J.Borotra and Miss S.Lenglen
H.L.de Morpurgo and Miss E.Ryan

1926 L.A.Godfree and Mrs.L.A.Godfree
H.Kinsey and Miss M.K.Browne

1927 F.T.Hunter and Miss E.Ryan
L.A.Godfree and Mrs.L.A.Godfree

1928 P.D.B.Spence and Miss E.Ryan
J.Crawford and Miss D.Akhurst

1929 F.T.Hunter and Miss H.Wills
I.G.Collins and Miss J.Fry

1930 J.H.Crawford and Miss E.Ryan
D.Prenn and Miss H.Krahwinkel

1931 G.M.Lott and Mrs L.A.Harper
I.G.Collins and Miss J.C.Ridley

1932 E.Maier and Miss E.Ryan
H.C.Hopman and Miss J.Sigart

1933 G.von Cramm and Miss H.Krahwinkel
N.G.Farquharson and Miss M.Heeley

1934 R.Miki and Miss D.E.Round
H.W.Austin and Mrs D.C.Shepherd-Barron

1935 F.J.Perry and Miss D.E.Round
H.C.Hopman and Mrs.H.C.Hopman

1936 F.J.Perry and Miss D.E.Round
J.D.Budge and Mrs.S.P.Fabyan

1937 J.D.Budge and Miss A.Marble
Y.Petra and Mrs.R.Mathieu

1938 J.D.Budge and Miss A.Marble
H.Henkel and Mrs.S.P.Fabyan

1939 R.L.Riggs and Miss A.Marble
F.H.D.Wilde and Miss N.B.Brown

1946 T.Brown and Miss L.Brough
G.E.Brown and Miss D.Bundy

1947 J.E.Bromwich and Miss L.Brough
C.F.Long and Mrs.N.M.Bolton

1948 J.E.Bromwich and Miss L.Brough
F.A.Sedgman and Miss D.Hart

1949 E.W.Sturgess and Mrs.S.P.Summers
J.E.Bromwich and Miss L.Brough

1950 E.W.Sturgess and Miss L.Brough
G.E.Brown and Mrs.P.C.Todd

1951 F.A.Sedgman and Miss D.Hart
M.G.Rose and Mrs.N.M.Bolton

1952 F.A.Sedgman and Miss D.Hart
E.Morea and Mrs.T.D.Long

1953 V.Seixas and Miss D.Hart
E.Morea and Miss S.Fry

1954 V.Seixas and Miss D.Hart
K.R.Rosewall and Mrs.W.du Pont

1955 V.Seixas and Miss D.Hart
E.Morea and Miss L.Brough

1956 V.Seixas and Miss S.Fry
G.Mulloy and Miss A.Gibson

1957 M.G.Rose and Miss D.R.Hard
N.A.Fraser and Miss A.Gibson

1958 R.N.Howe and Miss L.Coghlan
K.Nielsen and Miss A.Gibson

1959 R.Laver and Miss D.R.Hard
N.A.Fraser and Miss M.E.Bueno

1960 R.Laver and Miss D.R.Hard
R.N.Howe and Miss M.E.Bueno

1961 F.S.Stolle and Miss L.R.Turner
R.N.Howe and Miss E.Buding

1962 N.A.Fraser and Mrs.W.du Pont
R.D.Ralston and Miss A.S.Haydon

1963 K.N.Fletcher and Miss M.Smith
R.A.J.Hewitt and Miss D.R.Hard

1964 F.S.Stolle and Miss L.R.Turner
K.N.Fletcher and Miss M.Smith

1965 K.N.Fletcher and Miss M.Smith
A.D.Roche and Miss J.A.M.Tegart

1966 K.N.Fletcher and Miss M.Smith
R.D.Ralston amd Mrs.L.W.King

1967 O.K.Davidson and Mrs.L.W.King
K.N.Fletcher and Miss M.E.Bueno

1968 K.N.Fletcher and Mrs.B.M.Court
A.Metreveli and Miss O.Morozova

1969 F.S.Stolle and Mrs.P.F.Jones
A.D.Roche and Miss J.A.M.Tegart

1970 I.Nastase and Miss R.Casals
A.Metreveli and Miss O.Morozova

1971 O.K.Davidson and Mrs.L.W.King
M.C.Riessen and Mrs.B.M.Court

1972 I.Nastase and Miss R.Casals
K.G.Warwick and Miss E.F.Goolagong

1973 O.K.Davidson and Mrs.L.W.King
R.Ramirez and Miss J.S.Newberry

1974 O.K.Davidson and Mrs.L.W.King
M.J.Farrell and Miss L.J.Charles

1975 M.C.Riessen and Mrs.B.M.Court
A.J.Stone and Miss B.F.Stove

1976 A.D.Roche and Miss F.Durr
R.L.Stockton and Miss R.Casals

1977 R.A.J.Hewitt and Miss G.R.Stevens
F.D.McMillan and Miss B.F.Stove

1978 F.D.McMillan and Miss B.F.Stove
R.O.Ruffels and Mrs.L.W.King

1979 R.A.J.Hewitt and Miss G.R.Stevens
F.D.McMillan and Miss B.F.Stove

1980 J.R.Austin and Miss T.Austin
M.R.Edmondson and Miss D.L.Fromholtz

1981 F.D.McMillan and Miss B.F.Stove
J.R.Austin and Miss T.Austin

1982 K.Curren and Miss A.E.Smith
J.M.Lloyd and Miss W.M.Turnbull

1983 J.M.Lloyd and Miss W.M.Turnbull
S.Denton and Mrs.L.W.King

1984 J.M.Lloyd and Miss W.M.Turnbull
S.Denton and Miss K.Jordan

1985 P.McNamee and Miss M.Navratilova
J.B.Fitzgerald and Mrs.P.D.Smylie

1986 K.Flach and Miss K.Jordan
H.P.Guenthardt and Miss M.Navratilova

1987 M.J.Bates and Miss J.M.Durie
D.Cahill and Miss N.Provis

1988 S.E.Stewart and Miss Z.L.Garrison
K.Jones and Mrs.S.W.Magers

1989 J.Pugh and Miss J.Novotna
M.Kratzmann and Miss J.M.Byrne

1990 R.Leach and Miss Z.L.Garrison
J.B.Fitzgerald and Mrs P.D.Smylie

1991 J.B.Fitzgerald and Mrs.P.D.Smylie
J.Pugh and Miss N.Zvereva

1992 C.Suk and Mrs L.Savchenko-Neiland
J.Eltingh and Miss M.Oremans

1993 M.Woodforde and Miss M.Navratilova
T.Nijssen and Miss M.M.Bollegraf

1994 T.A.Woodbridge and Miss H.Sukova
T.J.Middleton and Miss L.M.McNeil

1995 J.Stark and Miss M.Navratilova
C.Suk and Miss G.Fernandez

1996 C.Suk and Miss H.Sukova
M.Woodforde and Mrs.L.Neiland

1997 C.Suk and Miss H.Sukova
A.Olhovskiy and Mrs L.Neiland

1998 M.Mirnyi and Miss S.Williams
M.Bhupathi and Miss M.Lucic

1999 L.Paes and Miss L.M.Raymond
J.Bjorkman and Miss A.Kournikova

2000 D.Johnson and Miss K.Po
L.Hewitt and Miss K.Clijsters

2001 L.Friedl and Miss D.Hantuchova
M.Bryan and Mrs L.Huber

2002 M.Bhupathi and Miss E.Likhovtseva
K.Ullyett and Miss D.Hantuchova

2003 L.Paes and Miss M.Navratilova
A.Ram and Miss A.Rodionova

2004 W.Black and Miss C.Black
T.A.Woodbridge and Miss A.Molik

2005 M.Bhupathi and Miss M.Pierce
P.Hanley and Miss T.Perebiynis

2006 A.Ram and Miss V.Zvonareva
B.Bryan and Miss V.Williams

2007 J.Murray and Miss J.Jankovic
J.Bjorkman and Miss A.Molik

2008 B.Bryan and Miss S.Stosur
M.Bryan and Miss K.Srebotnik

2009 M.Knowles and Miss A-L.Groenefeld
L.Paes and Miss C.Black

2010 L.Paes and Miss C.Black
W.Moody and Miss L.Raymond

2011 J.Melzer and Miss I.Benesova
M.Bhupathi and Miss E.Vesnina

2012 M.Bryan and Miss L.Raymond
L.Paes and Miss E.Vesnina

ROLL OF HONOUR

BOYS' SINGLES

1947 K.Nielsen	1964 I.El Shafei	1981 M.W.Anger	1998 R.Federer
S.V.Davidson	*V.Korotkov*	*P.Cash*	*I.Labadze*
1948 S.Stockenberg	1965 V.Korotkov	1982 P.Cash	1999 J.Melzer
D.Vad	*G.Goven*	*H.Sundstrom*	*K.Pless*
1949 S.Stockenberg	1966 V.Korotkov	1983 S.Edberg	2000 N.Mahut
J.A.T.Horn	*B.E.Fairlie*	*J.Frawley*	*M.Ancic*
1950 J.A.T.Horn	1967 M.Orantes	1984 M.Kratzmann	2001 R.Valent
K.Mobarek	*M.S.Estep*	*S.Kruger*	*G.Muller*
1951 J.Kupferburger	1968 J.G.Alexander	1985 L.Lavalle	2002 T.Reid
K.Mobarek	*J.Thamin*	*E.Velez*	*L.Quahab*
1952 R.K.Wilson	1969 B.Bertram	1986 E.Velez	2003 F.Mergea
T.T.Fancutt	*J.G.Alexander*	*J.Sanchez*	*C.Guccione*
1953 W.A.Knight	1970 B.Bertram	1987 D.Nargiso	2004 G.Monfils
R.Krishnan	*F.Gebert*	*J.R.Stoltenberg*	*M.Kasiri*
1954 R.Krishnan	1971 R.Kreiss	1988 N.Pereira	2005 J.Chardy
A.J.Cooper	*S.A.Warboys*	*G.Raoux*	*R.Haase*
1955 M.P.Hann	1972 B.Borg	1989 N.Kulti	2006 T.De Bakker
J.E.Lundquist	*C.J.Mottram*	*T.A.Woodbridge*	*M.Gawron*
1956 R.Holmberg	1973 W.Martin	1990 L.Paes	2007 D.Young
R.G.Laver	*C.S.Dowdeswell*	*M.Ondruska*	*V.Ignatic*
1957 J.I.Tattersall	1974 W.Martin	1991 T.Enquist	2008 G.Dimitrov
I.Ribeiro	*Ash Amritraj*	*M.Joyce*	*H.Kontinen*
1958 E.Buchholz	1975 C.J.Lewis	1992 D.Skoch	2009 A.Kuznetsov
P.J.Lall	*R.Ycaza*	*B.Dunn*	*J.Cox*
1959 T.Lejus	1976 H.Guenthardt	1993 R.Sabau	2010 M.Fucsovics
R.W.Barnes	*P.Elter*	*J.Szymanski*	*B.Mitchell*
1960 A.R.Mandelstam	1977 V.A.Winitsky	1994 S.Humphries	2011 L.Saville
J.Mukerjea	*T.E.Teltscher*	*M.A.Philippoussis*	*L.Broady*
1961 C.E.Graebner	1978 I.Lendl	1995 O.Mutis	2012 F.Peliwo
E.Blanke	*J.Turpin*	*N.Kiefer*	*L.Saville*
1962 S.Matthews	1979 R.Krishnan	1996 V.Voltchkov	
A.Metreveli	*D.Siegler*	*I.Ljubicic*	
1963 N.Kalogeropoulos	1980 T.Tulasne	1997 W.Whitehouse	
I.El Shafei	*H.D.Beutel*	*D.Elsner*	

BOYS' DOUBLES

1982 P.Cash and J.Frawley	1996 D.Bracciali and J.Robichaud	2010 L.Broady and T.Farquharson
R.D.Leach and J.J.Ross	*D.Roberts and W.Whitehouse*	*L.Burton and G.Morgan*
1983 M.Kratzmann and S.Youl	1997 L.Horna and N.Massu	2011 G.Morgan and M.Pavic
M.Nastase and O. Rahnasto	*J.Van de Westhuizen*	*O.Golding and J.Vesely*
1984 R.Brown and R.Weiss	*and W.Whitehouse*	2012 A.Harris and N.Kyrgios
M.Kratzmann and J.Svensson	1998 R.Federer and O.Rochus	*M.Donati and P.Licciardi*
1985 A.Moreno and J.Yzaga	*M.Llodra and A.Ram*	
P.Korda and C.Suk	1999 G.Coria and D.Nalbandian	
1986 T.Carbonell and P.Korda	*T.Enev and J.Nieminem*	
S.Barr and H.Karrasch	2000 D.Coene and K.Vliegen	
1987 J.Stoltenberg and T.Woodbridge	*A.Banks and B.Riby*	
D.Nargiso and E.Rossi	2001 F.Dancevic and G.Lapentti	
1988 J.Stoltenberg and T.Woodbridge	*B.Echagaray and S.Gonzales*	
D.Rikl and T.Zdrazila	2002 F.Mergea and H.Tecau	
1989 J.Palmer and J.Stark	*B.Baker and B.Ram*	
J-L.De Jager and W.R.Ferreira	2003 F.Mergea and H.Tecau	
1990 S.Lareau and S.Leblanc	*A.Feeney and C.Guccione*	
C.Marsh and M.Ondruska	2004 B.Evans and S.Oudsema	
1991 K.Alami and G.Rusedski	*R.Haase and V.Troicki*	
J-L.De Jager and A.Medvedev	2005 J.Levine and M.Shabaz	
1992 S.Baldas and S.Draper	*S.Groth and A.Kennaugh*	
M. S.Bhupathi and N.Kirtane	2006 K.Damico and N.Schnugg	
1993 S.Downs and J.Greenhalgh	*M.Klizan and A.Martin*	
N.Godwin and G.Williams	2007 D.Lopez and M.Trevisan	
1994 B.Ellwood and M.Philippoussis	*R.Jebavy and M.Klizan*	
V.Platenik and R.Schlachter	2008 C-P.Hsieh and T-H.Yang	
1995 M.Lee and J.M.Trotman	*M.Reid and B.Tomic*	
A.Hernandez and M.Puerta	2009 P-H.Herbert and K.Krawietz	
	J.Obry and A.Puget	

GIRLS' SINGLES

1947 Miss G.Domken *Miss B.Wallen*	1964 Miss P.Bartkowicz *Miss E.Subirats*	1981 Miss Z.Garrison *Miss R.R.Uys*
1948 Miss O.Miskova *Miss V.Rigollet*	1965 Miss O.Morozova *Miss R.Giscarfe*	1982 Miss C.Tanvier *Miss H.Sukova*
1949 Miss C.Mercelis *Miss J.S.V.Partridge*	1966 Miss B.Lindstrom *Miss J.A.Congdon*	1983 Miss P.Paradis *Miss P.Hy*
1950 Miss L.Cornell *Miss A. Winter*	1967 Miss J.Salome *Miss E.M.Strandberg*	1984 Miss A.N.Croft *Miss E.Reinach*
1951 Miss L.Cornell *Miss S.Lazzarino*	1968 Miss K.Pigeon *Miss L.E.Hunt*	1985 Miss A.Holikova *Miss J.M.Byrne*
1952 Miss F.J.I.ten Bosch *Miss R.Davar*	1969 Miss K.Sawamatsu *Miss B.I.Kirk*	1986 Miss N.M.Zvereva *Miss L.Meskhi*
1953 Miss D.Kilian *Miss V.A.Pitt*	1970 Miss S.Walsh *Miss M.V.Kroshina*	1987 Miss N.M.Zvereva *Miss J.Halard*
1954 Miss V.A.Pitt *Miss C.Monnot*	1971 Miss M.V.Kroschina *Miss S. H.Minford*	1988 Miss B.Schultz *Miss E.Derly*
1955 Miss S.M.Armstrong *Miss B.de Chambure*	1972 Miss I.Kloss *Miss G.L.Coles*	1989 Miss A.Strnadova *Miss M.J.McGrath*
1956 Miss A.S.Haydon *Miss I.Buding*	1973 Miss A.Kiyomura *Miss M.Navratilova*	1990 Miss A.Strnadova *Miss K.Sharpe*
1957 Miss M.Arnold *Miss E.Reyes*	1974 Miss M.Jausovec *Miss M.Simionescu*	1991 Miss B.Rittner *Miss E.Makarova*
1958 Miss S.M.Moore *Miss A.Dmitrieva*	1975 Miss N.Y.Chmyreva *Miss R.Marsikova*	1992 Miss C.Rubin *Miss L.Courtois*
1959 Miss J.Cross *Miss D.Schuster*	1976 Miss N.Y.Chmyreva *Miss M.Kruger*	1993 Miss N.Feber *Miss R.Grande*
1960 Miss K.Hantze *Miss L.M Hutchings*	1977 Miss L.Antonoplis *Miss Mareen Louie*	1994 Miss M.Hingis *Miss M-R.Jeon*
1961 Miss G.Baksheeva *Miss K.D.Chabot*	1978 Miss T.Austin *Miss H.Mandlikova*	1995 Miss A.Olsza *Miss T.Tanasugarn*
1962 Miss G.Baksheeva *Miss E.P.Terry*	1979 Miss M.L.Piatek *Miss A.A.Moulton*	1996 Miss A.Mauresmo *Miss M.L.Serna*
1963 Miss D.M.Salfati *Miss K.Dening*	1980 Miss D.Freeman *Miss S.J.Leo*	1997 Miss C.Black *Miss A.Rippner*

1998 Miss K.Srebotnik *Miss K.Clijsters*	
1999 Miss I.Tulyagnova *Miss L.Krasnoroutskaya*	
2000 Miss M.E.Salerni *Miss T.Perebiynis*	
2001 Miss A.Widjaja *Miss D.Safina*	
2002 Miss V.Douchevina *Miss M.Sharapova*	
2003 Miss K.Flipkens *Miss A.Tchakvetadze*	
2004 Miss K.Bondarenko *Miss A.Ivanovic*	
2005 Miss A.Radwanska *Miss T.Paszek*	
2006 Miss C.Wozniacki *Miss M.Rybarikova*	
2007 Miss U.Radwanska *Miss M.Brengle*	
2008 Miss L.Robson *Miss N.Lertcheewakarn*	
2009 Miss N.Lertcheewakarn *Miss K.Mladenovic*	
2010 Miss K.Pliskova *Miss S.Ishizu*	
2011 Miss A.Barty *Miss I.Khromacheva*	
2012 Miss E.Bouchard *Miss E.Svitolina*	

GIRLS' DOUBLES

1982 Miss B.Herr and Miss P.Barg *Miss B.S.Gerken and Miss G.A.Rush*	1994 Miss E.De Villiers and Miss E.E.Jelfs *Miss C.M.Morariu and Miss L.Varmuzova*	2005 Miss V.Azarenka and Miss A.Szavay *Miss M.Erakovic and Miss M.Niculescu*
1983 Miss P.Fendick and Miss P.Hy *Miss C.Anderholm and Miss H.Olsson*	1995 Miss C.Black and Miss A.Olsza *Miss T.Musgrove and Miss J. Richardson*	2006 Miss A.Kleybanova and Miss A.Pavlyuchenkova *Miss K.Antoniychuk and Miss A.Dulgheru*
1984 Miss C.Kuhlman and Miss S.Rehe *Miss V.Milvidskaya and Miss L.I.Savchenko*	1996 Miss O.Barabanschikova and Miss A.Mauresmo *Miss L.Osterloh and Miss S.Reeves*	2007 Miss A.Pavlyuchenkova and Miss U.Radwanska *Miss M.Doi and Miss K.Nara*
1985 Miss L.Field and Miss J.Thompson *Miss E.Reinach and Miss J.A.Richardson*	1997 Miss C.Black and Miss I.Selyutina *Miss M.Matevzic and Miss K.Srebotnik*	2008 Miss P.Hercog and Miss J.Moore *Miss I.Holland and Miss S.Peers*
1986 Miss M.Jaggard and Miss L.O'Neill *Miss L.Meskhi and Miss N.M.Zvereva*	1998 Miss E.Dyrberg and Miss J.Kostanic *Miss P.Rampre and Miss I.Tulyaganova*	2009 Miss N.Lertcheewakarn and Miss S.Peers *Miss K.Mladenovic and Miss S.Njiric*
1987 Miss N.Medvedeva and Miss N.M.Zvereva *Miss I.S.Kim and Miss P.M.Moreno*	1999 Miss D.Bedanova and Miss M.E.Salerni *Miss T.Perebiynis and Miss I.Tulyaganova*	2010 Miss T.Babos and Miss S.Stephens *Miss I.Khromacheva and Miss E.Svitolina*
1988 Miss J.A.Faull and Miss R.McQuillan *Miss A.Dechaume and Miss E.Derly*	2000 Miss I.Gaspar and Miss T.Perebiynis *Miss D.Bedanova and Miss M.E.Salerni*	2011 Miss E.Bouchard and Miss G.Min *Miss D.Schuurs and Miss Hao Chen Tang*
1989 Miss J.Capriati and Miss M.McGrath *Miss A.Strnadova and Miss E.Sviglerova*	2001 Miss G.Dulko and Miss A.Harkleroad *Miss C.Horiatopoulos and Miss B.Mattek*	2012 Miss E.Bouchard and Miss T.Townsend *Miss B.Bencic and Miss A.Konjuh*
1990 Miss K.Habsudova and Miss A.Strnadova *Miss N.J.Pratt and Miss K.Sharpe*	2002 Miss E.Clijsters and Miss B.Strycova *Miss A.Baker and Miss A-L.Groenfeld*	
1991 Miss C.Barclay and Miss L.Zaltz *Miss J.Limmer and Miss A.Woolcock*	2003 Miss A.Kleybanova and Miss S.Mirza *Miss K.Bohmova and Miss M.Krajicek*	
1992 Miss M.Avotins and Miss L.McShea *Miss P.Nelson and Miss J.Steven*	2004 Miss V.Azarenka and Miss V.Havartsova *Miss M.Erakovic and Miss M.Niculescu*	
1993 Miss L.Courtois and Miss N.Feber *Miss H.Mochizuki and Miss Y.Yoshida*		

The Rolex Wimbledon Picture of the Year Competition 2012

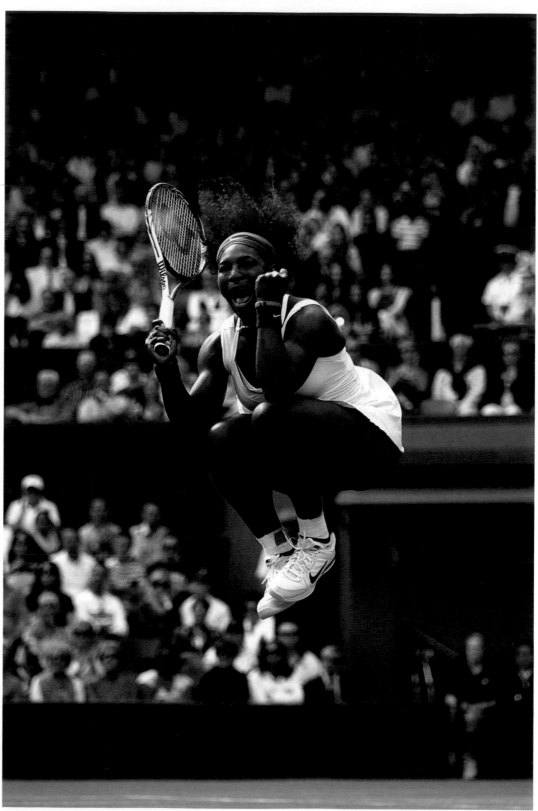

Serena Williams celebrates winning her Ladies' Singles third-round match against Zheng Jie on Day Six.

Photographer:
Clive Brunskill
(Getty Images)